THE ART OF ANDREW WYETH

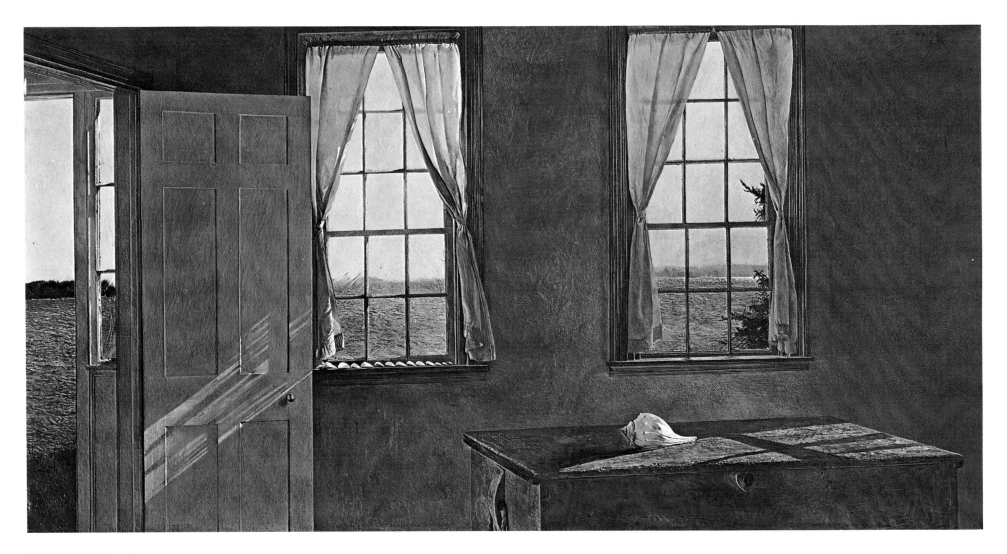

HER ROOM 1963
Tempera, 25 x 48 in.
William A. Farnsworth Library and Art Museum, Rockland, Maine

WANDA M. CORN

The Art of Andrew Wyeth

With Contributions by

BRIAN O'DOHERTY

RICHARD MERYMAN

E. P. RICHARDSON

Published for The Fine Arts Museums of San Francisco
by the New York Graphic Society, Boston

International Standard Book Number 0-8212-0516-1 (Cloth edition)
International Standard Book Number 0-8212-0685-0 (Paperback edition)
Library of Congress Catalog Number 72-93900

Eighth Hardcover Edition/Third Paperback Edition

New York Graphic Society books are published by Little,
Brown and Company.
Published simultaneously in Canada by Little, Brown
and Company (Canada) Limited.

Manufactured in the United States of America

The Fine Arts Museums of San Francisco are indebted to the
following publishers for permission to reprint material
from copyrighted articles:

©1964, *The Atlantic Monthly Company;* ©1965, *Life;*
©1965, *Show;* ©1968, United Features Syndicate, Inc.

The Andrew Wyeth quotations on pages 26, 34, 38, and 88 are
from Richard Meryman's article, "Andrew Wyeth: An Interview,"
published in *Life*, May 14, 1965, and reprinted herein.

"Fight in the Forest" by N. C. Wyeth from *The Last of the
Mohicans* by James Fenimore Cooper is used by permission of
Charles Scribner's Sons. Copyright 1919 Charles Scribner's Sons;
renewal copyright 1947 Carolyn B. Wyeth. "Siege of the
Round-House" by N. C. Wyeth from *Kidnapped* by Robert Louis
Stevenson is used by permission of Charles Scribner's Sons.
Copyright 1913 Charles Scribner's Sons; renewal copyright
1941 N. C. Wyeth.

Designed by Adrian Wilson, San Francisco

Picture Editor: Lynda C. Kefauver

Color Consultant: Harry H. Lerner

Graphic Coordination: Frank De Luca

Type set in Bembo by Peters Typesetting Inc., San Francisco
Paper: Cameo Dull by S. D. Warren Company, Boston, Massachusetts
Printed by Meehan-Tooker, East Rutherford, New Jersey
Bound by A. Horowitz & Son, Fairfield, New Jersey

Contents

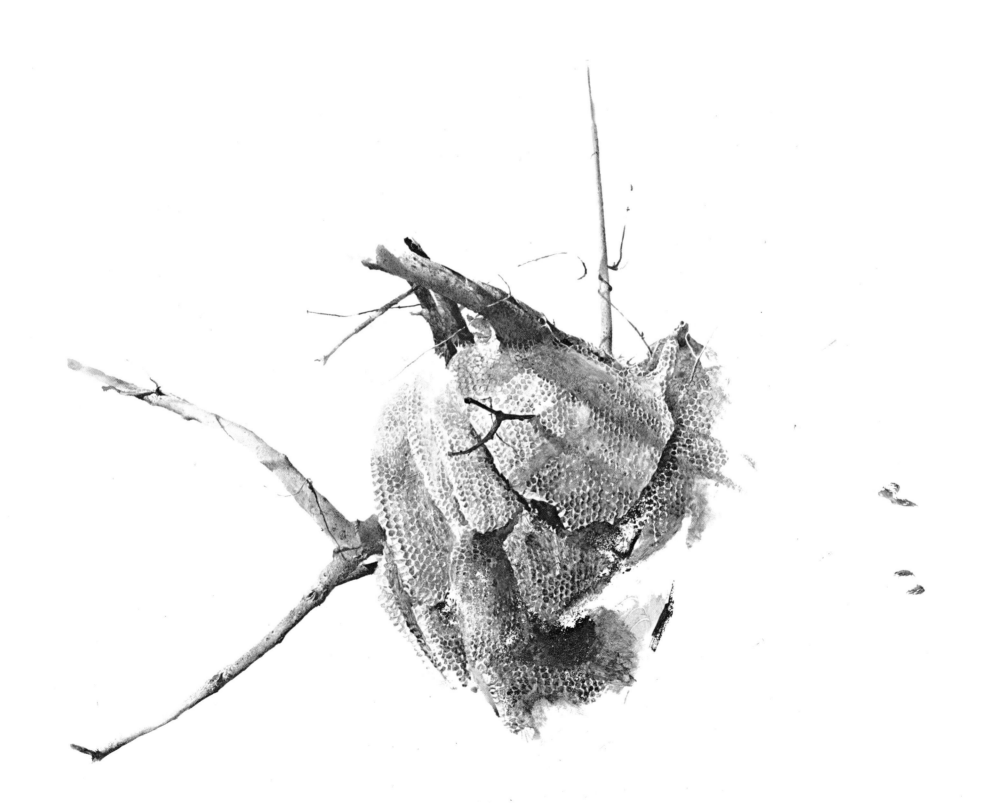

Foreword

It is a tribute to Wanda Corn, who organized the exhibition and edited this book, that the work of Andrew Wyeth has been seen from a fresh point of view. Her own study of the artist, and the essays that she has chosen to accompany it, delve below the surface of the paintings to explore the artist's psychological energy sources and to demonstrate that while his works are personal in orientation, they simultaneously reflect many of the broader impulses and currents of our times. They can, in short, be discussed in the context of modern American art.

This view is an eye-opener, even for a life-long Wyeth admirer like myself. As a child of the thirties I grew up on Wyeth, not Andrew, but N. C. Wyeth, his father, who illustrated the renowned Scribner's editions of children's classics. My daydreams were peopled with N. C. Wyeth characters: kings and princesses, buccaneers and buckskins.

It was at Harvard in 1947 that I saw my first Andrew Wyeths. My freshman adviser was Philip Hofer, and Wyeths hung on the walls of his office in the basement of Houghton Library. There were others in the home of the late Frederic B. Kellogg, adviser to Protestant students. I found Andrew's work enormously appealing, both because it seemed such a talented extension of his father's training and influence, raised to a higher artistic power, and because my own personal fascination as an amateur painter centered on realism and landscape.

But if Cambridge in the late forties and early fifties harbored Andrew Wyeths on office walls and in homes, they were not yet evident in public spaces. As a student in the architecture department, I was listening to Walter Gropius and later living in his new Graduate Center. We ate in the dining room in the presence of the enormous Joan Miro

canvas that now hangs in the lobby of the Museum of Modern Art in New York. Richard Lippold's aluminum *Tree of Life* was outside in the garden, but not totally acceptable. Chemise-clad Radcliffe girls danced around it in spring rites which ended with the planting of ballbearings from which little trees of life perhaps would sprout.

Generally speaking, architecture was to be functional and undecorated, and art was properly expressionistic and abstract. The Institute of Modern Art in Boston had just done a John Marin retrospective which was followed by the first major exhibition of Edward Munch in the United States. Henry Clifford did a Matisse retrospective at the Philadelphia Museum of Art which traveled to the Museum of Modern Art in New York, a city about to be captivated by Jackson Pollock. A decade of Abstract Expressionism was to follow.

During these years, although Andrew Wyeth's work seemed at odds with that of the pacesetters, his reputation was growing steadily in other quarters. Strangely, I saw my first Andrew Wyeth exhibition in Tokyo in 1953. It was an exhibition of dry brush and watercolors which seemed to find a responsive audience in Japan, due perhaps to Wyeth's nature-inspired subject matter and the spontaneity of his execution. In America his paintings were being sought increasingly by a group of wealthy patrons. When the big Andrew Wyeth show came to the Whitney in 1967, some critics begrudged him this popularity, and many of the cognoscenti found him out of step with contemporary art. Artists tended to see him as an immense talent, but essentially an outsider.

In the early 1960's the human figure returned to that very Museum

WINTER BEES, detail 1959
Dry brush, 21 x 27 in.
Private Collection

9

of Modern Art where it had been *persona non grata* for so long. Pop Art was "in" and the New Realists were on their way. In keeping with this renewed interest in representational traditions, Wanda Corn has now reconsidered Andrew Wyeth's realism: its sources, its development, and its meaning. For her insights we are indebted to the curatorial eye which sees things afresh. The scholarship resulting from that insight supplied the datum for a new exhibition.

The support of Andrew Wyeth and his wife Betsy was essential to the success of our undertaking. They responded warmly to the concept that his work was overdue an opportunity to be seen in the West, and each time we visited in Chadds Ford or Maine they were marvelously hospitable. They seemed genuinely to enjoy our visits, but it always weighed on my conscience that the time the artist spent with the museum director may have been time away from his studio.

We are grateful to the many museums which loaned important and popular paintings from their collections and to other lenders who parted with paintings which are sought after repeatedly for public exhibition. Mindful that the decision was a difficult one for many, we wish to extend our warmest thanks to all who put aside their private feelings to make their works of art available and by doing so made possible a far richer exhibition.

We acknowledge with thanks the substantive assistance from two groups of friends who shared the costs and administrative burdens of the exhibition: The Museum Society and the Bank of America. Our special thanks to William S. Picher, Chairman of the Exhibition Committee, appointed by The Museum Society, for his generous giving of time and talent to the making of the exhibition; and to Alden Winship Clausen, President of the Bank of America, who made possible by an exhibition grant, a most meaningful demonstration of support for an important civic and cultural event.

Ian McKibbin White
Director of the Museums

Acknowledgments

A book and exhibition of this magnitude requires, or so it seems, a cast of thousands; my first note of appreciation is extended to the many who have helped but who remain unnamed below.

This project could not have even begun without the full support of Mr. and Mrs. Andrew Wyeth and the artist's dealer, E. Coe Kerr. My gratitude for their friendship, advice, and enthusiasm is boundless. The success of the exhibition is due, as well, to those who have lent so generously in the past and who have now let themselves be coaxed to give up their pictures once again.

My appreciation also goes to all members of the museum administration and staff for their patience and teamwork. Particular thanks must go to Ian White for inviting me to undertake this project; to Lanier Graham for his wise counsel, administration, and dialogue; to Frederick Snowden and Thomas Garver for their various contributions to the exhibition preparations, and to Deborah Loft and Lynda Kefauver for their indispensable assistance and organizational skills. As successive assistants on this project, they helped to prepare all aspects of the exhibition and book. Gail Gilbert, in the ninth hour, volunteered time and energy to the checking of facts and figures for the bibliography and chronology.

I owe a personal note of thanks to a number of family members and friends: to Elizabeth Powers, Eunice Lipton, and Moira Roth for their shared enthusiasms and sustaining friendships; to my father, Keith M. Jones, for his unflagging interest in this project, which characteristically ranged from advice on photography to critical readings of the manuscript; to Keith M. Jones, Jr. for black and white photography used in the book, and to my husband, Joseph J. Corn III, who is now a *bona fide* member of that Establishment of Author's Spouses whose names appear in this column rather than on the title page where they really belong.

My final debt is to those who contributed so much to the making of the book: to Adrian Wilson, whose personal touch is evident throughout its design; to Harry Lerner for his expertise on the color reproductions; to Frank Lerner for his color photography; and to the staff members of the New York Graphic Society, especially Betty Childs, for their guidance and support. Finally, my special thanks to the book's contributors for permission to reprint their writings on the artist; and especially to Richard Meryman, who shared, through both his published writings and private conversations, his understanding and warm appreciation of the artist.

Wanda M. Corn

Preface

"The best criticism can hope to do," says a modern literary critic, "is to set the work in as many illuminating contexts as possible: the context of the genre to which it belongs, of the whole body of work of its author, of the life of the author and of his times."* Such an inclusive goal is precisely the aim of this compilation of writings and pictures: to put Andrew Wyeth and his work "in as many illuminating contexts as possible," given only the limitations imposed by the format of an exhibition book. To this end the book includes contributions of a diverse nature ranging from the oral interview to the technical or formal analysis. Three of the pieces in the book are here reprinted; my own has been written for the occasion of the exhibition. Reproductions of the artist's paintings are used throughout the texts, giving the reader the opportunity both to enjoy the work and to appraise the commentary it has provoked.

A few initial facts about the artists will help to guide the reader through some of the names and places mentioned by the authors. Andrew Wyeth comes from an artist family. His father, N. C. Wyeth, a well-known illustrator, is remembered particularly for his illustrations of Scribner's Illustrated Classics. Massachusetts-born, he first came to Wilmington, Delaware, to study with Howard Pyle, the famous turn-of-the-century illustrator. There he met and married Carolyn Bockius. They settled some dozen miles from Wilmington, in Chadds Ford, Pennsylvania, one of the tiny pre-Revolution towns on the Brandywine River, where they built their home and raised five children.

The family was a creative one. Two children besides Andrew became accomplished artists. Carolyn Wyeth and Henriette Wyeth Hurd, are both painters, as are two of N. C. Wyeth's students who married into the Wyeth family: Peter Hurd and John McCoy. Andrew's sister, Ann Wyeth McCoy, enjoyed a career as a musician, and his brother, Nathaniel Wyeth, became a scientist. Of Andrew Wyeth's own two sons, Nicholas is an art dealer in New York City, and the younger, James, is represented in the family tree of practicing artists, having achieved a reputation as a young painter within the last decade. This prolific family has made a substantial contribution to continuing the art traditions of the Brandywine Valley region, traditions that trace back to Howard Pyle and his students, many of whom, like N. C. Wyeth, settled in the area.

While many of the roots of Andrew Wyeth's art were nurtured by these regional art traditions, his own art has been acclaimed and admired nationally. Despite such publicity, he and his wife, Betsy James Wyeth, have an established pattern of life that is essential to his art, and that has remained relatively unchanged over the years. Their home from late fall until spring has always been in Chadds Ford, and in the late spring they leave for Cushing, Maine, to continue a routine of hard work and country living. Not only their consistent lifestyle but their creative partnership is remarkable. It has fallen to Betsy Wyeth to preserve the artist's privacy and the conditions he needs in order to create. This she does with a firm sense of duty and devotion. But more importantly, Betsy Wyeth might be viewed as the backstage muse for many of her husband's paintings. She has an intuitive flair for creating environments responsive to the artist's unspoken needs and helps foster his imagination through wide readings in history and genealogy, two of his own passionate interests. Finally, she is alert and sensitive to the complexities of Wyeth's creative process and—most gratifying in my own case—can make them intelligible to others. With admiration and respect, this book is dedicated to Betsy James Wyeth.

Wanda M. Corn

*Leslie A. Fiedler, *Love and Death in the American Novel* (New York, 1966), p. 10.

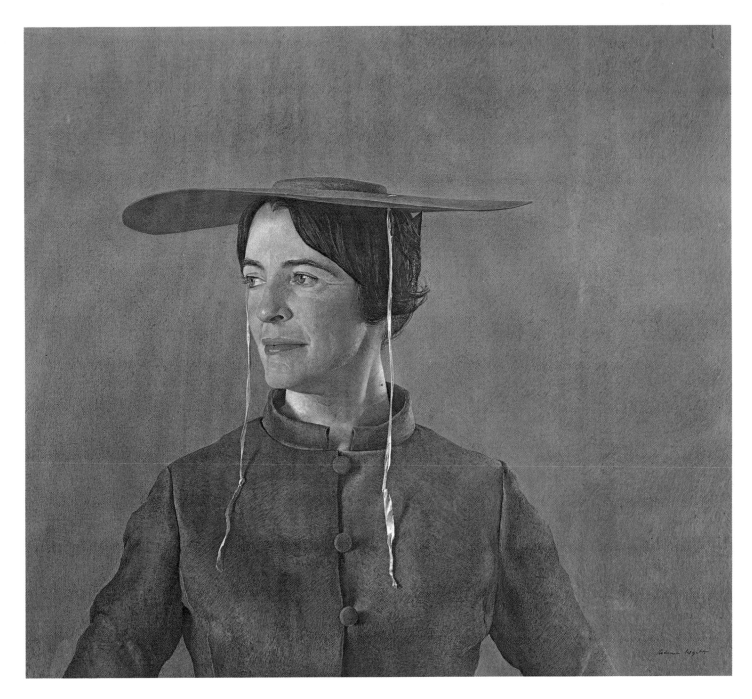

MAGA'S DAUGHTER 1966
Tempera, 27½ x 31 in.
Private Collection

13

Andrew Wyeth and his dog, Saco; Cushing, Maine, September 1967.
(Photo: Kirk C. Wilkinson)

Andrew Wyeth, Chadds Ford, Pennsylvania, 1963.
(Photo: Kirk C. Wilkinson)

A Visit to Wyeth Country

*Brian O'Doherty**

I

His head is small and compact, nut-like, with a tight rug of graying hair. His face is boyish and alert, the eyes blue, with sclera rinsed clear white. A bow-shaped upper lip projects over a row of small neat teeth. He smiles and laughs a lot, eyes puckering in crow's feet, and he has a habit of slapping a thigh and stamping a foot when he finds something particularly good. Standing, he plunges his hands deep in his pockets, shoulders hunched, head slightly tilted. He walks like an amiable and angular slow-motion Chaplin, his feet flipping out. His voice is naturally high, but he can deepen it thunderously when mimicking.

After one has said this it doesn't really amount to much. For his face is strangely indeterminate, as if it were somehow unformed and unfixed when he wasn't using it as a mask. Suddenly one realizes it is an actor's face, waiting for a character. ("Andy could have been a great actor," says his sister Carolyn.) The mobility of his face is extreme, and he can stretch and compress it at will. One evening at dinner in Maine he mimicked a local mortician filling out a wizened corpse with air. His face collapsed, caved in on itself, froze into a crabapple and then suddenly seethed, expanding slowly like a balloon until there wasn't a wrinkle left. His identity is fluid and fluctuating—like Willem de Kooning's. You can feel it changing and altering in a constant play while you talk to him. This makes you think you have got behind the mask, but when you leave you don't know whether you have.

*Excerpts from "Andrew Wyeth," an article first published in *Show*, V, No. 4 (May 1965), pp. 46–55, 72–75.

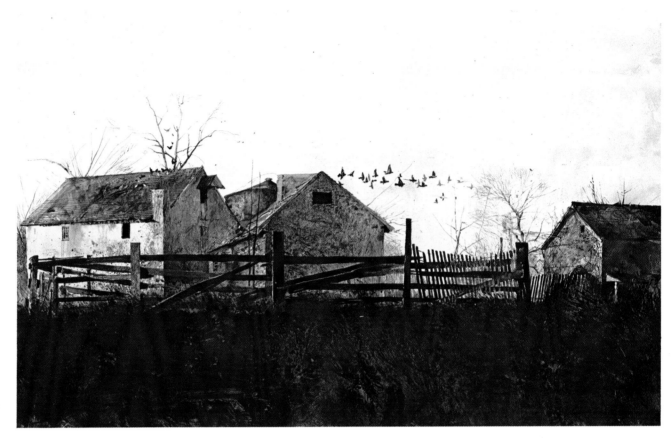

THE MILL 1959
Dry brush, 14⅜ x 22¾ in.
Private Collection

II

Chadds Ford is set in a brown and gray landscape, mild swells of earth tumbling the view, bare trees spotting the hills and running into brittle fringes against the sky. The map is veined with tributaries to the Delaware and Susquehanna rivers.

It is an old landscape, settled by Germans and Quakers. Their firm hand is still on it—shown in the solid stone buildings, the arable acres, the overlay of neatness and precision that comes from generations of responsible cultivation.

After spending some time in Chadds Ford, to drive up Route #1 to Route #202 is to run headlong into the coarser urban civilization hurtling by—the great throughway, blaring with signs, restless with traffic, cleaving with assertive logic in a straight line through the hills. In Wyeth's world the twentieth century is more hidden—bovine inoculation, the electric milker, the incubator, the combine harvester.

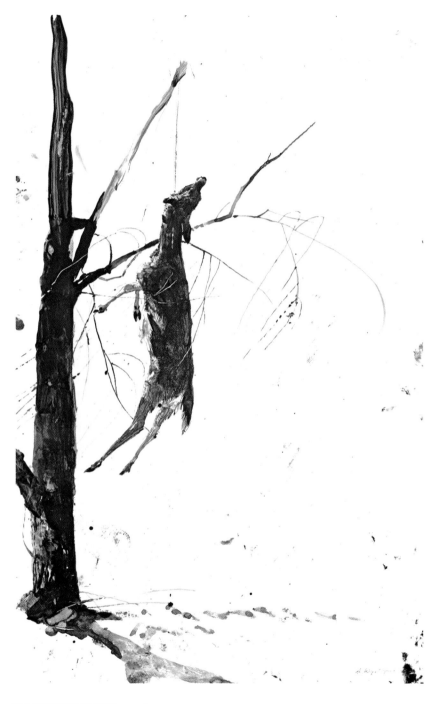

The whole Brandywine Valley is sign-posted by Andrew Wyeth's paintings. Here is the house off Route #1 where the dead deer hung. That became *Tenant Farmer* [opposite]. Here is the house where Tom Clark died. And here is where Adam, the model for the Eskimo-like figure in the painting of the same name, lives [page 89]. A place is altered because a picture happened there. A landscape becomes a stage for a crisis of thought, a dilemma of action, an event, an interior soliloquy. His real Chester County has—artistically—a lot in common with Faulkner's imaginary Yoknapatawpha County. Going through Wyeth country is like walking into a novel in progress and meeting the characters—with future indefinite, surprises expected from the lesson of the past hovering over every development like an inefficient blueprint.

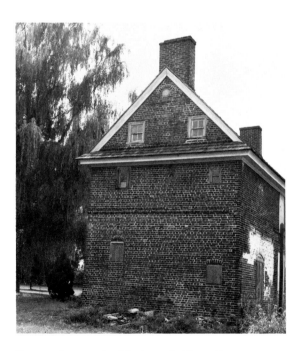

Recent photograph of the house in *Tenant Farmer*.
(Photo: Keith M. Jones, Jr.)

HANGING DEER 1961
Watercolor prestudy for *Tenant Farmer*, 21 ¾ x 13 ⅞ in.
Private Collection

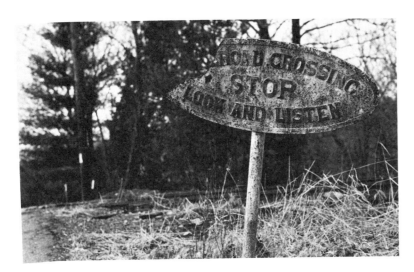

Wyeth has two novels constantly in progress—the Chadds Ford novel and the Cushing, Maine, novel. The landscape and the cast of characters are different. But each locale has a primary character, if one judges their importance by the way Wyeth is drawn back to them again and again: Karl Kuerner and Christina Olson.

Just before you come to Karl Kuerner's house you cross a railway where a large sign says STOP—LOOK—LISTEN. Here some of Wyeth's most intense feelings are anchored. In 1945 a car his father was driving cut out when straddled across the tracks. The train killed his father and his brother's two-year-old son. Wyeth's preoccupation with Karl owes something to that fact.

Railroad sign at crossing where N. C. Wyeth was killed in 1945.
(Photo: Keith M. Jones, Jr.)

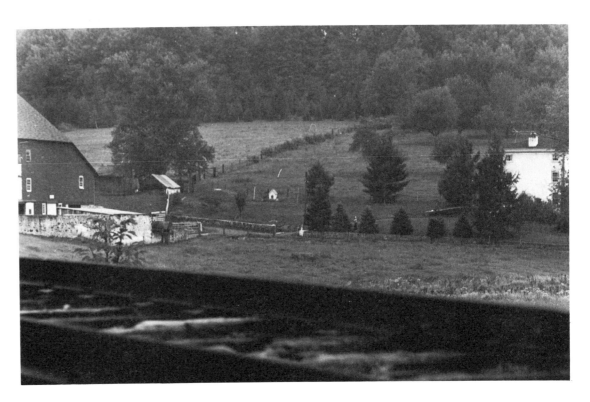

Kuerner's farm seen from the railroad tracks.
(Photo: Keith M. Jones, Jr.)

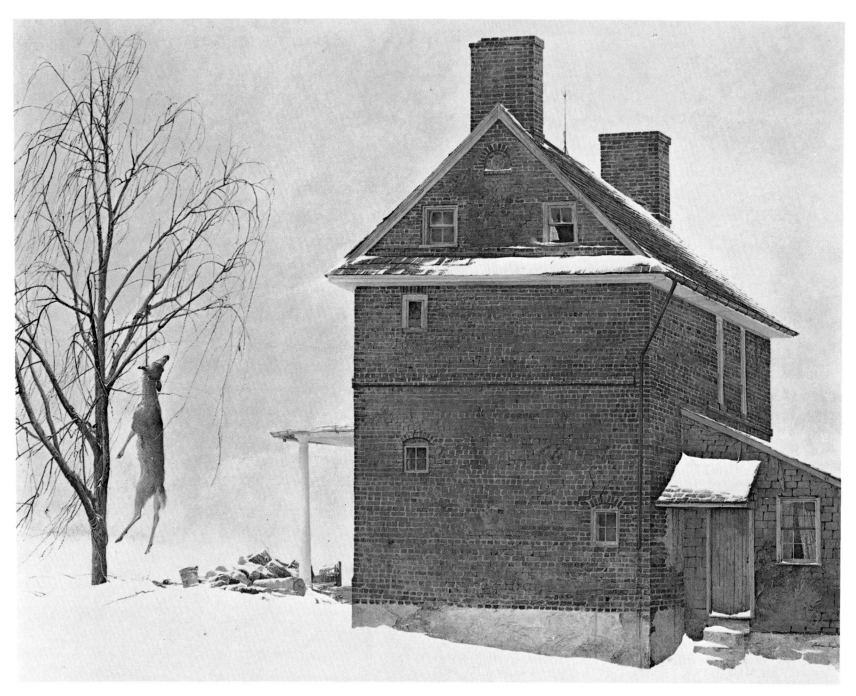

TENANT FARMER 1961
Tempera, 30½ x 40 in.
Delaware Art Museum, Wilmington
William and Mary Phelps Collection

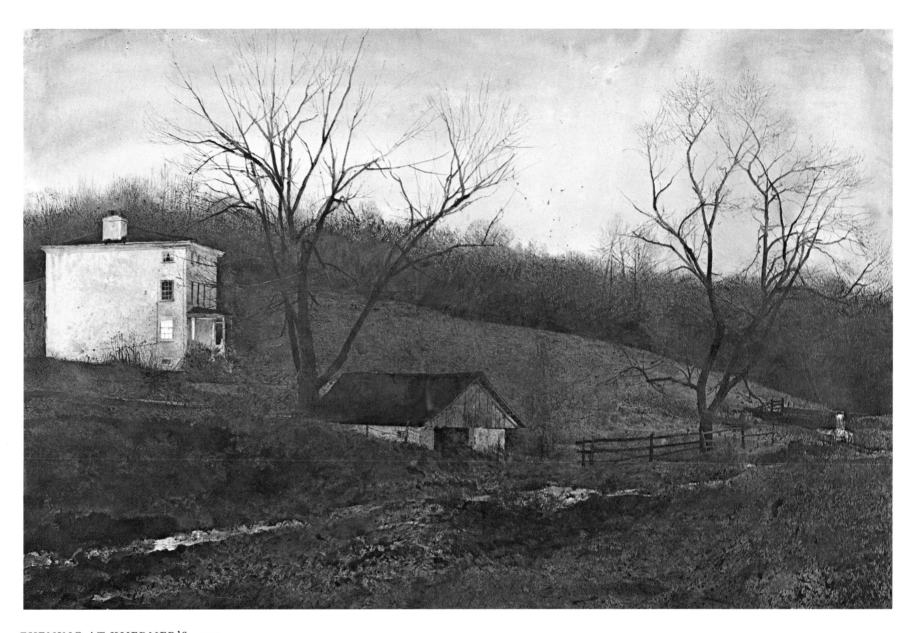

EVENING AT KUERNER'S 1970
Dry brush, 25 ½ x 39 ¾ in.
Private Collection

Karl's place has been the locus of dozens of paintings. In the *Young Bull* [opposite], Wyeth moved Kuerner's Hill to the right, shaved it bare of trees and pulled in the corner of the house from the left. Following his habit of oblique viewpoint, he squatted down before the long whitewashed wall when painting, shooting up at a typically high horizon.

After getting out of the car he squatted down to demonstrate, then rose to his feet to wave at Karl, a blocky figure wearing an old felt cap and gray jacket, coming out the front door. To the left, near the hen runs, a German shepherd barked and lunged on a rope. Karl came down the slight incline, hands in pockets, smiling. His square, powerful face is as ruddy as Wyeth painted it [left]. Wyeth is often faithful to the truth even when it is pictorially difficult.

KARL 1948
Tempera, 30 ½ x 23 ½ in.
Private Collection

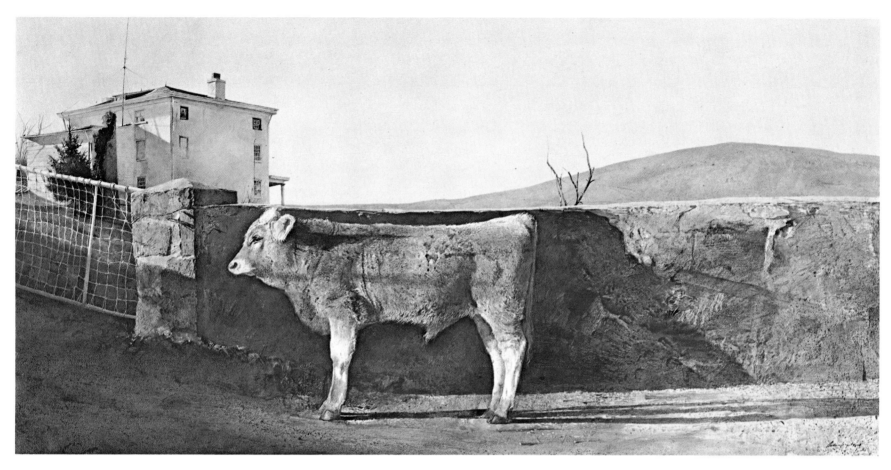

YOUNG BULL 1960
Dry brush, 20⅛ x 41⅝ in.
Private Collection

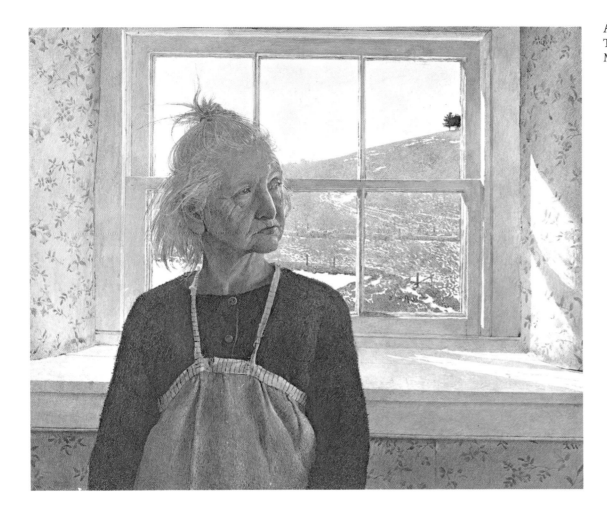

Inside, the house—like many country houses—was slightly smaller in scale than its occupants, so that it easily appeared crowded. The antimacassar neatness is due to Karl's sister-in-law, who came over from Stuttgart when his wife, Anna Kuerner, became strange a few years ago [above]. A thin woman, curtsying, dressed in black, hair gathered in a bun above her nape, she greeted us in German. We sat in the twilight of the slightly unused living room drinking Karl's champagne-like apple cider. Andy pointed to the window in the dining room from which he painted *Ground Hog Day* [page 70]. Karl kept pressing cider on us. He matures it in casks set on stone flags over a subterranean stream out in front near the avenue, a small stone grotto with a locked wooden door. There it ferments until clear as amber. He brought us out later, unlocked the door, showed us the inside of a natural icebox—cool even in midsummer—walled with dim clusters of casks [opposite].

"Once there was a great explosion," said Karl, back in the living room. "I looked at the back of a fermenting barrel and it had split this heavy barrel right up the back."

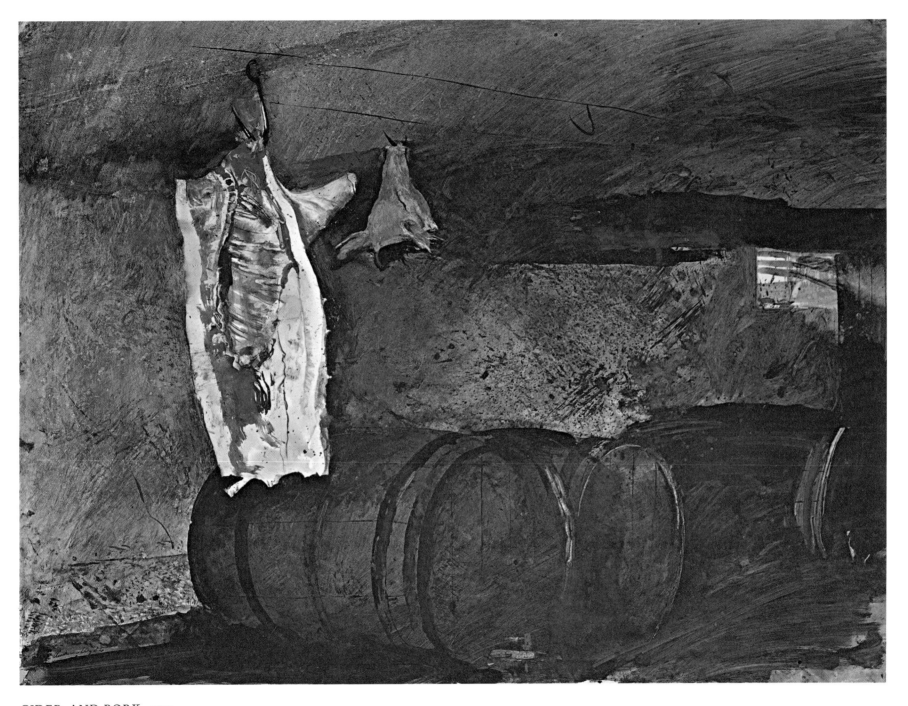

CIDER AND PORK 1955
Watercolor, 21 ¾ x 29 ¼ in.
Amanda K. Berls

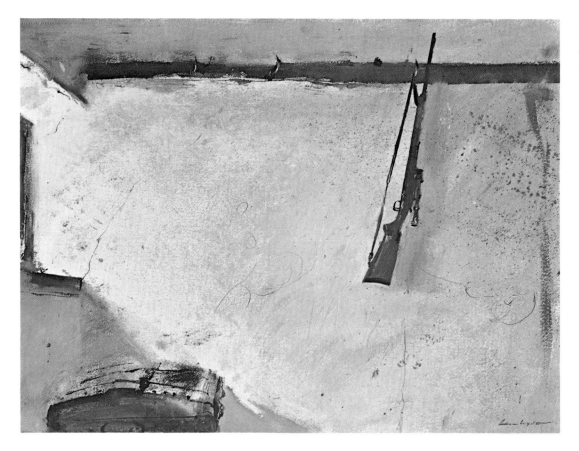

KARL'S ROOM 1954
Watercolor, 21¾ x 29¾ in.
The Museum of Fine Arts, Houston
Gift of Mrs. W. S. Farish

"It's strong stuff," said Wyeth, laughing. "Karl's place," he said when Karl briefly left the room, "could be Bavarian or Austrian—particularly in the wintertime. You might find a carcass of a deer freezing in the corner. That's my origin," he said seriously, "Swiss-German." ("Andy German?" said his sister Carolyn skeptically later. "What Andy is depends on who he's painting.") Karl had just come back from his first trip to Germany—near Nuremberg—since he came to America in 1920. On Andy's recommendation he had been to Dürer's house. "He was as bad as you are," said Karl. "He painted everything!"

"Get Karl to show you upstairs," said Andy. Karl led the way up the narrow stairs, around corners cut off by oblique walls, up to the attic where Wyeth had painted him. Up there he also painted a rifle way off center to the right, balanced by the top of a chest at lower left ("Karl brought the gun back from Germany"), between the two an appalling stretch of blank wall [above]. Wyeth's paintings of Karl and his environment often have a latent violence, just as his paintings of Christina have a desolate tenderness.

By one of those coincidences that happen to people who accept coincidence as a manifestation of hidden meanings, he and Karl were in the attic with a rifle the day President Kennedy was shot. "Karl was showing me a high-powered rifle with a telescopic lens," said Andy.

"I felt like Oswald," said Karl, smiling briefly. "It was unbelievable. It really hit me."

Christina Olson lives in the clapboard house her great-grandfather, a Hathorne, built out on Hathorne's Point—a bare promontory thrust into slate-gray Maine water. Once it was an inn used by the crews of clipper ships coming down from Newfoundland. One of them brought her father, a Swede born "just outside Göteborg." He settled down after he married her mother—also a Hathorne—and sailed on a schooner out of Rockland.

Now the last of the Olsons, Christina and her younger brother Alvaro, live in the family home. Al, a small man with a large nose, posed for an early Wyeth painting, *Oil Lamp*, but refuses to pose for the artist again. The artist paints him, however, in those things that belong to him: the corn drying upstairs, his blueberry baskets hanging in the shed, his grain bags and the blue measure [pages 28–30]. In *Hay Ledge* [page 31], it is Alvaro's barn and dory, a boat unused since he gave up the sea to be a companion to Christina and to make a livelihood from the land. Much of his living comes from blueberry farming. The blueberries grow almost wild in low rug-like tangles in the fields that slope away from the house.

Christina and Alvaro Olson with Andrew Wyeth, about 1950.
(Photo: Kosti Ruohamaa, Black Star)

The Olson house, Cushing, Maine.
(Photo: Keith M. Jones, Jr.)

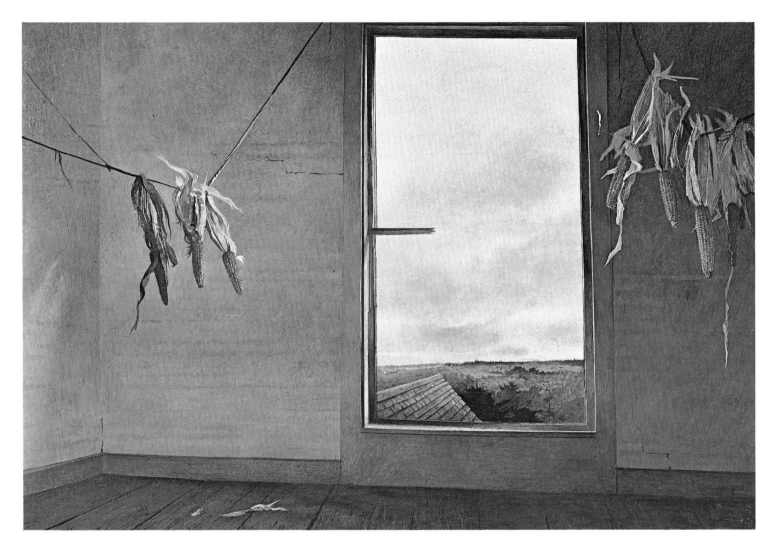

SEED CORN 1948
Tempera, 15 3/8 x 21 7/8 in.
Private Collection

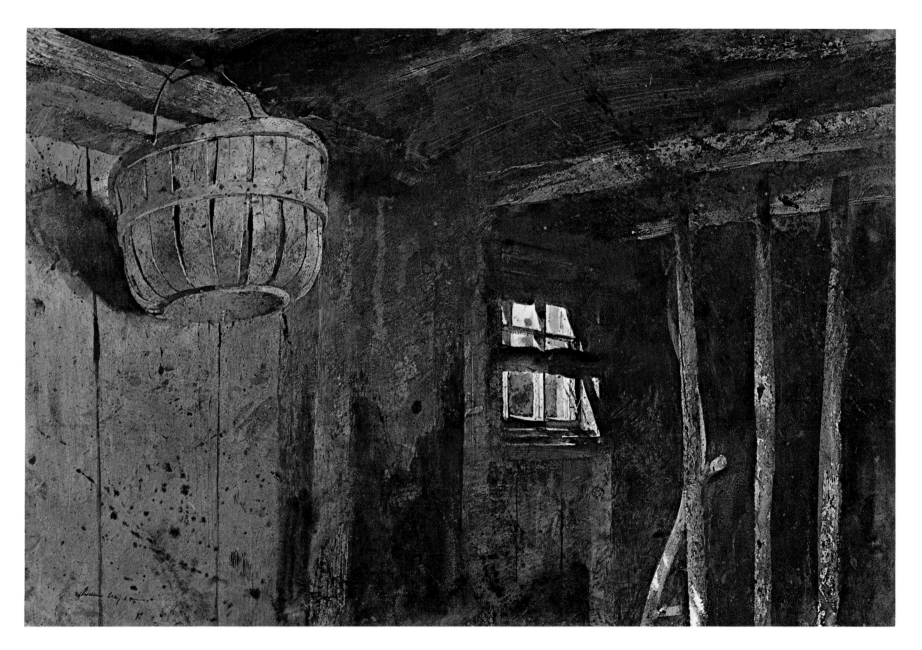

THE STANCHIONS 1967
Watercolor, 19 x 28 in.
Mr. and Mrs. Mortimer Spiller

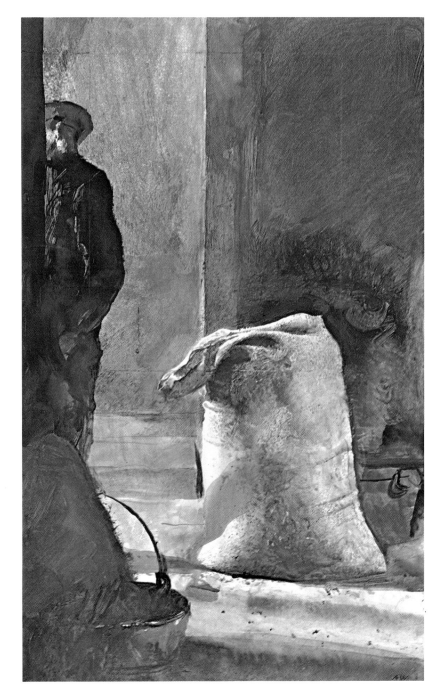

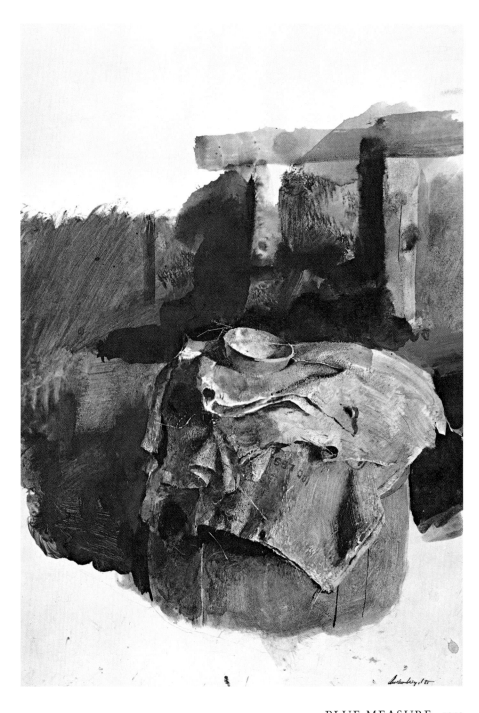

GRAIN BAG 1961
Watercolor, 22 1/2 x 15 in.
Private Collection

BLUE MEASURE 1959
Dry brush, 21 3/8 x 14 7/8 in.
Private Collection

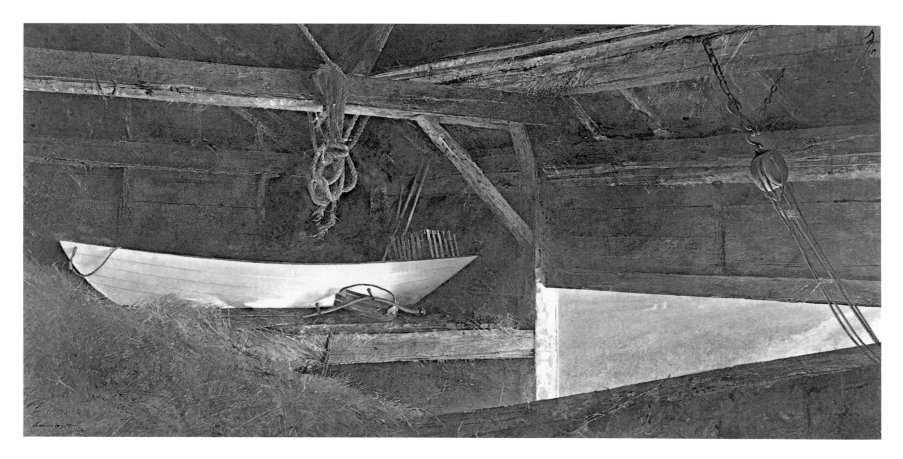

HAY LEDGE 1957
Tempera, 21 x 45 in.
Mr. and Mrs. Joseph E. Levine

Christina sat stiffly, leaning back, facing the landward window. She rested one arm on a table piled with an accumulation of household trivia that looked as if time had slowed down for them—partly paralyzed, infrequently moved. Behind her was the black range that Wyeth has painted [opposite]. Al sat inconspicuously between the range and the seaward window. The light was dim, the air pungent, the interior crowded. The colors were Wyeth colors—dun, ochre, and black. Christina's color scheme was inevitably Wyeth too—her strong hair reddish gray, her eyes deeply brown, her flowered print dress a faded blue. "Christina's house," wrote Andy Kopkind, "contains the anonymous leavings of years of confinement. The smell of burning oil, charred wood, fat cats and old cloth fills the air." This has been her environment since a childhood attack of polio reduced her locus of activity to painful yards.

KITCHEN AT OLSONS 1967
Watercolor, 21 ¼ x 13 ⅝ in.
Private Collection

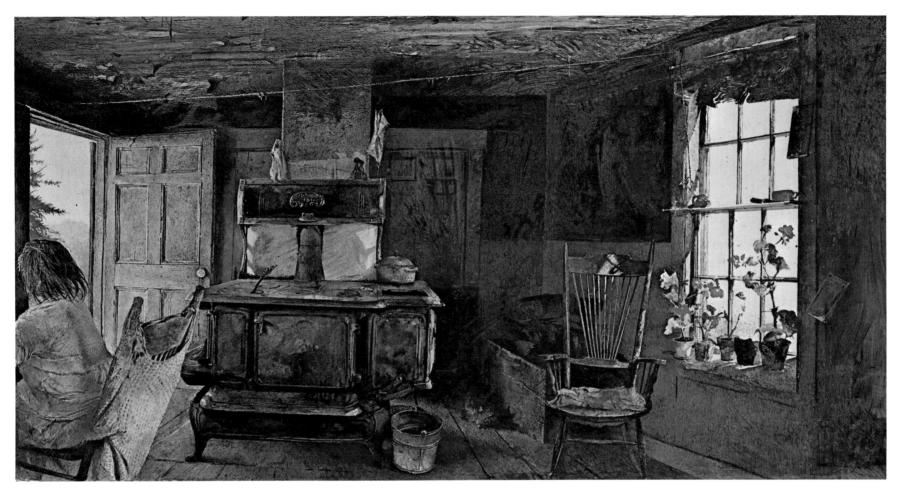

WOOD STOVE 1962
Dry brush, 13 ¾ x 26 ¾ in.
William A. Farnsworth Library and Art Museum, Rockland, Maine

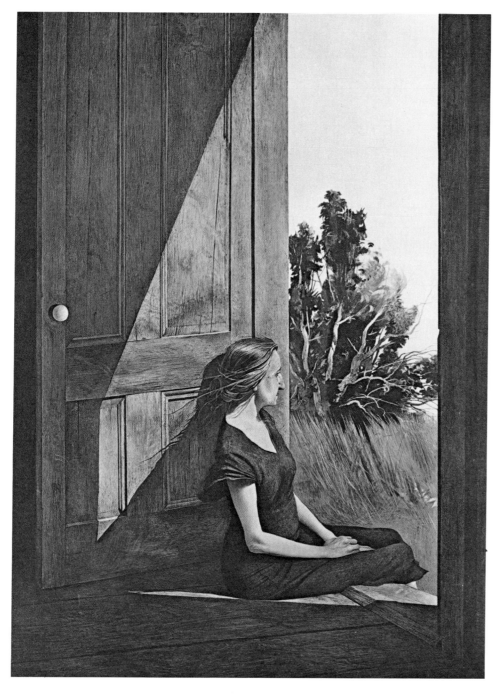

But the first thing that one notices about Christina is her voice. It is firmly lucid, a practical countrywoman's voice, and it immediately wipes out her myth, the romantic half-pitiable aura of a spirit strait-jacketed into immobility. Her voice is immediate, without self-pity, and she follows what she has to say with a shrewd slow look from her brown eyes. She has a force of character that would make any condescension to her paralysis an insult.

"Christina loves animals— kittens are her whole world— and to watch her hold that little thing in that hand of hers—it was phenomenal. She to me is the essence of New England—witchcraft. She has such knowledge of hardship and her being is so strong— to me she rules like a queen, absolutely."

CHRISTINA OLSON 1947
Tempera, 33 x 25 in.
Mr. and Mrs. Joseph Verner Reed

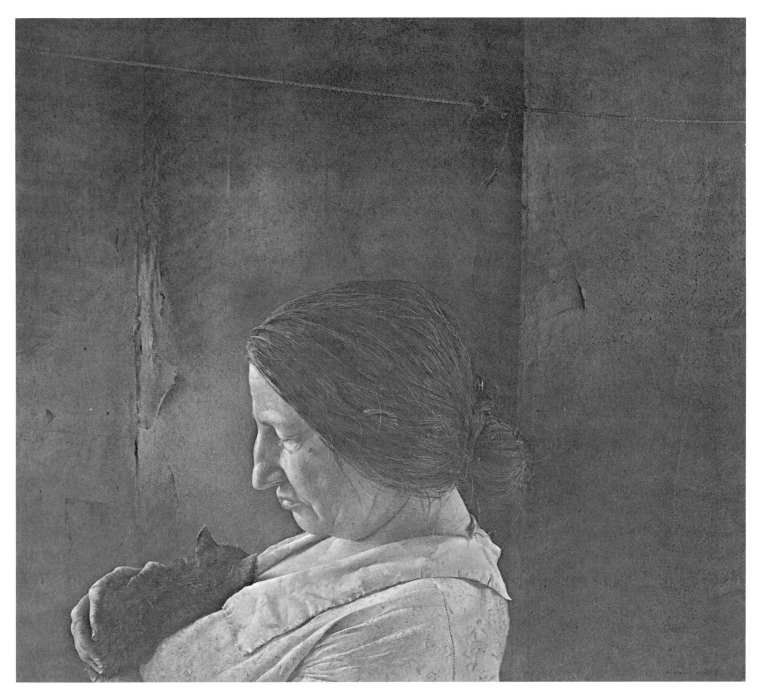

MISS OLSON 1952
Tempera, 24¾ x 28¼ in.
Private Collection

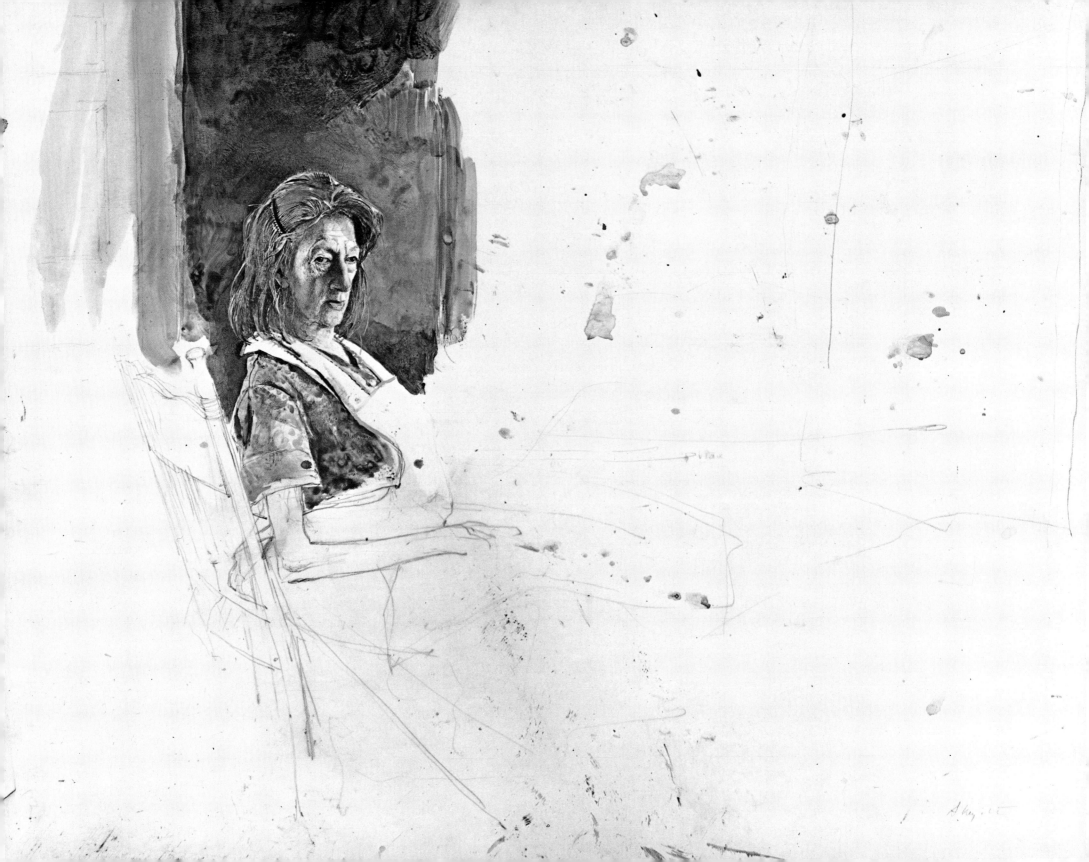

THE APRON 1967
Dry brush and watercolor,
22 x 28 in.
Private Collection

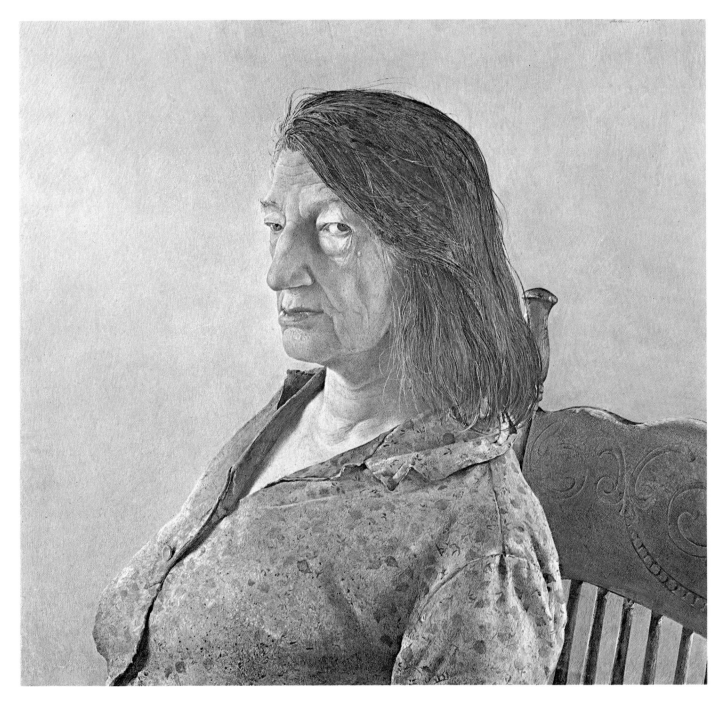

ANNA CHRISTINA 1967
Tempera, 21 ½ x 23 ½ in.
Amanda K. Berls and Museum of Fine Arts, Boston

Wyeth has done many studies, watercolors, and temperas of Christina and her environment, making her the most famous model in modern American art. Which of Wyeth's paintings did she prefer? She half-turned in the high chair, held back by her anchored torso, and pointed to a stained cardboard box, bound with cord, under a cat on a crowded table. I pushed off the offended cat and handed it to her. She opened it up slowly, went deliberately through a collection of reproductions and selected *Christina's World* [opposite].

"I like that one best."

Rummaging deeper she brought out some photographs of her family—sunlight, bright faces, Edwardian clothes, all held in the click of a camera, the house's lively history condensed and preserved in a cardboard box. She lingered over a strapping young woman standing beside a bearded man in a wheelchair, then pointed a firm finger. "That is me—and my father." She showed some more. Christina doesn't talk much unless she has something to say.

"When I painted it in 1948, Christina's World hung all summer in my house in Maine and nobody particularly reacted to it. I thought, 'Boy, is this one ever a flat tire.' Now I get at least a letter a week from all over the world, usually wanting to know what she's doing. Actually there isn't any definite story. The way this tempera happened, I was in an upstairs room in the Olson house and saw Christina crawling in the field. Later, I went down on the road and made a pencil drawing of the house, but I never went down into the field. You see, my memory was more of a reality than the thing itself. I didn't put Christina in till the very end. I worked on the hill for months, that brown grass, and kept thinking about her in her pink dress like a faded lobseter shell I might find on the beach, crumpled. Finally I got up enough courage to say to her, "Would you mind if I made a drawing of you sitting outside?" and drew her crippled arms and hands. Finally, I was so shy about posing her, I got my wife Betsy to pose for her figure. Then it came time to lay in Christina's figure against that planet I'd created for her all those weeks. I put this pink tone on her shoulder—and it almost blew me across the room."

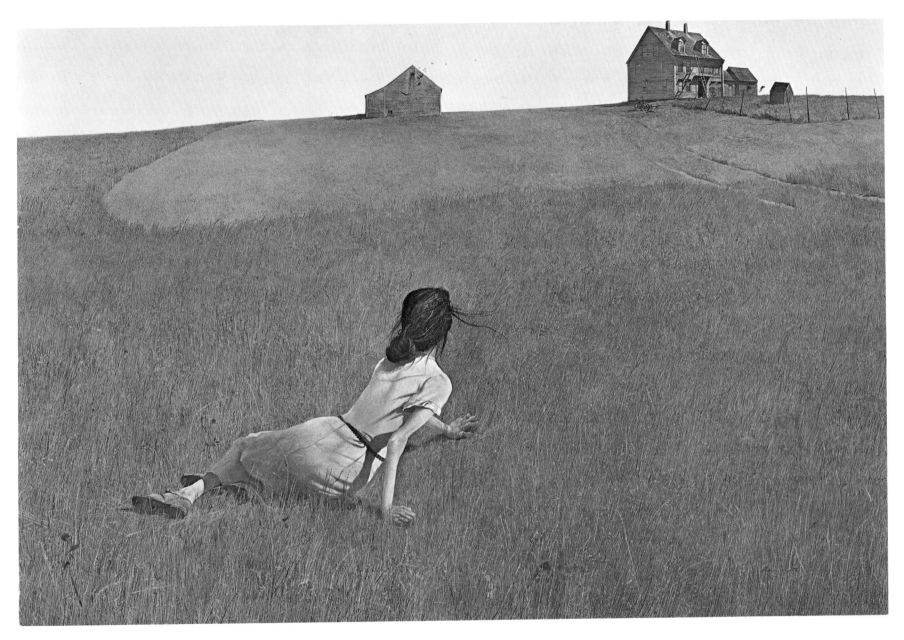

CHRISTINA'S WORLD 1948
Tempera, 32¼ x 47¾ in.
The Museum of Modern Art, New York
Purchase, 1949

Betsy Wyeth's family, the Jameses, lived near Christina. Betsy knew her from childhood, remembers playing around Christina's father's chair—in which he sat arthritic and immobile. As a girl she got into the habit of regular visits to Christina, cutting her hair, and doing small jobs for her. The first time Betsy met Andy—on July 12, his 22nd birthday—she took him to see Christina. "I don't know what made me take him there," says Betsy, laughing, "because I hadn't taken any of the other guys there. Maybe because I was learning to drive and wanted to drive the car. There was nothing profound about it at all."

"Christina didn't make any impression on me then," said Wyeth. "Just the house. It's strange, I wasn't conscious of her personality. As far as painting people goes, it didn't mean anything to me until after my father's death. That's why Karl's portrait was so important to me."

Christina became the nerve center of a vital plexus of feeling for Wyeth. He painted in his favorite lair, an upstairs room, listening to Christina occasionally stirring underneath. Sometimes she would call him for pie. He would see a hand push the pie onto the bottom stair, waiting until the sound of her dragging body receded before going to get it. Going home, he would leave his unfinished painting behind, "soaking up the atmosphere." Some of his pictures still faintly exhale the pungent burnt-wood odor of Christina's home.

He painted most frequently from upstairs windows in the southwest gable. In *Wind From the Sea* [page 125], the frayed curtains lift as a puff of air enters the stagnant room, like a breath that disturbs the perfect, bone-dry simulacra of decay. Looking out that window across the declining field he got the idea for *Christina's World*. Legend has it he saw Christina pull her way across the field after visiting the family graveyard near the sea—a bit of schmaltz that has stuck to the finished picture.

The painting took two months, during which he made close sketches of Christina's hair and body and hands. Betsy posed for the figure, which was the last thing he put in—"the pink dress," says Wyeth as if savoring a pleasant taste, "like a dried lobster shell." For him the figure was the focal point of an evanescent moment through which the emptiness and desolation around are brought into clear focus. "I can work for months on a single background if I know there's something going over it that is fleeting." He feels now he could have got the same effect by leaving out Christina, by eliminating until the space is charged with maximum meaning by minimum means—the modern dream of the absolute symbol, of which Rothko's work—which Wyeth admires—is the miraculous example.

Down on the shelving blueberry field, looking back at the shingled barn and desolate clapboard house, one can see how Wyeth shaved the scene into utter simplicity. House and barn are closer together in the painting, the hen runs are gone, along with some trees that break the integrity of the design. The field on which the painted Christina supports herself has been combed of detail. "Wouldn't I like to go down there and pick blueberries," said Christina to her brother Al once. "If she could," he said later, "she wouldn't want to."

From the blueberry field the house seems eerily untenanted. It is gray, weathered, in want of repair [page 159]. The windows are partly covered with old flour bags, their torn triangular edges hanging like desolate pennants. Turning and taking a few more steps seaward, one comes suddenly on a dead gull with a bloody neck hanging from a stick, warning the berry-hungry gulls that wheel and ride the wind above. Wyeth has painted that too.

Two years after the writing of this article, both Alvaro and Christina died and the Olson paintings were to come to an end. Alvaro died on Christmas Eve in 1967, and Christina's death came one month later. The day before Christina was buried in the family graveyard in the January cold of 1968, the artist quickly sketched the scene [below]. His final paintings of the Olson house and belongings came in the following two summers while the house was slowly emptied of its goods and prepared for sale. These works pay final homage to the New England house and friendship that had been open to the artist for more than twenty years. Wandering through the empty house, Andrew Wyeth could still sense Alvaro's and Christina's lingering presences: in the gray and blue doors of the shed [page 42] or in the last swallows of the summer seen from an upstairs window of the abandoned house [page 43].

W.M.C.

CHRISTINA'S FUNERAL 1968
Pencil, 13½ x 16¾ in.
Private Collection

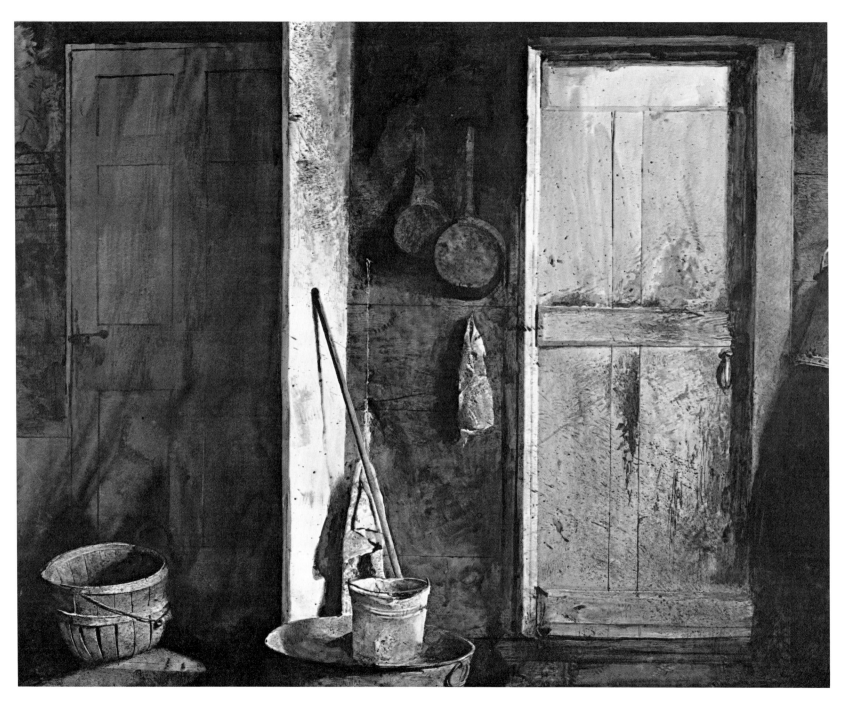

ALVARO AND CHRISTINA 1968
Watercolor, 22 1/16 x 28 1/16 in.
William A. Farnsworth Library and Art Museum, Rockland

END OF OLSONS 1969
Tempera, 18 1/4 x 19 in.
Mr. and Mrs. Joseph E. Levine

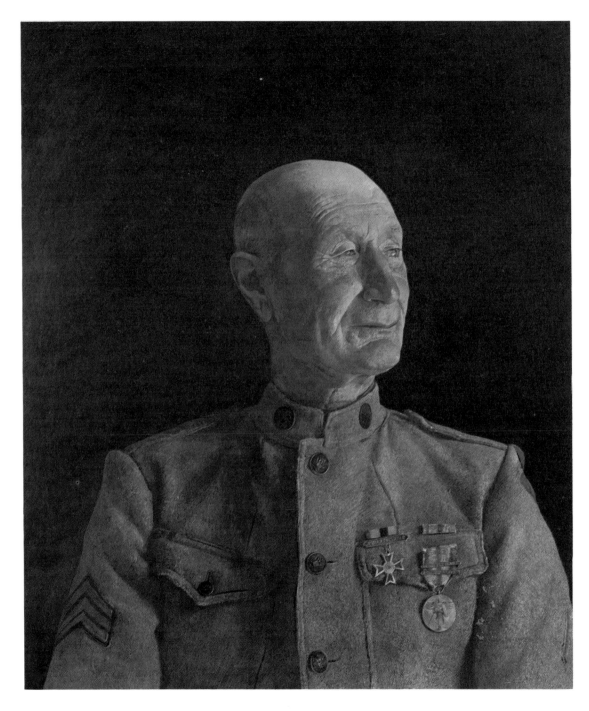

THE PATRIOT 1964
Tempera, 28 x 24 in.
Private Collection

Andrew Wyeth: An Interview

*Richard Meryman**

In the art world today, I'm so conservative I'm radical. Most painters don't care for me. I'm strange to them. Actually, I don't consider myself an artist in the usual sense. Talking art bores me and I hate to get caught painting—here I am working on this damn thing. Hate it. I hate to have people see me with my watercolor block under my arm —here I am going painting. That's just awful. Those pictures of the artist standing with his big palette in front of a portrait—Jesus, I think it's awful. Artists will say, "If only I could get the effect of that sulfur-yellow sky above that landscape." I'm never struck by that stuff—cloud formations. Or friends will say, "Andrew, I know a place you would *love* to paint." God, that has nothing whatever to do with what I do.

A lot of people say I've brought realism back—they try to tie me up with Eakins and Winslow Homer. To my mind, they are mistaken. I honestly consider myself an abstractionist. Eakins' figures actually breathe in the frame. My people, my objects, breathe in a different way; there's another core—an excitement that's definitely abstract. My God, when you really begin to peer into something, a simple object, and realize that profound meaning of that thing—if you have no emotion about it, there's no end.

I have such a strong romantic fantasy about things—and that's what I paint, but come to it through realism. If you don't back up your dreams with truth, you have a very round-shouldered art. I can honestly say that I didn't paint this portrait of Ralph Cline, *The Patriot* [opposite], because he was terribly picturesque—a big hat and overalls, tobacco juice, had Indian blood and made a lot of folksy Maine

*First published in *Life*, May 14, 1965, pp. 93-116, 121.

remarks. It wasn't till after I started painting him that I began finding out what a remarkable man he was.

Four years ago he was marshal in a parade in Thomaston, Maine, near where I spend every summer, and I remember his amazing figure, something about the way he walked, his build, this feeling of very erect. He had on a dark blue uniform of the Veterans of Foreign Wars and a little hat. I was struck by him, not to paint—but it stayed with me. Then, last summer I was doing a watercolor near his house and he came by and bent over—and that face—that stayed with me—and at his sawmill, the way he would reach in with his hand and pull up the logs. Honestly, I don't know what it was—something very elusive made me ask him to pose. And it wasn't till later that I began wondering if he had a First World War uniform. Then the whole thing began to build in my mind—that bald head.

You see, I don't say, "Well, now I'm going to go out and find something to paint." To hell with that. You might just as well stay home and have a good glass of whisky. Really, I just walk a great deal over the countryside. I try to leave myself very blank—a kind of sounding board, all the time very open to catch a vibration, a tone from something or somebody—like Ralph Cline. Every so often I'll catch, out of the corner of my eye, off balance, a flash impression of something—a spark of excitement. If it holds in my memory, maybe weeks or even years later, very suddenly, very suddenly—maybe even walking down a street in New York City—that thing will dawn on me. Just like that. Then the idea enriches in my mind and I embellish

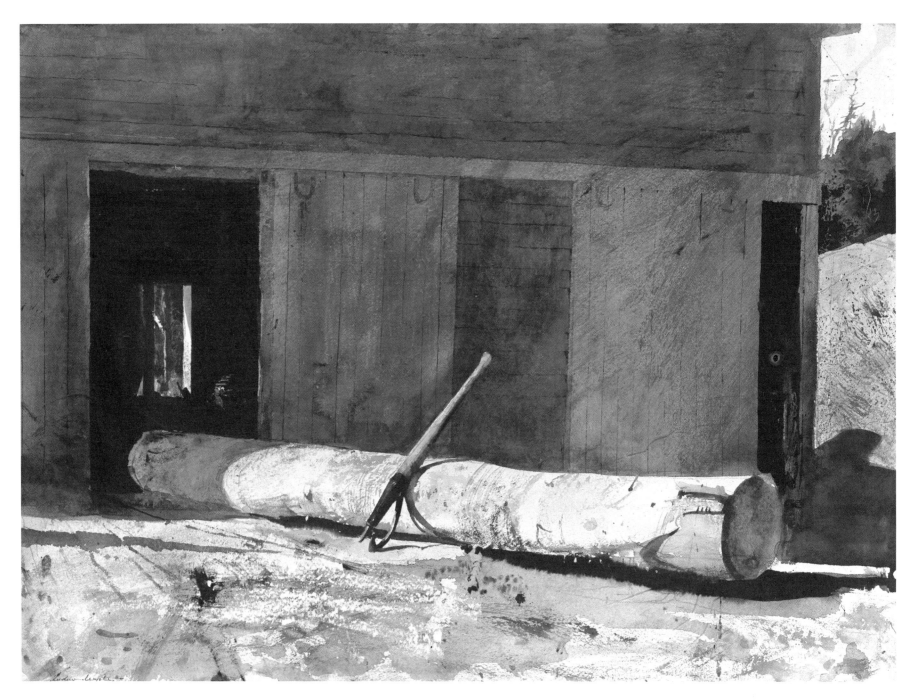

THE PEAVEY 1965
Watercolor, 21 1/2 x 29 3/4 in.
Private Collections

it maybe for weeks—or it disintegrates and goes to nothing—which so often happens. Vacuum—I call it blank brains.

I can remember the first time this happened to me. I was a kid of fifteen and had been spending weeks drawing the sheep owned by an old man named Spud Murphy—a bachelor, lived on bread and potatoes. I remember it was evening and he turned and walked back of his pigpens into a grove of apple trees. And he turned a little, and I remember seeing his back dark, and the light on his face. And I remember being terribly excited. It was very, very important to me and I wanted to explain it to Pa and didn't know how. It was a very queer thing. Even to this day—like with Ralph Cline—I get strange, my hair rises on the back of my head when I begin to sense something. And nothing can stop me from doing it. I can't go anywhere, do anything but grab that thing.

I wanted to paint Ralph in the loft of his sawmill [opposite], to steep myself in him. I sat him down there and he was terribly nervous. And it was something for me, too. I started one drawing in pencil and sort of struck dull. But finally, talking, he'd laugh and this little smile hung on afterward, and I moved to the left and he looked out the window, and in fifteen minutes I had a drawing just on the corner of the pad. It was just a fleeting expression of his and I don't remember drawing it —couldn't do it again. I was moved and everything was spontaneous.

I brought it home—didn't show it to Betsy—and hid it behind the refrigerator. I was terribly excited about it. That's a very nervous, tense time for me. After supper I said, "I've got something. I'm probably nuts, but this thing really thrills me," and I hauled my pad out. I flashed the drawing at her for a second and then took it away. If a person has time to analyze too much, talks it out—you deaden the thing, freeze it. But Betsy's remarkable because she has an intuition that catches what I'm after. She's marvelous. All she said this time was, "My God, Andy, just terrific; just terrific." If she'd been dull and said, "Oh, well"—it would have killed it right there.

I always go through a period in a painting which is all in tones of excitement. And I find that memory is what carries that abstract essence which originally excited me. So, the next day in my studio, away from Ralph, I enlarged my original drawing onto the final panel. I knew if I waited and considered for a couple of days, I might put it in just proper like—and lose that momentary spark. But I did delay until late that afternoon, when I didn't exactly feel like it and had been doing other things.

Usually I'll be very odd about when I start a painting. I think timing is one of the most important things in painting. I might lay it in with a few strokes when you'd least suspect—just before I have to go somewhere, or Betsy calls me for dinner or a movie, or I've just come back from somewhere. Then I'll leave it very rough and rush off, before I start to manipulate it. I want to be sure of putting it down rather dully, so that I'm getting at the problem without all the niceties of artistic thought. Sometimes I'll leave a panel on my easel for days and days and look at that bare panel. I might put one line on it. I don't want to put too much down because it'll freeze the idea. I want to keep it fluid—be able to dream about it.

You see, a lot of my pictures—Ralph Cline, for instance—come from dreaming of my past experience. As a child I loved toy soldiers, had an enormous collection. And I used to go to my father's studio and he'd saved the newspapers of the First World War—the brown sections, the rotogravure—and I used to pore over those as a little child. I can remember the smell of that newspaper, the pictures, the page of the casualty list, pictures of General Pershing, Frank Luke the Balloon Buster, or Rickenbacker or Leonard Wood, or Captain Whittlesey of the Lost Battalion, or even the tunic of the man who was killed in Serbia at the start of the war. That could be his tunic Ralph has on. All that faded into the picture I wanted to paint—my truth behind the fact.

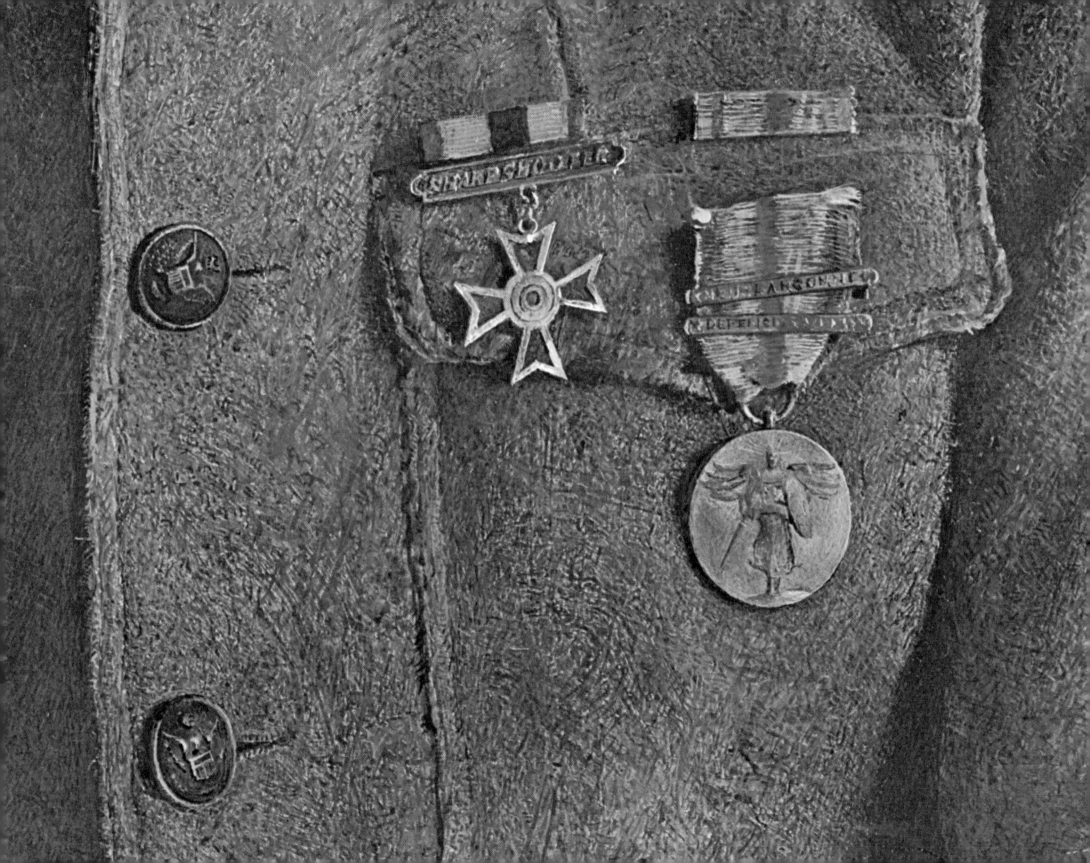

After I get in the mood of a thing I'm painting, I love to work on the background. In this portrait of Ralph it isn't just a dark tone to show off the head. It's actually a world—it's the thunder of the Meuse-Argonne—it's the dirt and mud he stood in the trenches—it's the tobacco he chews, the smell of the wood in his sawmill. I love to dream, to think, about this thing that's going to live in that background. It's the most exciting thing. I kept thinking about that bald head, that round oval, while I was driving my car, lying in bed. In that curve along the top of that head was the essence, really, of what excited me. It was the whole beginning of that painting. I started with just tone—nothing but tone—just dark skin burnished from the weather and, where his hat always was, the bald light top, which could be the head of the American bald eagle. All this is why I say my work really lives on its abstract quality.

Now, I just about lived with Ralph Cline for a month and a half—almost became Ralph, Betsy tells me. He started out making a lot of his very clever Maine character remarks, which he's full of and are as amusing as hell. But that finally died out and the truth began very quietly to emerge. I love the guy—great depth, seventy-one years of age and still as vital as ever—very sharp edge, likes very few people, yet such a warm man, such dignity, pride, intelligence—a type it's very rare to get to sit and be natural with you, especially in Maine. Yet underneath is a guy who loves the women, is cunning, and—oh, what a guy! He's really something. We talked about sex, everything. That's why we got along—he knew I knew the other side of him but also the really fine side. Absolutely the patriot. The American flag means everything to him. Kind of man that fought at Concord Bridge. He patrolled the Mexican border at the time of Pancho Villa and in World War I was a sergeant—fought all through the Meuse-Argonne. I'd accidentally hit on the thing that meant the most to him—and I think I got it into the picture.

You see, I don't just sit there and paint at something, placidly dabbing at the thing once removed. I get involved, and Ralph turned out to be the kind of character I love to dream about. So, it was partly painted before I ever painted it. That man is partly me.

THE PATRIOT, detail
(Full painting on page 44.)

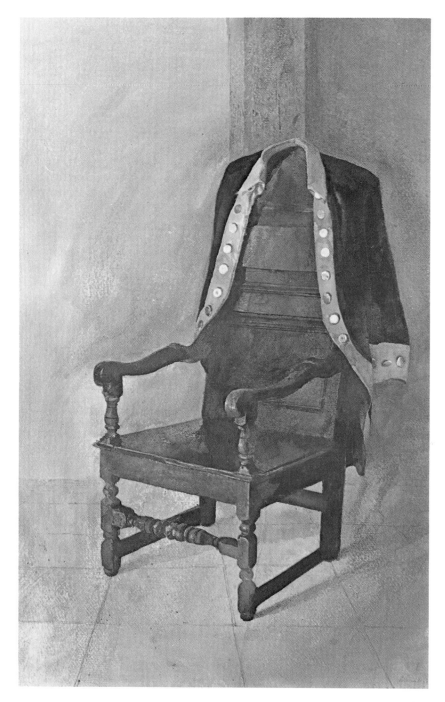

THE GENERAL'S CHAIR 1969
Watercolor, 29 x 20⅞ in.
Mr. and Mrs. Joseph E. Levine

49

GARRET ROOM 1962
Dry brush, 17 7/8 x 22 3/4 in.
Private Collection

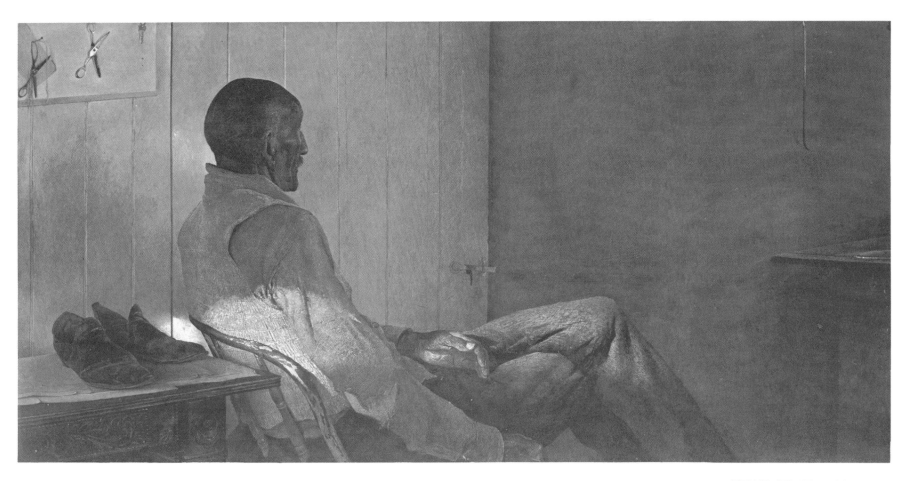

THAT GENTLEMAN 1960
Tempera, 23½ x 47¾ in.
Dallas Museum of Fine Arts

Once, while I was doing a painting of a Negro called Tom Clark—it was called *That Gentleman* [above]—Halloween came along. I shaved every bit of hair off my head. I was absolutely bald. Then I put alizarin crimson all over my whole head and then took brown ink and rubbed it over very transparently and the red came through. I tipped my eyes with adhesive tape, enlarged my nostrils a little and I actually looked like Tom Clark. I was becoming a part of my painting, really. [Other paintings of Tom Clark pages 50, 52, 53.]

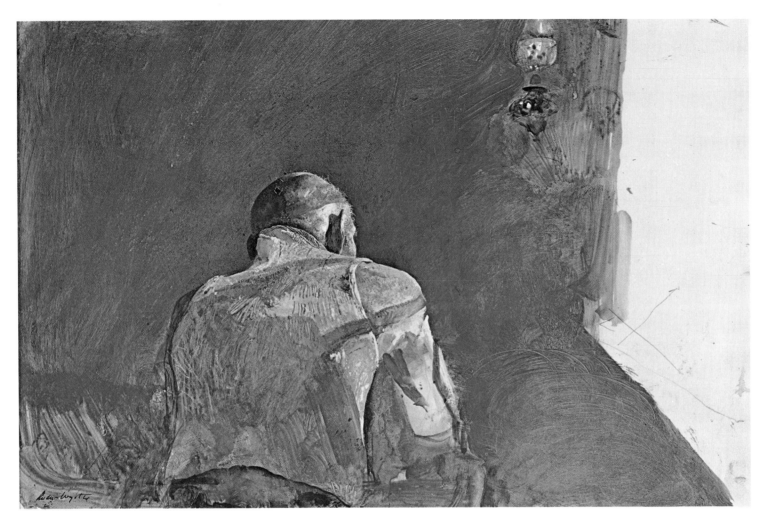

MORNING SUN 1959
Dry brush, 13 1/2 x 21 in.
Mr. and Mrs. Mortimer Spiller

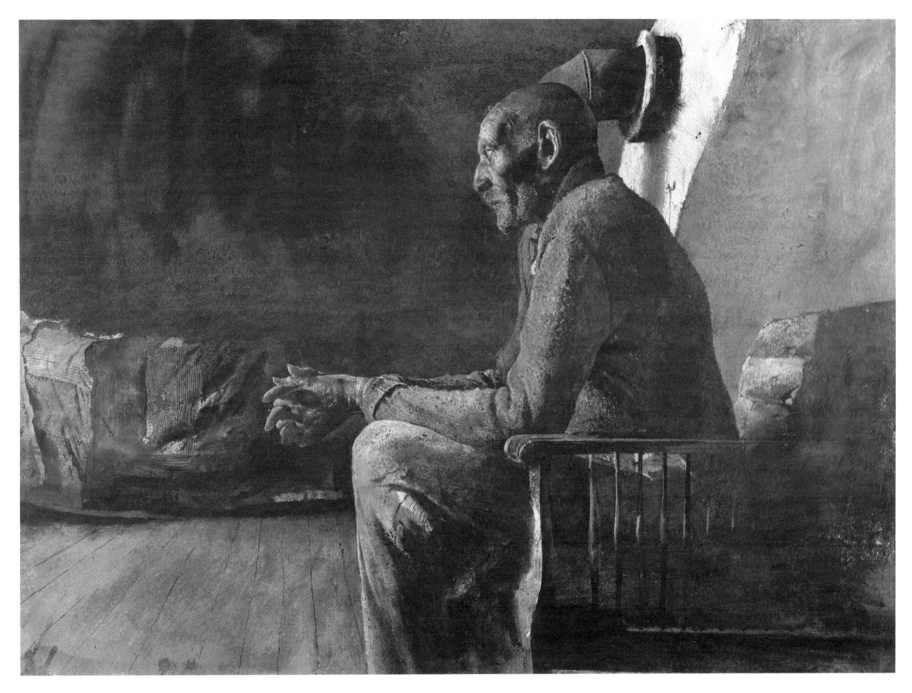

CHESTER COUNTY 1962
Watercolor, 22 1/4 x 30 3/4 in.
Mr. and Mrs. William Sherwood Cook

SUNDOWN 1969
Watercolor, 22 x 30½ in.
Mr. Frank C. Whittelsey, III

You look at my pictures—*Christina's World*, *The Patriot*, *Miss Olson* [pages 39, 44, 35]—there's witchcraft and hidden meaning there. Halloween and all that is strangely tied into them. For me, the paintings have that eerie feeling of goblins and witches out riding on broomsticks—damp rotting leaves and moisture—smell of make-up—as a child, the smell inside of a pumpkin when a candle is lit—the feel of your face under a mask walking down a road in the moonlight. I love all that, because then *I* don't exist anymore. To me it's almost like getting inside of my hound, Rattler, and walking around the country looking at it through his eyes.

What I'm trying to say is that I start every painting with an emotion—something I've just got to get out. These immaculately painted things—you'd think I was a very calm mathematician. Truth is, I use tempera partly because it's such a dull medium—those minute strokes put a brake on my real nature—messiness. My wild side that's really me comes out in my watercolors—especially of snow, which is absolutely intoxicating to me. I'm electrified by it—the hush—unbelievable. A white mussel shell on a gravel bank in Maine is thrilling to me because it's all the sea—the gull that brought it there, the rain, the sun that bleached it there by a stand of spruce woods. Most artists just look at an object and there it sits.

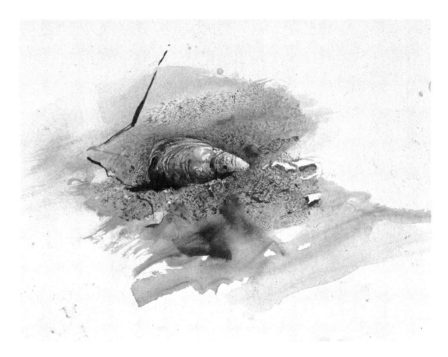

SEA SHELLS, detail. 1953
Dry brush, 11 7/8 x 16 in.
Private Collection

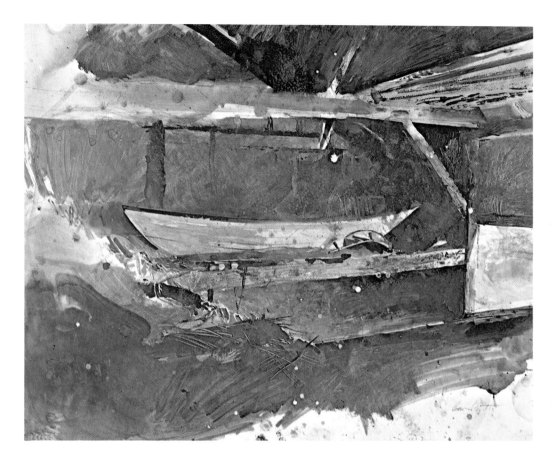

Prestudy for *Hay Ledge* 1957
Watercolor, 22 x 28 in.
Coe Kerr Gallery Inc.
(Finished painting on page 31.)

My struggle is to preserve that abstract flash—like something you caught out of the corner of your eye, but in the picture you can look at it directly. It's a very elusive thing. I'll get it in a preliminary drawing, but then the more finished a painting is going to be in the end, the more I've got to get that momentary off-balance quality in the very base of the thing. For that, it's got to get completely out of my control. When you spend months on a tempera, you've got to watch out the mind doesn't take over the emotion. I do wild things—if somebody saw me, they'd think I was nuts, ruining it. Then I haul it back in, bring the forms and bones into reality and shapes—refine it. If it's all just a placid development, to hell with that. You'll get a normal, regular painting.

I'll take weeks out doing drawings, watercolor studies, I may never use. I'll throw them in a backroom, never look at them again or drop them on the floor and walk over them. But I feel that the communion that has seeped into the subconscious will eventually come out in the final picture. Another thing I do—I'll be working along and suddenly drop my brush, turn my back quickly and rush away and shut the door. I want to leave the painting while I'm in a state of wondering. Then I can dream about it all night, and the next morning I walk in and can tell in a second whether it's crud or if I've still got it.

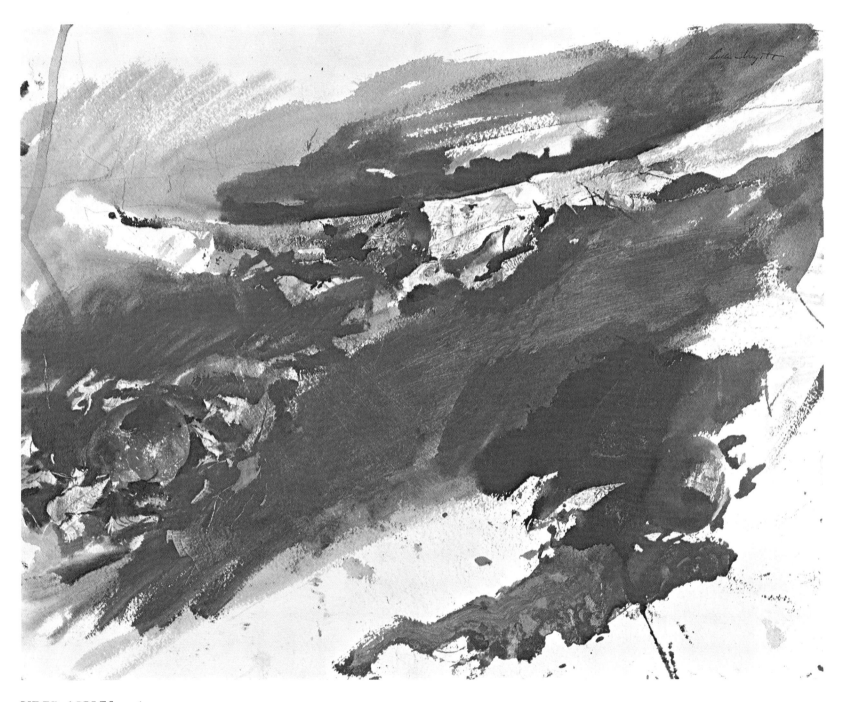

CIDER APPLES 1963
Watercolor, 18 7/8 x 24 in.
Private Collection

I think in my life the real turning point—when the emotion thing really became the most important—was the death of my father, in 1945. He was killed when a train hit his car at a crossing. We had a wonderful friendship. Of course, he'd been my only teacher, and he was a wonderful, remarkable person. When he died, I was just a clever watercolorist—lots of swish and swash. When he died—well—now I was really on the spot and had this terrific urge to prove that what he had started in me was not in vain—to really do something serious and not play around with it, doing caricatures of nature. I had a vast gloomy feeling. Fortunately, I had always had this great emotion toward the landscape and so, with his death, I seemed to—well—the landscape took on a meaning—the quality of him.

The first tempera I did after that is called *Winter 1946* [opposite]. It's of a boy running, almost tumbling down a hill across a strong winter light, with his hand flung wide and a black shadow racing behind him, and bits of snow, and my feeling of being disconnected from everything. It was me, at a loss—that hand drifting in the air was my free soul, groping. Over on the other side of that hill was where my father was killed, and I was sick I'd never painted him. The hill finally became a portrait of him. I spent the whole winter on the painting—it was just the one way I could free this horrible feeling that was in me—and yet there was a great excitement. For the first time in my life, I was painting with a real reason to do it.

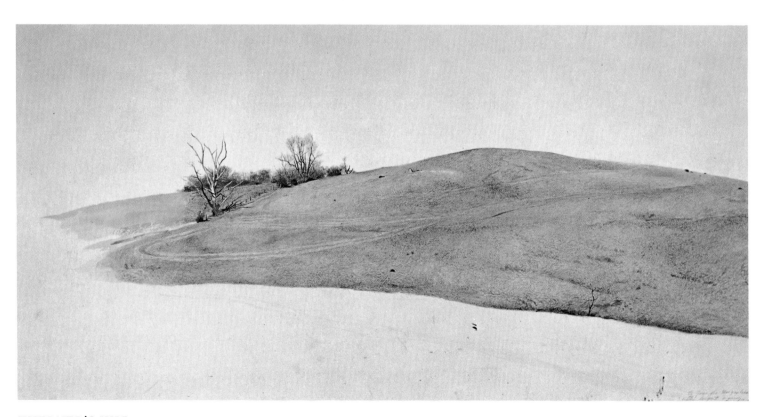

KUERNER'S HILL 1945
Pencil and dry brush, 22 x 44 in.
Mr. Robert L. B. Tobin

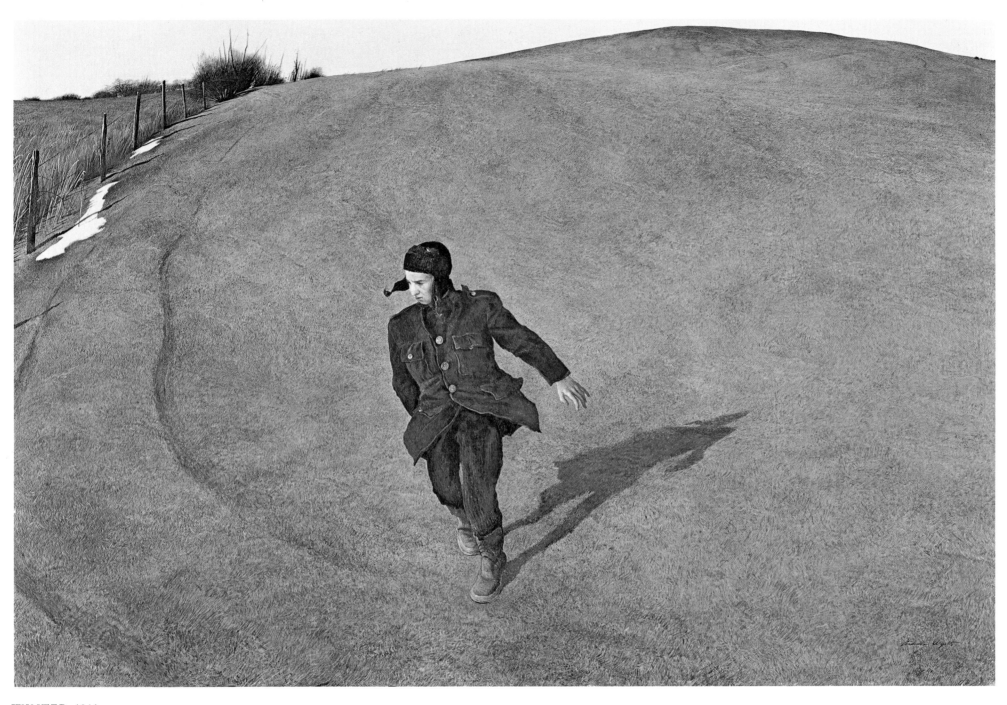

WINTER 1946
Tempera, 31 ⅜ x 48 in. 1946
North Carolina Museum of Art, Raleigh
Museum Purchase Fund

FLOCK OF CROWS 1953
Dry brush, 10 x 19½ in.
Private Collection

People talk to me about the mood of melancholy in my pictures. Now, I do have this feeling that times passes—a yearning to hold something—which might strike people as sad. And I grant you, my things aren't high key in color or joyous or Renoiresque or Frenchy—which is what a lot of people want today—the visual cocktail. I think the right word is not "melancholy," but "thoughtful." I do an awful lot of thinking and dreaming about things in the past and the future—the timelessness of the rocks and the hills—all the people who have existed there. I prefer winter and fall, when you feel the bone structure in the landscape—the loneliness of it—the dead feeling of winter. Something waits beneath it—the whole story doesn't show. I think anything like that—which is contemplative, silent, shows a person alone—people always feel is sad. Is it because we've lost the art of being alone?

SNOW FLURRIES 1953
Tempera, 37¼ x 48 in.
Margaret I. Handy

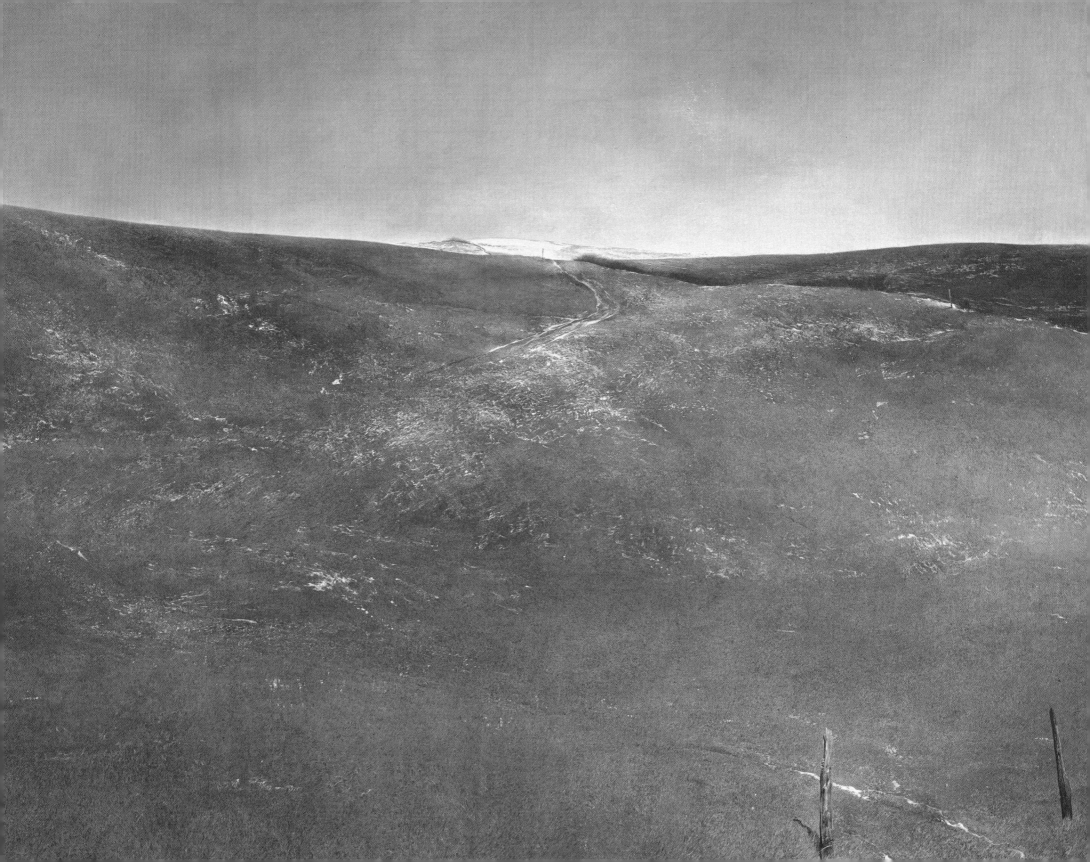

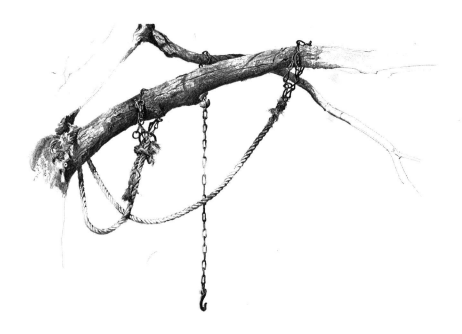

ROPE AND CHAINS 1956
Pencil drawing for *Brown Swiss*, 17 7/8 x 23 3/4 in.
Private Collection

But I'll admit, maybe I dream of more loneliness than is actually there. I'm very untruthful, really, as a person. And my work is, too. That's why people are so often disappointed when they see a place I've painted a picture of. My work is not a depiction of this country particularly. I know they like to make me the American painter of the American scene, like Edward Hopper. Really, I've actually created my own little world—what I want. I mean, in *Brown Swiss* [pages 64–65], Karl Kuerner's house is in a vast wilderness of the North. But that's the way my little world is, you see.

Letter to William and Mary Phelps, January 27, 1957
Watercolor and pencil, 9 7/8 x 7 in.
Delaware Art Museum, Wilmington
William and Mary Phelps Collection

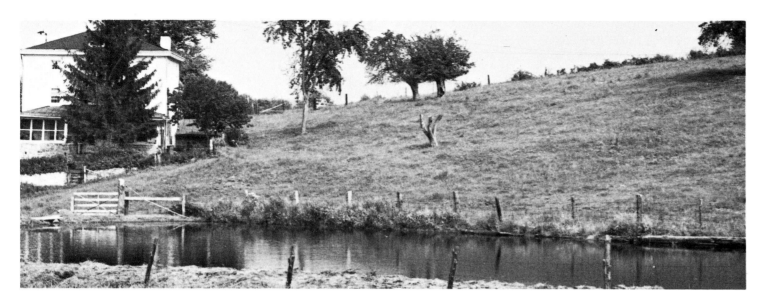

Photograph of Kuerner's Farm,
September 1972.
(Photo: Keith M. Jones, Jr.)

First drawing for *Brown Swiss*
Ink, 7⅛ x 15½ in. 1957
Private Collection

"*I really think* Brown Swiss *is one of my best things. And a lot of people, critics, said, 'It's good, Andy, but my eyes just go to that white house. It's almost falling off the left side.' That's just what I wanted—awkward, off balance. I remember I'd worked on the painting for months—to the point where I had all the literal truth, the workmanship, almost overstudied. But I'd never gotten wild during it—out of control—given it the fire I felt.*

One evening just before dinner I mixed up a huge bowl of ochre color and raw sienna, very watery. Then I stepped back and threw it all over this huge painting, color dripping down. Then I rushed out. If I'd seen it drying all patchy, maybe, I'd have tampered with it—and doubted. The next morning I found I'd made it. I take terrible chances like that. Sometimes I miss and it's awful—chaos. But I'd rather miss sometimes and hit strong other times, than be an in-between person."

BROWN SWISS 1957
Tempera, 30 x 60 in.
Mr. and Mrs. Alexander M. Laughlin

I've spent most of life up to now pretty much alone. And I like it. I was the youngest of five kids and wasn't very well—sinus trouble. They went to school; I was just left alone. As often happens with the youngest, I grew up on the outskirts of the family, unconsciously without too much scrutinizing. I had a little colored boy for a friend —but a lot of the time just wandered over these hills, in this little territory right here, looking at things, not particularly thinking about art —hell no, just being perfectly to myself, but being very much alone. An ideal life for an artist. So, whenever I paint an open field or the inside of a house with loneliness implied, it's not a concocted dramatic thing—it's natural for me.

That's what I always feel about people who imitate me. It's not natural with them. They'll do the open fields with, instead of one crow, fifty crows. The most important thing, the emotion—your own restraint, your own involvement—is missing.

That's partly why you can't go anywhere and find a school that paints like me. My background is so different; I worked everything out by trial and error. My father just talked about life in general. On about the quality of folds in drapery and the way light comes across it. He got down to the essence of things. He never taught technique: this is the way you paint hair—sky—how to handle your brush to get that effect.

That's the big danger—getting the way of putting in a face, doing a spruce tree. Nature is never a formula. Take Ralph Cline. When he saw the way I painted him, you might think his forehead came up and just went back like an egg. But I went around behind him and ran my hands over his head. If you're sensitive to the things you can't see, you can get a sense of roundness—get away from that bas-relief effect.

On Ralph I found his frontal bone had a strange little peak—and I put it in the portrait. It isn't a matter of photographic accuracy so much as—well, I feel every object has its own personal structure. If I was painting my son Nicky, unless I got the essence—of his nose, say—it wouldn't be Nicky [opposite].

A lot of portraits, they all look alike—the artist's conception of what a girl looks like—same eyes—details without passion. It's awful. These artists—their personalities—are so strong in front of their paintings, you never get to their objects—which should exist with a life of their own. They're actually saying, to hell with the object. But I feel the subjects I paint are far bigger than I am—I mean, to feel that I'm the creator, I'd have to be a half-wit. The finest compliment I ever had came from an art critic at a show of my work in Buffalo. I told him I didn't want to get in his way, and he said, "Don't worry about that, Mr. Wyeth. You're absolutely no competition for your work."

I'm always amazed when people talk about my refined technique. I do carry things pretty far. But I know ten artists that paint with more technical accuracy and closeness than I do. But you've got to watch that the technique isn't all you see. Once Mrs. Eakins came into her husband's studio and said, "Oh, Tom, that hand is beautifully painted. I've never seen you do one better." Eakins took a palette knife and scraped it right off the canvas. "That's not what I wanted," he said, "I wanted you to *feel* the hand."

Take *The Patriot*. I could refine it more, smooth it out. But I don't want to take away from the certain dirtiness I felt in that man—of tobacco juice and stain and sweat. If you clean it up, get analytical, all the subtle emotion that caught you first goes sailing out the window.

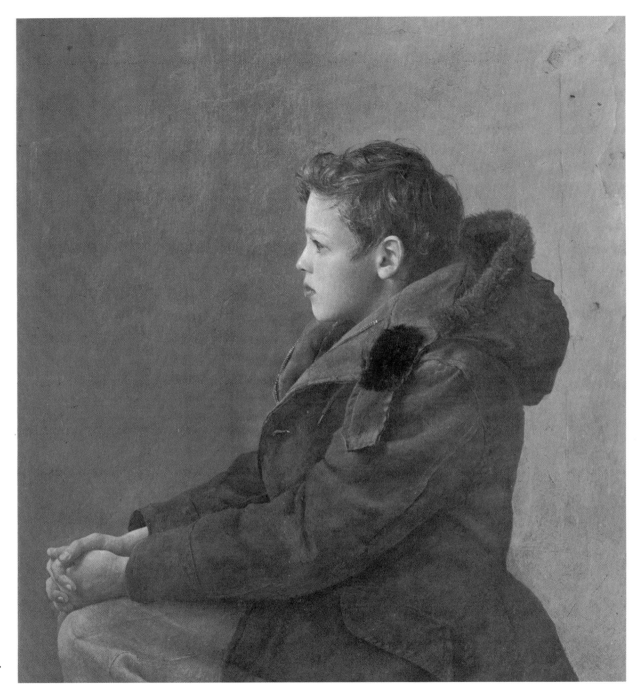

NICHOLAS 1955
Tempera, 32½ x 30¾ in.
Private Collection

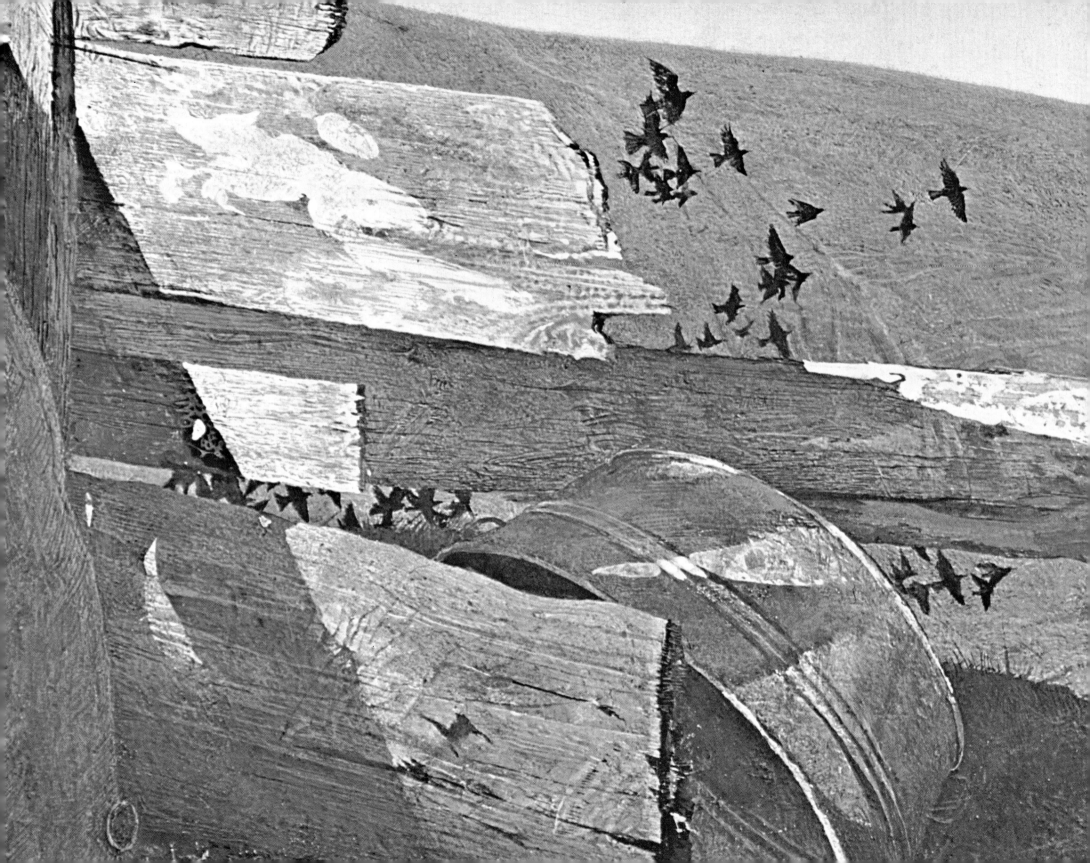

Motion, of course, is something I'm very interested in. You can get motion in—well—even in the attitude of this man. Ralph Cline. He isn't static. You look at the painting in a very dim light and get a gleam here, one there—a lost-and-found quality from a very odd arrangement of light and dark—the complexities of America, I think. And his head is turned—quick. He'll turn back in a moment. His grin is just quieting down, but there's a sadness too; he could almost cry. But if there's too much motion, it gets sort of cheap—the candid camera sort of thing. To my mind, that's the difference between Rembrandt and the Frans Hals-Sargent type of painting. There is motion in Rembrandt—his people turning toward the light. But it's frozen motion; time is holding its breath for an instant—and for eternity. That's what I'm after. I've done a bunch of grackles flying up behind the shed [opposite]. I think they speed in the picture, but they're also sort of an eternal monument to their speed. But, God, it's such a fine line.

Now, there's nothing I like better than fire. God, I came from a father who was blood and guts. But the danger today is that the cheap spark is apt to catch on quicker than the deep spark, the subtle spark. To my mind the master is the one who can simultaneously give the effect of simplicity and restraint—yet you can go right up to it and explore it endlessly with the greatest joy. This portrait of Ralph Cline it's very subtle. You're not overpowered by his expression, but if you look for a while, you begin to sense the feeling. I don't think it would stand out in a big show, say at The Museum of Modern Art. I think you'd pass it by. Everything is screaming with exaggeration today. I think artists today are caricaturing the truth, and life to me is more serious than that.

Also, I detest the sweetness I see in so much realistic painting. Awful. That's one of the great dangers of my technical accomplishment. I can get awfully nice in my lovely drifts of melted snow and get very delicate and pleasant. The abstractionists obliterate the object because it's one way of escaping perfunctory picturesqueness. Then it's easier because you don't have that goddamn thing of subject matter, an object standing in your way. You've just got color and mood. But I'd never be satisfied with just that. Why can't we have reality too, so we can understand it? Does it have to be gibberish?

I think a lot of people get to my work through the back door. They're attracted by the realism, then begin to feel the abstraction. They don't know why they like the picture. Maybe it will be sunlight—like *Ground Hog Day* [page 70]—hitting on the side of the window. They enjoy it because perhaps it reminds them of some afternoon. But to me the sunlight could just as well be moonlight as I've seen it in that room. Maybe it was Halloween—or a night of terrible tension, or I had a strange mood in that room. There's a lot of me in that sunlight an average person wouldn't see. But it's all there to be felt.

ADAM, detail.
(Full painting on page 89)

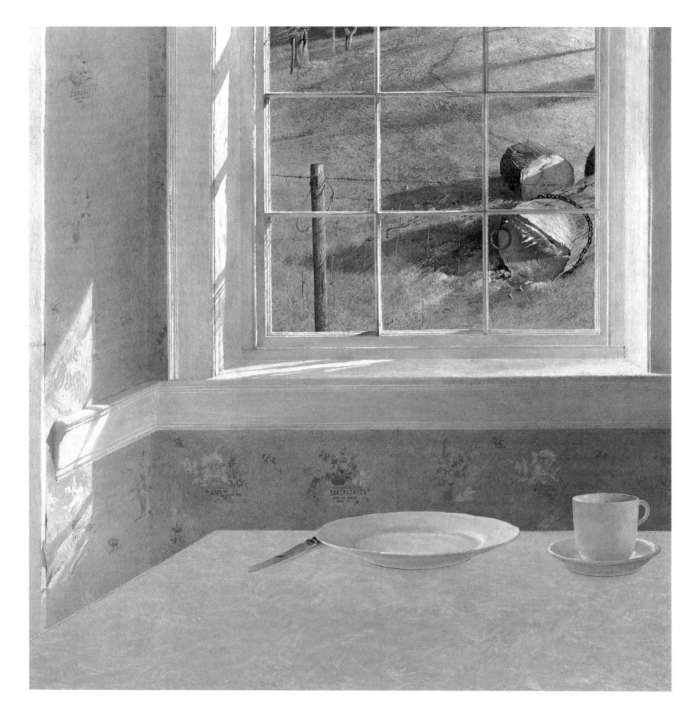

GROUND HOG DAY 1959
Tempera, 31 x 31 in.
Philadelphia Museum of Art
Purchased: Adele Haas Turner and
Beatrice Pastorius Turner Memorial Fund and
contributions from Mrs. John Wintersteen
and a Friend of the Museum.

I often go into my studio and look at my work in the dark, with maybe a moon outside, to enjoy it for a completely different reason—the abstract quality. Painting Ralph Cline, I'd go over to that loft in his sawmill on gray days when we couldn't work and I'd swing the picture away into the dark. I'd go back across the loft and all that would show of the painting would be the white of his head. It was marvelous to me. To have a picture—say like *Brown Swiss*—in your studio, and working on it—it's marvelous because it's like a bone to go in and gnaw at. There may be chaos in the panel, but in a corner of it there might be a window or a pile of rocks gleaming, complete, and still in another place, vacancy—then something else comes. And then finally, when you get far enough along in a thing, you feel as though you're living there—not working at a painting—but actually working in that valley. You're there.

That's why I would never let anybody watch me painting. I don't want to be conscious of myself. I think it would be like somebody watching you have sex—painting is that personal to me. But I don't think many artists feel this way.

You see, I'm a secretive bastard. That's why Ralph Cline fitted right in with me. Nobody knew he was posing and he loved that—maybe it was the Indian in him. He made a trap door with a lock on it to keep people out of the loft. Just what I loved. This goes right back to the Halloween idea again. Whenever I dress up in costumes, then I'm inside, looking out, watching—and it's not me people are reacting to. I'm not there.

I wish I could paint without me existing—that just my hands were there. I wish I could be Rattler going through these woods, looking up at the branches in the sunlight, the leaves falling down on top of him. When I'm alone in the woods, across these fields, I forget all about myself. I don't exist. I'd just as soon walk around with no clothes on.

But if I'm suddenly reminded of myself, that I'm me—then everything falls to pieces. That's why I paint so much—all the time—so that I'm not conscious of my hands or the fact that I have brushes. It all just happens. That's what I hate about doing portraits—the person has to be there, watching me. I have to talk.

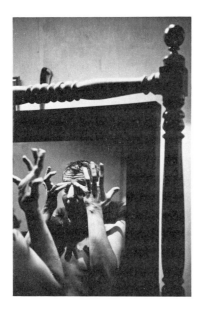
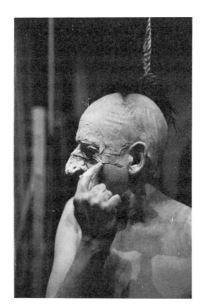
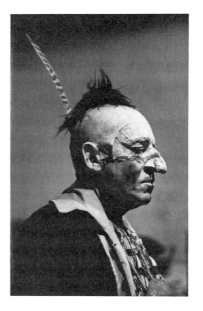

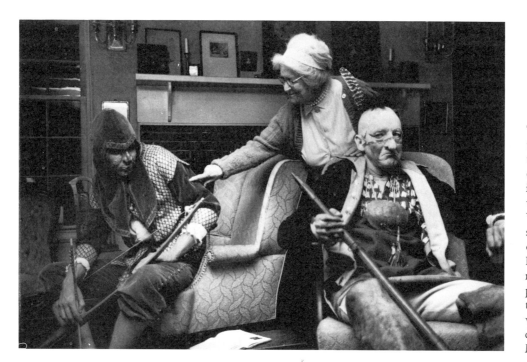

These photographs were taken in the fall of 1964 as Wyeth dressed up on Halloween in costumes originally owned by the illustrator Howard Pyle, who was the teacher of N.C.Wyeth. Wyeth put on his make-up in secret, transforming himself into one of General Washington's Indian scouts clad in a Continental Army coat. In the last photograph, Mrs. N.C.Wyeth, the artist's mother, tries to guess who is hidden underneath each disguise. (Photos: Burk Uzzle, Magnum Photos Inc.)

If my work ever lives, it might be for its feeling of strange removal from people—a mood of detachment. Ralph Cline in that portrait, he's a real person, yes, and you want to go near him. But I think there's a good deal of reserve in it—like in *Lime Banks* [opposite] and *Winter 1946* and *Christina's World* [pages 59, 39]. It's as though, when I painted *The Patriot*, I'd disappeared, was disembodied—floating above it, looking down on the whole state of Maine and that little figure in the uniform—which still fits him perfectly—sitting up in the loft of that mill and looking out that window into the deep dense spruce woods. It's as though I had died many years ago.

Now, I couldn't get any of this feeling without a very strong connection for a place. Really, I think one's art goes only as far and as deep as your love goes. I don't paint these hills around Chadds Ford because they're better than the hills somewhere else. It's that I was born here, lived here—things have a meaning for me. I don't go to Maine particularly because of the salt air or the water. In fact, I like Maine in spite of its scenery. There's a lot of cornball in that state you have to go through—boats at docks, old fishermen, and shacks with swayback roofs. I hate all that.

You wouldn't say that painting of Ralph Cline is particularly a painting of Maine. And yet, I think I've come closest to getting the true meaning of the way I feel about Maine in that picture—almost by the smell of it. There's something very basic about the country there. It has an austere quality—very exciting—the quietness, the freedom. I like it because it has an edge—like Ralph Cline.

All this is why I never go anywhere but Maine and Pennsylvania. I don't feel for a minute that other artists should run their lives like I do, but you do have to protect yourself, and everything we do is either going to take away or give. Robert Frost's life is a very good example. His later poems are not the important ones. He stopped living the thing that nourished him. That's the great danger of success and why I refuse to go places. If I'm worrying, have I got a dinner jacket or, gosh, I've got to buy some tickets for an airplane to get me to Chicago—boy, that kind of thing just absolutely flattens me out.

You know, after you travel you're never the same—you get more erudite, you get more knowledge. I might lose something very important to my work—maybe innocence. And anyway, all those poops come back from Europe, I don't see where they're so damned deeper in what they do. Seems to me they get thinner. About all they can do is bore you with a hundred slides of what they've looked at.

From my first girl friend to great art critics, I've been criticized for being too narrow. "Andrew, it would help your work to travel abroad—you've got to broaden your outlook—you'd come back with a fresh eye." If there's one thing that really gets me going, it's the lack of belief today in what can be creative America in an artist. I actually like people such as Eakins and Homer. I admire Edward Hopper more than any painter living today—not only for his work, but because he's the only man I know who actually feels that America can stand on its own. [*Hopper died in 1967. Ed.*]

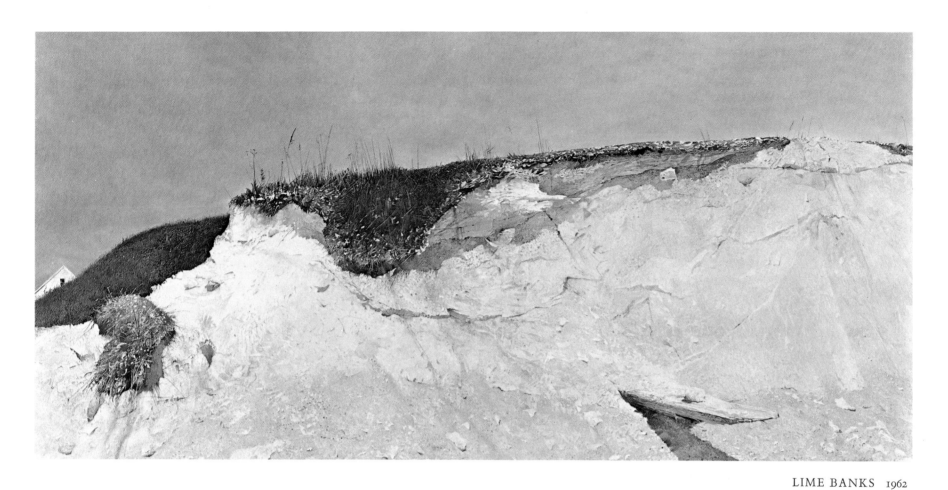

LIME BANKS 1962
Tempera, 26¾ x 51½ in.
Mr. Smith W. Bagley

*"I love white things. One night I was out walking
and saw this lime bank near an old kiln and it
gleamed dry white in the moonlight. I love to make
up my face on Halloween and I knew what the
experience was. The next morning I got up very
early, rushed out to my studio to sketch it out,
grabbed the closest thing—the wall—and drew the
outline on it. Oh, I love white. Marvelous.
It excites my imagination."*

WOLF RIVERS 1959
Tempera, 13 1/2 x 13 in.
Private Collection

You see, I just give no quarter to contemporary foreign art. When I say that America's absolutely *it*, people always say, "But Cézanne, Picasso, Braque." They're saying, "Yes, but we're children over here in painting." I'm not talking about subject matter but a very American quality—an indigenous thing you're born with. I think Franz Kline had it very strongly, even though he's abstract. It's the quality of the early weather vanes, the hinges on the doors. It's very hard to pinpoint. *The Patriot*—there's a certain awkward, primitive quality in that portrait I feel could only have been done by an American. It's sort of dry, for one thing. Robert Frost's best poetry has a dry quality.

I've had people say, why paint American landscapes? There's no depth in it—you have got to go to Europe before you can get any depth. To me that's inane. If you want something profound, the American countryside is exactly the place. You go to New York City, say, and you get a lot of people with a little bit of this and that, and you get a watered-down human being. But take Ralph Cline, who has lived in Maine most of his life. If you're interested in essences, you can go to Ralph Cline and get an essence absolutely in a being. There's something about an apple that's pure McIntosh that hasn't been cross-bred with other apples.

After the portrait of Ralph Cline was finished, I showed it first to his family. His wife wept and his son didn't say anything, just went over to Ralph and hugged him. Then I had Ralph ask a few of his most intimate friends over. It was a very emotional experience for me. Some of those men wept, too, when they saw the picture. When you get New Englanders to feel that way—boy!

Later I took the portrait down to the local grocery store—the owner knew Ralph—and leaned it up against his canned-goods shelves. I often do that to judge it. Let's see it against real competition—canned peaches—harsh color.

When I'm done with a picture, I can take criticism. When I've carried it as far as I can—and I'm not saying that I'm ever satisfied, because I'm not—then people can rip it to pieces. I'll be sorry it wasn't successful, but it's over the dam. But, boy, in the middle of a picture, I don't show it because I'd be too damn supersensitive. I'm so tense, I don't care if it's a child coming in makes a comment, it makes me mad. Isn't that awful?

Oddly enough my whole interest in a painting is when I'm painting it. Sure I care about it for a while—try to decide if I succeeded in what I was after. But strangely it doesn't make any difference to me whether the pictures are sold or not. Really, my purpose in painting is creating a thing. Fortunately I can make a living from my painting—but to be very honest, I don't know what I have in the bank account and I'm not particularly interested. I do about two temperas a year, and only about twenty watercolors are good enough to let out. Betsy keeps some things—and she wants to keep *The Patriot*—but if it was me, I wouldn't keep a thing. I'm never that satisfied with one.

But if the paintings are going to sell, I'll be the first one down on the dock to raise the price. What I don't like is having the prices publicized. Sometimes they're very exaggerated and make people think I'm a millionaire, which I'm not. And I know the people I paint sometimes wonder if I'm using them, if everything I do can get this high price.

There's one good thing about the prices, it makes people feel that art is important. America is so money conscious. I mean, if I had *Christina's World* here and I told people, well, there's a tempera that's worth thousands of dollars, oh, God, they'd really look—and maybe get something out of it. But when I first painted it, people walked right by it.

I can never be blasé about selling a picture. Only a damn fool would ever be completely sure of his position. The very last thing my father said to me was that I could never make a living out of the type of work that I believed in. He was very depressed because he thought the art world had completely reversed and so there was no more chance for his realism.

Ironically that's where I've been fortunate. I came at the right moment in American art. I was alone. Now there are a lot of realists coming along—I think partly because they've seen my success, to be perfectly honest—but I think today the abstractionists are the conservatives and I'm the modernist.

The only credit I'll give myself is that I did take advantage of my opportunity. I grant you I was born with more than ordinary ability, but I think I have driven myself harder than most artists towards the thing that I wanted. I've tried never to be easily satisfied, and I've been painting like fury now for forty years. I think now I'll probably do very little painting for the next twenty-five years. I sort of feel I want to dam it up again. I don't know. I have a feeling. You paint about as far as your emotions go, and that's about it.

But this thing does build up inside me until I just *have* to do something. I can think of nothing more exciting than just sitting in a cornfield on a windy fall day and listening to the dry rustle. And when I walk through the rows of blowing corn, I'm reminded always of the way a king must have felt walking down the long line of knights on horseback with banners blowing. I love to study the many things that grow below the corn stalks and bring them back into the studio to study the color. If one could only catch that true color of nature—the very thought of it drives me mad.

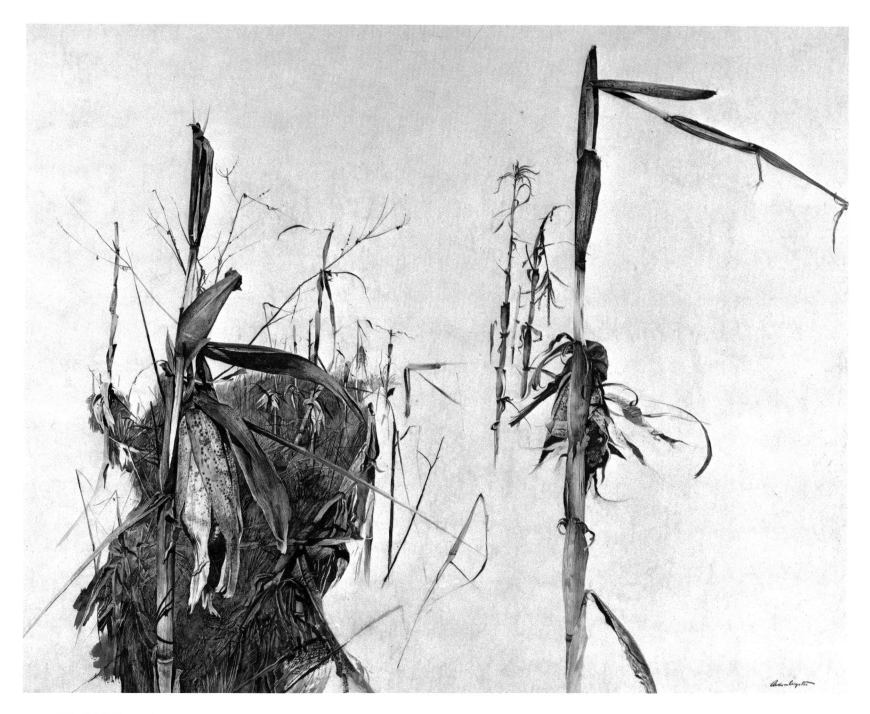

WINTER CORN 1948
Dry brush, 30 x 40 in.
Private Collection

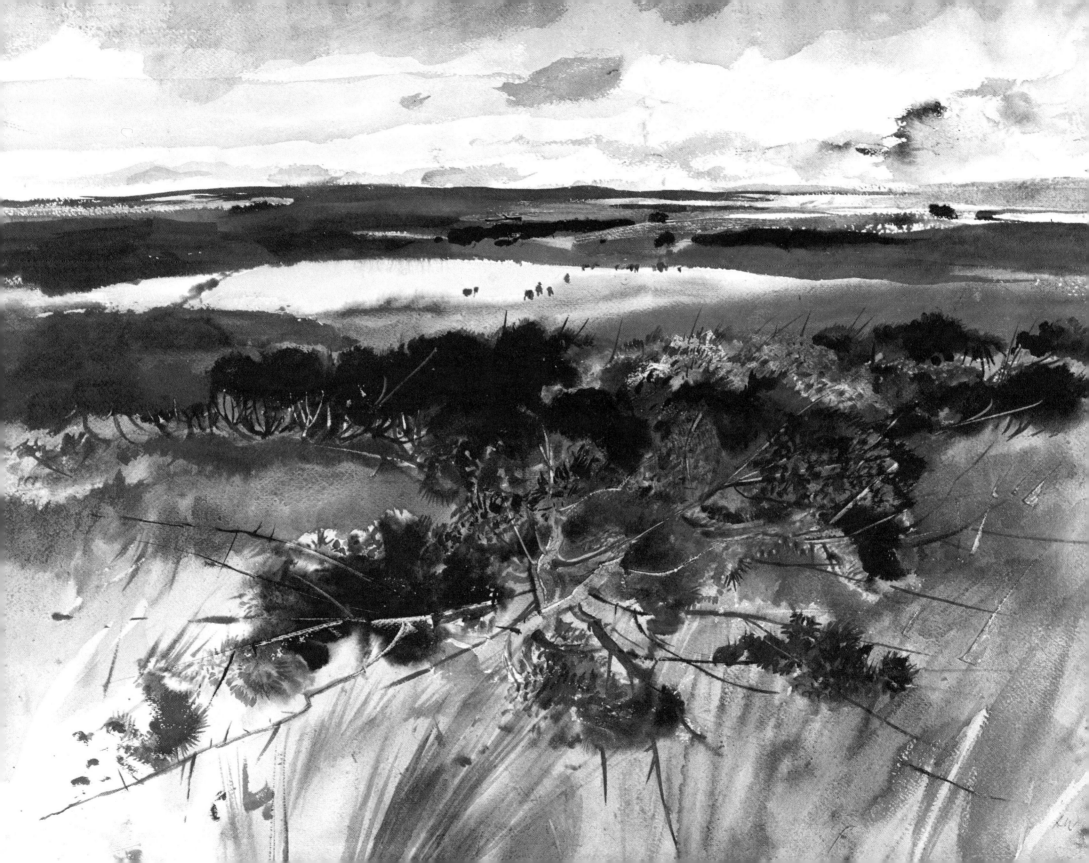

Andrew Wyeth's Painting Techniques

*E. P. Richardson**

Wyeth's painting style is a dialogue between spontaneity and discipline: between a passion for freedom and immediacy on the one hand, and on the other, a conviction that the wonder of the objects which make up this world can be grasped only by the most painstaking and loving study.

Like a number of notable American painters of the past hundred years, therefore, he finds watercolor congenial and uses it as a major, not a minor medium. After the facility of his early watercolors [left and right] (which he looks back upon now as dangerous), he hit upon a method of painting that appealed to him; he calls it dry brush watercolor. This is not a unique invention. Fifty years ago, for example, when a great deal of magazine illustration consisted of pen-and-ink drawings, the tool used by illustrators was not a pen but a fine watercolor brush, dipped into India ink and drawn to a fine point between the fingers or on a rag, squeezing out the excess ink in the process. A fine-pointed brush could draw as delicate a line as a crow-quill pen, yet it had a flexibility of stroke that no pen could give, or, with a dip of the brush, could turn into a thunderous wash.

*Excerpt from "Andrew Wyeth," an article first published in *Atlantic Monthly*, CCXIII, No. 6 (June 1964), pp. 62–71.

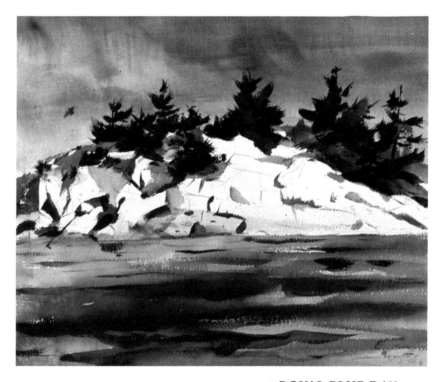

ROYAL BLUE DAY 1939
Watercolor, 18 x 22 in.
Private Collection

BLUEBERRY RACKERS 1941
Watercolor, 21 ½ x 29 ¼ in.
Private Collection

FARAWAY 1952
Dry brush, 13 ¾ x 21 ½ in.
Private Collection

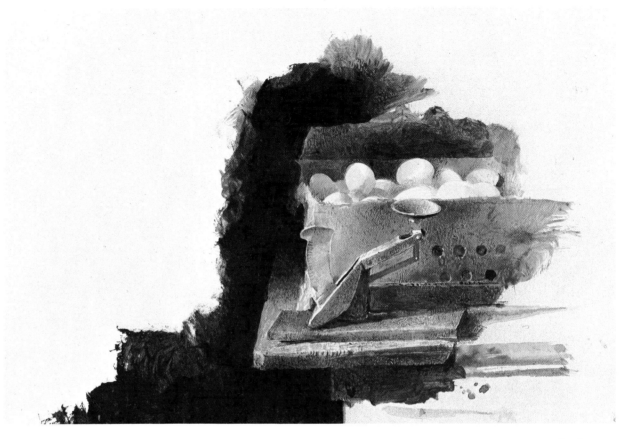

EGG SCALE, detail. 1959
Dry brush, 14⅞ x 17⅞ in.
Private Collection

Wyeth fell accidentally upon this combination of drawing and painting in watercolor. A picture called *Faraway* [opposite] of his son Jamie in a coonskin cap, he considers his earliest use of dry brush in a painting that satisfied him and that he allowed to be exhibited; but the technique is so natural an expression of his temperament that it must have been long germinating. Dry brush watercolor can be done either out of doors or in the studio. He considers it his most natural and spontaneous medium and speaks of it simply as "carrying watercolor a little farther." It seldom happens that he does not use both dry and wet brush together.

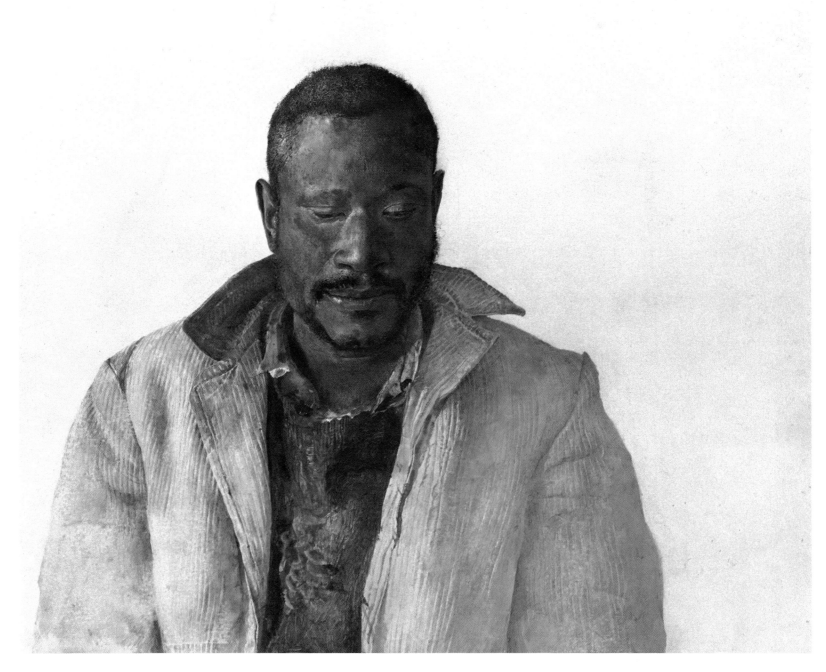

THE DRIFTER 1964
Dry brush, 23 5/8 x 29 in.
Private Collection

I complained to him a little about the things listed as dry brush in catalogues of his exhibitions that seemed to me indistinguishable from straight watercolor. "I know," he said, "people call all sorts of things dry brush that aren't really. The real dry brush watercolors are things like *The Drifter* [opposite]. I use both together. It's very important to me to keep things fluid in the beginning. I'm not a careful worker. There are splatters of paint all over my studio. Many pictures remain so nebulous that I can't show them. Dry brush is a great medium. But I can't control it. If I control it, it's no good.

"Artists today," he went on, "think of everything they do as a work of art. It is important to forget about what you are doing—then a work of art may happen." This was a revealing statement from someone who is criticized for the perfection of his technique. Then he said again, "I want to keep the quality of a watercolor done in twenty minutes but have all the solidity and texture of a painting." Richness of texture within the broad tones of his pictures has become, in fact, as important to Wyeth as the precision of his brushstroke. Unlike most painters, he works over his watercolors: sometimes he will use opaque white to give density, or will lift off the color with any means at hand—sandpaper, or the palm of his hand pressed on the wet color —to give transparency [right]. (Anyone who will examine Winslow Homer's apparently direct watercolors will find that he also worked over them in all sorts of ways.) And although he says he can't control dry brush, his technique is now at the point of craftsmanship where skill becomes unconscious and the mind concentrates entirely on what it wishes to say.

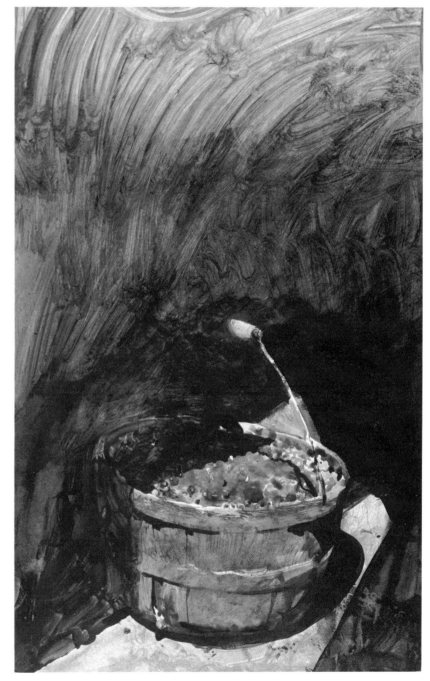

PIEBERRIES 1967
Watercolor, 21 ½ x 13 ½ in.
Private Collection

THE BED 1956
Pencil prestudy for *Chambered Nautilus*, 13 ⅞ x 21 ½ in.
Private Collection

In contrast to the freshness and spontaneity of his watercolors are the paintings in tempera and the precise pencil drawings made as preparatory studies for them. At one time he used to make full-size, very detailed watercolor studies for the tempera pictures, but the preparation he now prefers is pencil. "What kind of pencil?" I asked, thinking of the beautiful silvery quality of those drawings. "Just a regular store pencil, neither soft nor hard. I tried lithographic crayon, but I didn't like its scratchiness. I love the quality of pencil. It helps me get to the core of a thing, and it doesn't compete with the painting. With pencil I can study things in detail—it gives me the architectural structure—but the color stays like a dream at the back of my mind until I come to paint."

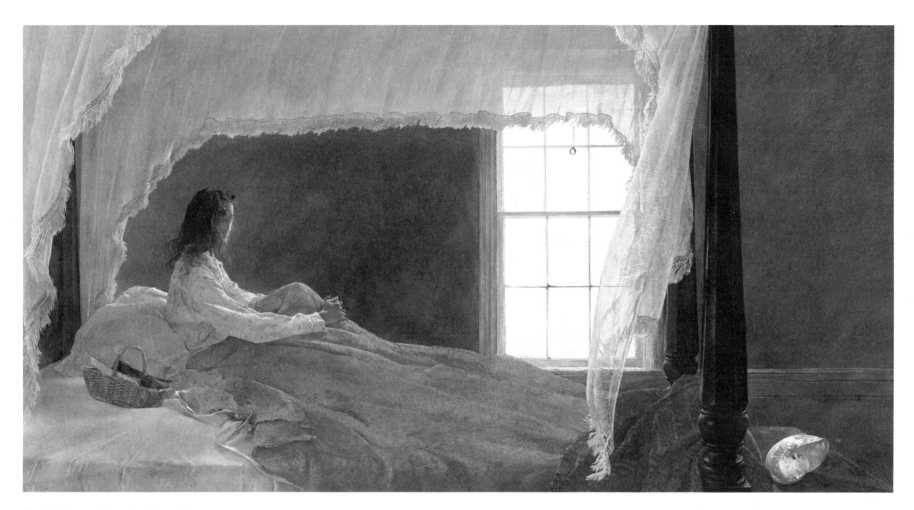

CHAMBERED NAUTILUS 1956
Tempera, 24¾ x 47⅞ in.
Mr. and Mrs. Robert Montgomery

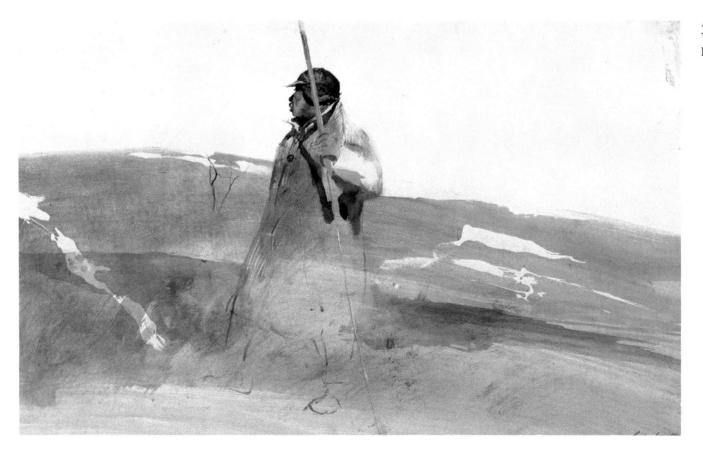

ABOVE ARCHIE'S 1961
Watercolor, 16¾ x 28 in.
Private Collection

"This is Adam Johnson, a wonderful looking Negro whom I've never really caught. It was a cold winter morning—a strong sun but everything frozen— and he was raking around and I suddenly saw him silhouetted against a distant hill that had white snow patches on it—that zebra feeling—terrific. There was something about that figure, the snow patches and the clear sky that expressed how I feel about Pennsylvania in the winter—and I do think I caught it, though I don't consider this a completed picture. I do a watercolor like this as a notation—as one would write in a diary."

The medium for his most sustained and controlled statements is egg tempera, used on gesso panels just as it was used when Cennino Cennini wrote his description of the technique in fourteenth-century Florence. It is dry mineral pigment, ground to a fine powder, mixed with yolk of egg and thinned with water. Modern chemical pigments have not yet invaded the ancient technique, at least as Wyeth uses it; his colors are the old earths and minerals. Some he grinds himself; some come from the New Mexico ranch of his brother-in-law, Peter Hurd; some are from India, or Spain; and he showed me with delight his cobalt blue—ground lapis lazuli from Persia. His palette is the normal shape, but made of metal, with sunken cups, not unlike those of a biscuit pan, around the edge in which the colors can be kept moist; yolk of egg in a glass dish; pure water in another; and fine watercolor brushes. That is all.

Tempera is not a portable medium like watercolor; it is a slow, patient, detailed technique. "I enjoy having a picture in my studio that I can nibble on, and feel that I can come close to the essential. I don't know whether I can ever master it as I'd like. Not many people

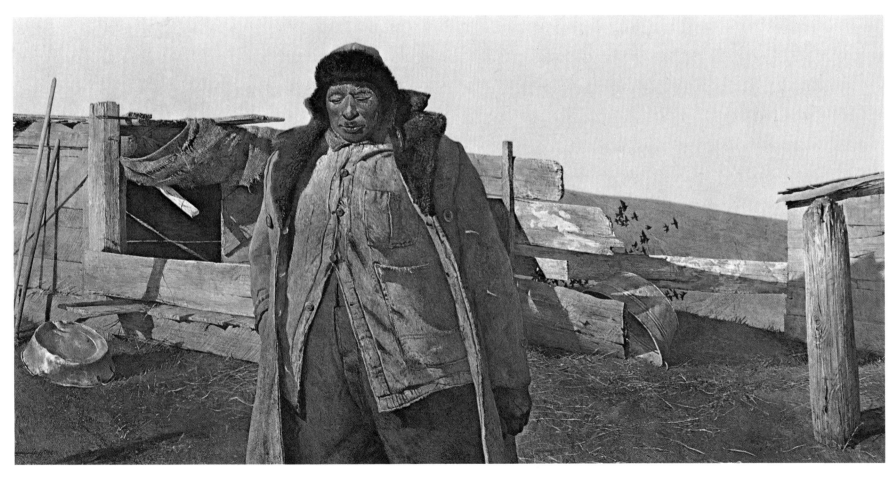

ADAM 1963
Tempera, 24 x 48 in.
Private Collection

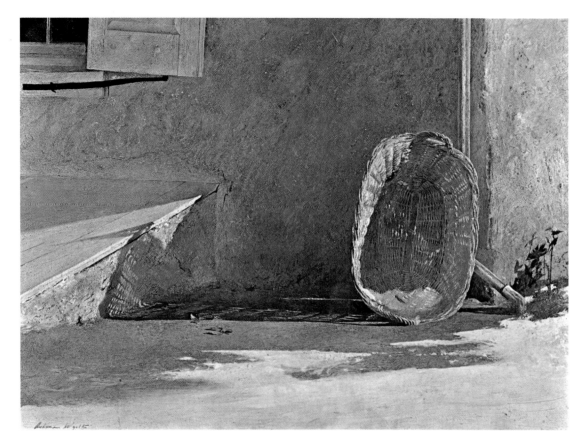

MONDAY MORNING 1955
Tempera, 12 x 16⅜ in.
Mr. and Mrs. John Hay Whitney

have, I believe. Even with Botticelli there is a falling off in his later things, don't you feel? The thing that makes me hang on to tempera is that if a picture does come off, it has a power and a solidity nothing else has; and there's a schematic quality about pure tempera that I like. It doesn't fit into the big shows of today; it's not spontaneous, it doesn't shine like oil, it has a dry substance. But"—his eye lit on a faded blue jacket hanging on the plaster wall—"look at that blue. Nothing else can do the air within that shadow so well as tempera."

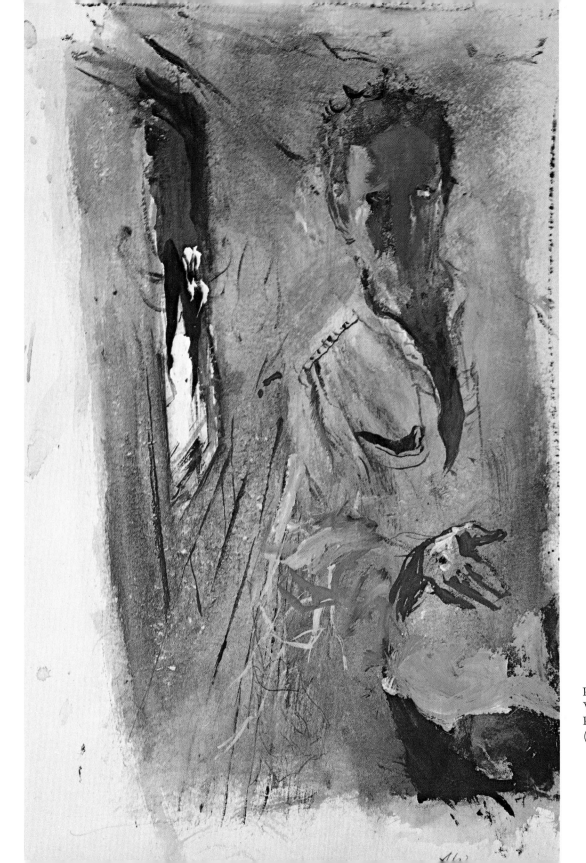

Prestudy for *The Revenant* 1949
Watercolor, 16½ x 10¾ in.
Private Collection
(Finished painting on page 143.)

The Art of Andrew Wyeth

Wanda M. Corn

I

*"Most of what is said and written about me seems to be set to
the tune of 'Turkey in the Straw.'"*[1]

The Andrew Wyeth most of us know is the product of one of modern America's most peculiar and compulsive pursuits: the transformation of its most interesting and fashionable artists into extravagant superstars of mythical proportions. This national mania, variously celebrating and ridiculing, turns complex and intelligent personalities into grotesque caricatures. Marilyn Monroe, for example, became the bleached-blond pin-up with a cheesecake figure, the public being indifferent to the sensitive and warm individual behind the calendar pose. Similarly, the news media stripped the painter Jackson Pollock of any personal identity and made his name into a commercial synonym for the crazed and alienated modern artist. Making light of his passionate search for a new pictorial means, the press dubbed him "Jack the Dripper," implanting the idea that Pollock's drip technique was psychotic, an artistic sublimation of errant psychic energies.

Andrew Wyeth's press has been kinder, perhaps, but no less guilty of producing a caricature that highly distorts the artist. Sometimes the press gives us a picture of Wyeth as a kind of modern primitive, an untraveled and unschooled artist whose paintings bear no relationship to twentieth-century institutions and thought. In this vein one critic has suggested that Wyeth is so independent of historical and international trends in art that he could just as well have painted in 1890

as in 1960, and in any provincial country. "Minor details or costume or property might vary; a hired hand might stand on an acanthus instead of a blueberry plant. But Wyeth's concept is essentially outside history and independent of location."[2]

At other times Wyeth is hailed as the "people's painter," the hero-artist of agrarian America. His images of the countryside and its folk are said to be plainspeaking, appealing to everyone's love for picturesque America; as a corollary, the artist is pictured as humble, unassuming, a man of the soil. Evidence of this public appraisal appears not only in the press, but on the artist's very doorstep, where he often finds admirers who have made pilgrimages to Chadds Ford or Cushing. One such enthusiast, a farmer's daughter, typified the public's presumed kinship with Wyeth when she went unannounced to his home, expecting him to "just throw open the house" and then to "talk about old barns all afternoon."[3] Not only visitors but fan mail becomes a daily chore for the artist, bulging as it is with photographs of split-rail fences and barn doors that well-meaning correspondents invite him to record in paint. Other strangers, even more insensitive to the artist's temperament, have written to request that he paint them and their houses in poses and landscapes similar to that of *Christina's World*.

While every myth may contain a kernel of truth, one is struck upon meeting the artist by how misinformed the public is about this man. He does not live a life cut off from modern events or people: he owns cars, flies in airplanes, takes a passing interest in national politics, and goes to current movies; he reads the art reviews in *The New York Times*, knows well the work of other artists, impresses one with his extraordinary memory, and is a local historian of some repute.

To be sure, he and his wife live in the country, but not in blue jeans on an operating farm as the myth would have it. Betsy Wyeth has inspired and managed the meticulous restoration of a cluster of three eighteenth-century buildings that once constituted a grain mill on the Brandywine. The Wyeths live in the miller's house, using the granary and mill for other family purposes. The carefully chosen and classic American provincial decor of their home and the groomed rusticity of its lands are echoed in the rural homes and estates of the du Ponts and other professionals who live along the same country roads in the

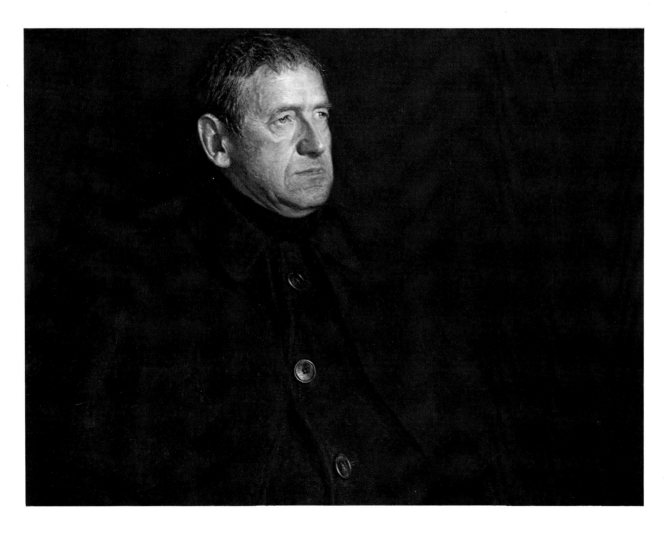

James Wyeth, *Portrait of Andrew Wyeth* 1969
Oil on canvas, 24 x 32 in.
Mr. and Mrs. James Wyeth

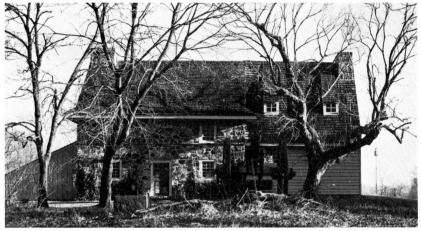

The Mill, Mr. and Mrs. Andrew Wyeth's home in Chadds Ford.
(Photo: Joseph J. Corn, III)

Brandywine Valley. Like many of these people, Wyeth's lifestyle appears from its externals to be closer to that of a country squire than that of a tenant farmer.

Wyeth's public caricature probably is most simplistic in its description of the artist himself. The press likes to label him as reticent and shy. He is, in fact, extremely congenial, but beguilingly elusive and unpredictable as a personality. Like the proverbial onion, there are fascinating layers to Wyeth but you never feel you have uncovered the core. Photographers catch one layer—Wyeth's zest for life, his contagious boyish grin, animated gestures, and cocked head. When members of Wyeth's family paint him, they give us an older man, one who seems more burdened and privately withdrawn [opposite].[4] And then there is the Wyeth who, while laughing and talking, is al-

ways watching: noting a beautiful button on a visitor's coat, shrewdly characterizing a new face or personality, mentally recording the fleeting changes of light on the immediate surroundings. There is also the Wyeth who disappears without warning for hours at a time, sometimes to the studio, sometimes to visit one of his very few real friends, often to walk for miles alone through the woods and countryside. On those rare occasions when someone discovers him drawing, it is never in the open fields or along the seashore like a traditional landscapist, but in the darkness of a springhouse, among the stones of a graveyard, or in the emptiness and quiet of a country church. This is the Wyeth we glimpse through his paintings.

Wyeth's immense popularity as an artist is partly to blame for the erroneous assumptions which have sprung up about him.[5] One has become overly familiar with his name and his paintings: reproductions of his work are ubiquitous—*Christina's World* turns up on a wall opposite a Van Gogh in *2001, A Space Odyssey*; in the daily newspaper, even Snoopy the dog talks about *his* Andrew Wyeth [below]! Such grand-scale popularization has tended to encourage an image of the artist living in cluttered old houses among the battered pails and frayed curtains he so often paints.

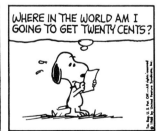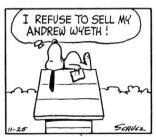

Charles M. Schulz, *Peanuts*, November 25, 1968
©1968 United Feature Syndicate, Inc.

Jackson Pollock, *Autumn Rhythm (Number 30)* 1950
Oil on canvas, 105 x 207 in.
The Metropolitan Museum of Art, New York
George A. Hearn Fund, 1957

Franz Kline, *Mahoning* 1956
Oil on canvas, 80 x 100 in.
Collection Whitney Museum of American Art, New York
Gift of the Friends of the Whitney Museum of American Art

A great deal of the misunderstanding, however, stems from the fact that Wyeth's meteoric rise to fame in the 1950's and 60's came at a time when other artists of his generation made headlines as the new abstract painters of the so-called New York School [left]. Next to their wall-sized canvases of flowing color and flamboyant stroke, Wyeth's carefully rendered tempera panels of rural landscapes and figures looked curiously innocent, seemingly out of touch with other artists and current trends. Much of the critical attention in the press and art journals of these years focused on the stylistic gulf that separated Wyeth's figural work from that of the Abstract Expressionists.[6] Wyeth was often cast as a kind of Neanderthal, either as a mere illustrator or, more charitably, as the last surviving exponent of realism in a world that many critics and painters felt could be expressed only in abstract idioms. As one New York artist kindly put it, "He's like someone who writes marvelous sonnets, but I don't read sonnets much."[7]

Wyeth has taken on the task of self-defense graciously. Asked often to comment on abstract painting, he has spoken with genuine admiration for the energy and vitality which he finds in the works of artists such as Franz Kline, Willem de Kooning, and Jackson Pollock. Indeed, many of his loose and gestural sketches bear strong resemblances to some of the abstract work of these artists. (See, for instance, the sketches on pages 57 and 63.) Bemused by the supposed battle between himself and the abstractionists, he good-naturedly lampooned the situation in his 1961 Christmas card, which reproduced a cartoon that had appeared in a local newspaper. A strange, futuristic creature, a kind of bastardized cubist figure, stands dumbfounded in front of a Wyeth work: "I don't get it," he exclaims!

Wyeth's jocular defense should not obscure the fact that in many ways he has been victimized by a very intense and narrowminded critical climate. Up until very recent times the most interesting art criticism has centered almost exclusively on the vanguard, the most progressive painting of the past as well as of the moment. Such a perspective has tended to ignore or cast suspicion on those artists who develop more or less independently of vanguard trends and who relate only peripherally to the most experimental trends of their moment in

history. Some may be rural, like the English painter Samuel Palmer, some parochially tied to a country's own unique intellectual climate, such as the Pre-Raphaelites or the Biedermeier painters, or some are simply highly individualistic and relatively insensitive to artistic fashion, such as William Blake and Albert Ryder. Others may have become wedded to a particular viewpoint early in their careers, one that may then have been in the vanguard but that with the passage of time became outmoded and seemingly dated. This was certainly the case with the late careers of artists such as Charles Burchfield and Edward Hopper who matured as painters in the heyday of realism in the 1930's and who subsequently withstood the publicity and excitement surrounding abstract painting to remain until their recent deaths steadfastly committed to painting from a close study of nature.

All of this suggests the need for a new approach to the art of Andrew Wyeth. Rather than dramatizing the qualities separating his painting from that of the New York schools over the last twenty-five years, we should seek to place his work within the artistic and intellectual currents which formed him, and to examine the evolution and dynamics of his creative process. Such a perspective will necessarily question some of the assertions of his critics. Is Wyeth, for instance, really a "painter totally divorced from the present century,"[8] as one of them has put it, or can he be seen as having a place within the figural and landscape traditions of twentieth-century American painting? Is he painting within anachronistic, nineteenth-century realist traditions, or, as others have claimed, as a self-appointed "realist" interpreter of pastoral America? Perhaps it is entirely misleading to call an artist a "realist" who, time and time again, is drawn to the same models, the same farms and weathered houses, and to the same blighted seasons of the year. It may be far more accurate to see Wyeth's highly individualized, almost idiosyncratic indulgence in his circumscribed surroundings as an exploitation not so much of a *physical* universe as of a *psychic* one. To approach Wyeth's art from these directions will lend flesh and blood to our conception of him as an artist, and may give a new dimension to his already inordinately popular paintings.

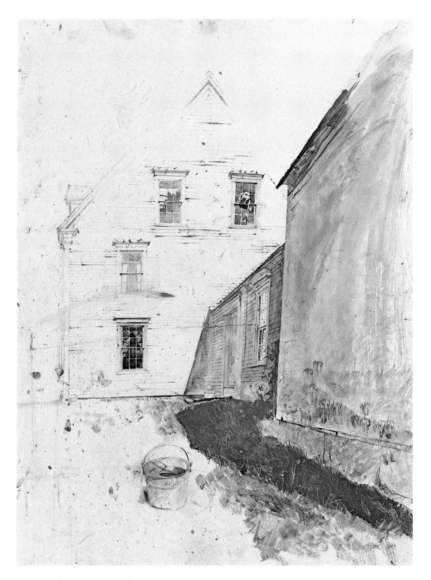

BARN SWALLOWS 1965
Watercolor and pencil prestudy for *Weather Side*, 29 x 22 in.
Private Collection
(Finished painting on page 159.)

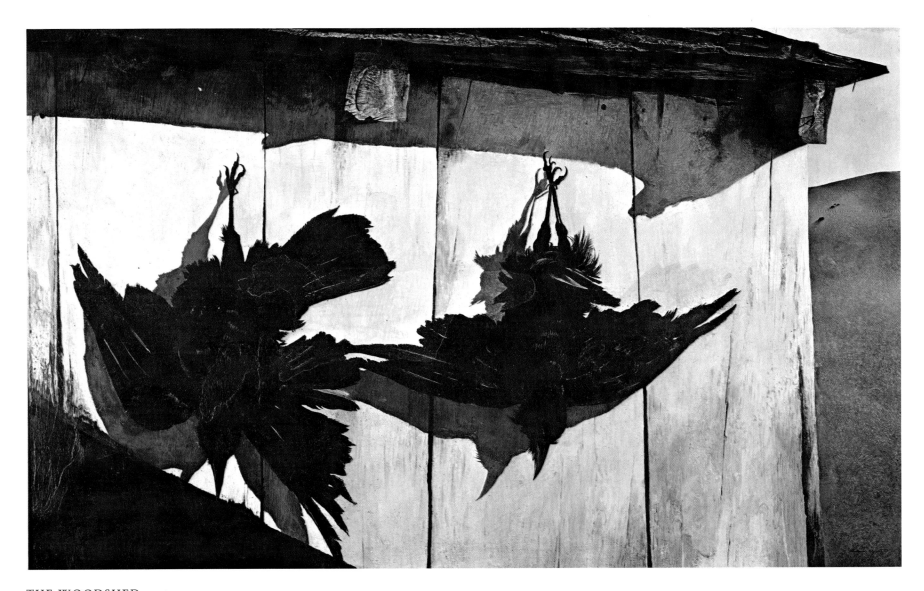

THE WOODSHED 1945
Tempera, 33 ½ x 56 ½ in.
Mr. and Mrs. C. Porter Schutt

II

"I admire Edward Hopper more than any painter living to-day—not only for his work but because he's the only man I know who actually feels that America can stand on its own."[9]

Andrew Wyeth belongs to the generation that grew up between the world wars. Born in 1917, his baby years were colored by reminiscences of the horrors and heroism of the First World War. He was a teenager during the great Depression. Just as he reached adulthood and maturity, the whole world was swept into another tragic war.[10]

This bare chronology suggests that his was a generation brought up on the milk of harsh human realities. To be developing as an artist in the late 1930's and early 1940's meant coming of age in a time of bleakness. Things often seemed out of control; the future was terrifyingly uncertain; and the demonic side of man increasingly reigned around the world.

Not surprisingly, artists of this particular generation tended to turn inward and become introspective in their expression. Their art is often emotionally autobiographical, communicating a deep sense of loss and displacement. Some of these artists, like Edwin Dickinson and Ivan Albright, painted metaphors of death, destruction, and disintegration. Many painted surrealist fantasies of dreams and absurdities. Others—Jackson Pollock and Mark Rothko—studied Jung, primitive rituals, and ancient myths as they struggled to create a style expressive of man's primal nature. Wyeth too, as we shall see, came to create an extremely private and subjective art, one which in part offers a personal definition of continuity and permanence in face of the instabilities and uncertainties of modern life. Like others of his generation, his art, at its most meaningful level, clearly exposes a heightened sensitivity to life's ambiguities and darker realities.

The larger unrest of human history is echoed in the aesthetic flux and indecision that characterized the art world during Wyeth's early development as an artist. Even in retrospect the period of the 1930's and 40's has never come to be characterized by any one strong artistic

Andrew Wyeth, Summer 1972.
(Photo: Peter Beard)

Edward Hopper, *Approaching a City*
Oil on canvas, 27 x 36 in. 1946
The Phillips Collection
Washington, D.C.

Thomas Hart Benton, *July Hay* 1943
Oil and tempera, 38 x 26¾ in.
The Metropolitan Museum of Art, New York
George A. Hearn Fund, 1943

movement or memorable exhibition. (Look at the problem textbook writers on modern American art have had with this period.) If there was a single dominant trend, it was the compelling interest that artists took in realist modes.[11] To be sure, there were a certain number of American painters who continued to respond to the cubist and expressionist styles of the previous decades, and some who were painting total abstractions. But following World War I, an ever-increasing number of American artists firmly rejected the extremism of European modernism to work in various styles of realism. To these artists, Cubism and Expressionism were unnecessarily obscure and overly intellectualized, too dependent upon pure form and color for their messages, and not given enough to expressing essential human issues. Furthermore, these modern styles were foreign imports intimately associated with countries that seemed to be dying of cultural cancer.

The most prevalent reaction manifested itself in American scene painting, the portrayal of American places and people. This new focus on American themes is often called "Regionalism," a term popularly and proudly used in the 1930's and 40's to describe both painting and literature inspired by close acquaintance with and observation of a particular American locale, be it the American South, the Midwest, New York, Cape Cod, or Gloucester. In painting, the term "Regionalism" has been narrowly linked to the work of Thomas Benton, John Curry, and Grant Wood, painters whose works so explicitly portray typical American faces, manners, and conditions. Yet the term has much wider relevance. It really describes the fascinating nationwide impulse that in and around the Depression years propelled not only the artists just mentioned, but other painters, photographers, poets, novelists, and musicians, to an intimate study of their own country: its people, its architecture, its beauties, and its miseries [left].

This impulse was complex. In part, it grew out of the heightened national consciousness of the inter-war years, a period when Americans were acutely aware of themselves as a people with problems and traditions different from those of the Old World. Added to this was the conviction, which had been fermenting since Walt Whitman had first proclaimed it, that Americans had not yet produced a modern idiom expressing the uniqueness of contemporary American life. Finally and most importantly, much of the interesting American art of these decades was motivated by the dawning awareness that the intricacies and particulars of any man's life, no matter how drab and ordinary, could be creatively transformed into valid artistic statements. Thus, in *Winesburg, Ohio*, Sherwood Anderson shaped his small-town experiences into a Breugel-like parable of human desires and follies. Grant Wood rejected the expressionist still lifes and landscapes of his earlier years and memorialized the faces of his Iowa neighbors as archetypal images of provinciality. Burchfield, Hopper, and later, Wyeth, took the ordinary houses of rural America as seriously as Henry Adams had taken Chartres Cathedral, creating haunting and poignant symbols of man's loneliness [right]. And in photography, Margaret Bourke-White, Walker Evans, and Dorothea Lange trained their cameras upon some of the nameless and forgotten faces of poor Americans and found there the dignity and warmth of all humankind [page 103].

Charles Burchfield, *Old Farm House (September Sunlight)* 1932
Watercolor, 14 7/8 x 21 in.
Fogg Art Museum, Cambridge
Purchase Louise E. Bettens Fund

Edward Hopper, *Marshall's House* 1932
Watercolor, 14 x 20 in.
Wadsworth Atheneum, Hartford

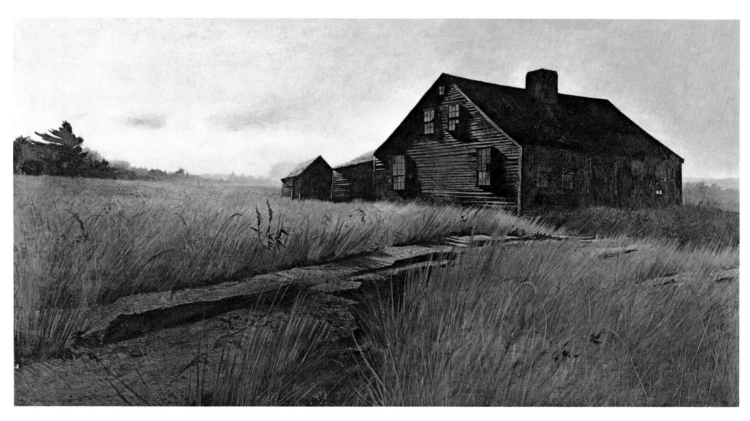

EAST WALDOBORO 1945
Tempera, 24 1/4 x 47 3/8 in.
Mr. and Mrs. W. S. Carpenter, III

This preoccupation with the ordinary and commonplace in quest of wider truths is what William Carlos Williams once called the "particularization of the universal." Williams, a buoyant spokesman for the study of America, said it didn't matter where the artist worked, but that he should give it the most careful scrutiny, a total "application of the senses." Through the artistic study of even a "downhill street in a Pennsylvania small town," he said, we can see "ourselves lifted from a parochial setting . . . ourselves made worthy in our anonymity."[12] This is precisely the spirit in which Andrew Wyeth examines his few miles of Pennsylvania and Maine. Wyeth has often said that he thrives on Cushing, Maine, not because of the romance of the sea (which he rarely paints), but because of its "nothingness." "That is just what I like about it. You have to

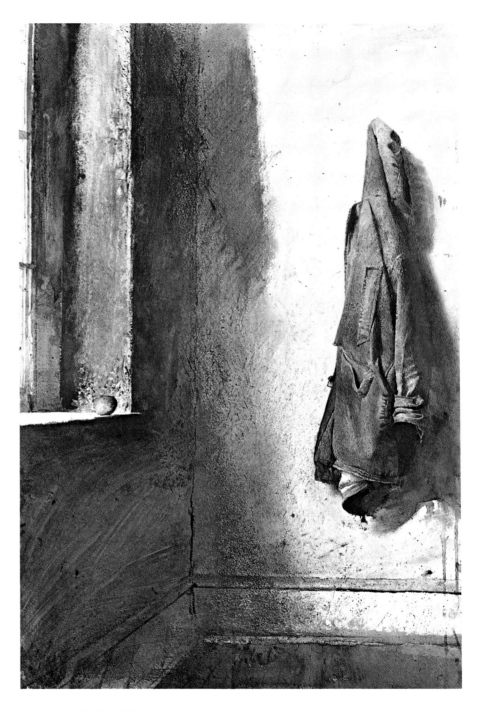

Charles Burchfield, *Pussy Willows* 1936
Watercolor, 33 x 25½ in.
Munson-Williams-Proctor Institute, Utica
Edward W. Root Bequest

WILLARD'S COAT 1968
Dry brush, 23½ x 20 in.
Mr. and Mrs. Nicholas Wyeth

peer beneath the surface. The commonplace is the thing, but it's hard to find. Then if you believe in it, have a love for it, this specific thing will become a universal."[13]

Putting ultimate faith in the potential profundity of a circumscribed sphere of experience does not in itself, of course, create great art. The great problem of Wyeth and other regionally oriented artists has been to find ways to shape their experience into a contemporary art of lasting significance. This was a particular challenge in the 1920's and 30's. An artist growing up in this period who wanted to paint what he saw could find no ready models in the modernism of the previous decades, which, since the 1880's, had rejected most forms of visual realism.

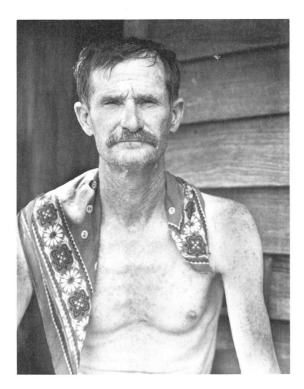

Walker Evans, *Sharecropper, Hale County, Alabama* 1936

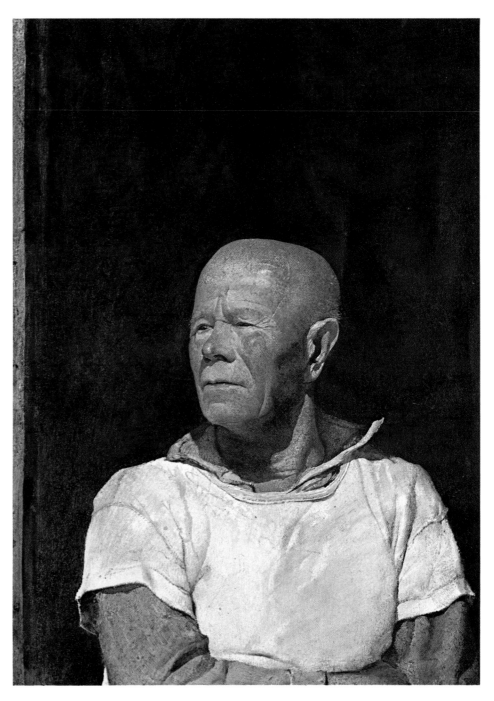

THE FINN 1969
Dry brush, 28¾ x 21 in.
Mr. and Mrs. Joseph E. Levine

Many artists, therefore, looked back in time to the respected old masters as stylistic sources for an art of monumental proportions and lasting beauty. Thomas Benton and Reginald Marsh, for instance, turned to the theatrical art of the Mannerists and Baroque masters, particularly to El Greco, Tintoretto, and Rubens; Grant Wood embraced the crisp realism of the early Flemish masters, and, as we shall see later, N. C. Wyeth and his son Andrew turned to Dürer, Rembrandt, and Winslow Homer. In search of an art of permanence and authority, an early Renaissance "realist" technique, the art of tempera painting, was revived. Used by Thomas Benton, Reginald Marsh, Ben Shahn, Charles Sheeler, Peter Hurd, and both N. C. and Andrew Wyeth, tempera became one of the favored media of the period.[14]

Although all of the American scene painters, including Wyeth, were unsympathetic to the extremism and illegibility of modern styles, their eclectic borrowings included many of the compositional discoveries of Cubism and Expressionism. Acutely aware of the modern dictates of plastic values, balance of masses, and abstract patterns, they combined their realism with modern picture-making principles. Beneath the surface of a Hopper or a Grant Wood landscape, for instance, we find deliberate simplifications and compositional patterns, such as the grid of diagonals and verticals in a Hopper or the repeating rhythms of tightly contoured hilltops in a Grant Wood [pages 100, 108]. Shadows assume bold independence as geometric shapes, while the distorted outlines and exaggeration of form in a painting such as Benton's *July Hay* give a kind of pictorial tension impossible in realism before this century [page 100].

These paintings then, are not in the naturalistic traditions of the nineteenth century. Rather than the Impressionists' *plein-air* realism (canvases painted on location), for instance, theirs is a studio realism, often dependent on sketches done directly from nature, but with composition and color relationship worked out in the privacy of the atelier. So too with Wyeth, who is constantly adjusting relationships, simplifying and altering what he has seen to intensify the original visual experience. If we compare the painting *Brown Swiss*, for instance, with a recent photograph of the original site, Wyeth's studio alchemy is obvious [pages 63, 64–65]. Pulling the hill up high behind the house and jigsawing the landscape into four lean triangles of alternating light and dark, he has created unsettling perfection and calm out of the fields and pond of a plain Pennsylvania farm. In another tempera, *Far from Needham* [opposite], we are given the pine tree and rock as a single majestic and imposing presence, the tree branches extending out over the shoulder of the rock like a regal headdress. In natural fact, however, the two elements, rock and spruce, are many yards apart, undistinguished and anonymous members of the Maine landscape. By subtly enlarging and silhouetting the contours of the rock and tree, compressing the distance between them so as to unite them, and infusing the rock with a radiant glow, the artist has taken truly modern forms of poetic license. Wyeth so enjoys these abstract pictorial qualities in his work, whether of color or form, that he takes undiluted pleasure in studying a tempera upside down, of viewing it in the half-light of moonlight or dusk, or even as it appears in a photographic negative.

Two recent photographs of the rock and tree that Wyeth painted in *Far from Needham*. The first, a side view, shows the actual distance between the tree and rock. The other somewhat approximates the artist's angle in painting the picture. The rock has been slightly buried since he painted it in 1966. (Photos: Keith M. Jones, Jr.)

FAR FROM NEEDHAM 1966
Tempera, 44 x 41 ¼ in.
Private Collection

ALAN 1955
Drybrush prestudy for *Roasted Chestnuts*, 4⅞ x 4⅞ in.
Private Collection

It is not only this design-consciousness, but Wyeth's understanding of pictorial space which links him to other modern American realists. Since the advent of Cubism, with its emphasis on fluid and fluctuating spaces, no artist has been content with traditional modes of perspective, and modern realists have been no exception. They discovered that distorted and untraditional viewpoints, for instance, were found to create a modern pictorial experience, namely that of making the spectator's orientation *vis-à-vis* the picture ambiguous and indeterminate. Hopper liked to build pictures on an oblique angle with some element of the landscape cutting across the picture and obscuring the horizon line, making it virtually impossible for the spectator to know where he is standing, or to enter very deeply into the picture [page 100]. Wyeth uses very similar devices.[15] In *Wind from the Sea* [page 125], he confounds the viewer by creating the illusion of simultaneously looking straight out the window and obliquely along the wall. This has the effect of "disembodying" the spectator, enhancing the other disquieting aspects of the painting. In Wyeth's later paintings, the eye level continues to be a shifting one: in *Roasted Chestnuts* [opposite], *Ground Hog Day*, or *Weather Side* [pages 70, 159], one visually is pulled deep into the distance, but at the same time, in contradiction to normal optical experience, one finds himself looking down at the ground, which appears to be flowing out of the picture and under his feet.

First Color Sketch for *Roasted Chestnuts* 1955
Watercolor, 13 ½ x 8 ½ in.
Mr. and Mrs. Harry G. Haskell, Jr.

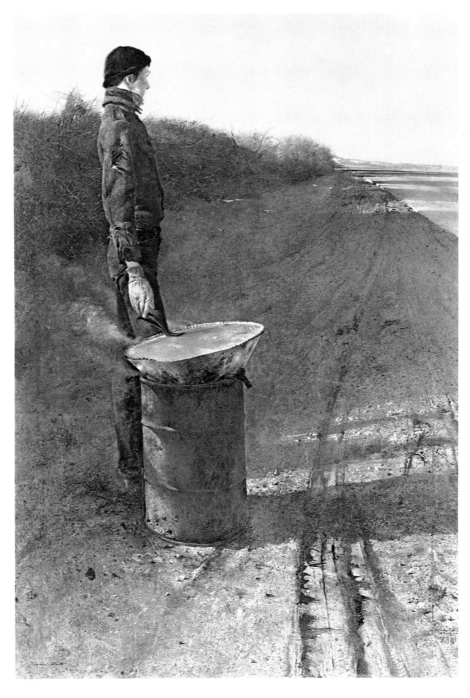

ROASTED CHESTNUTS 1956
Tempera, 48 x 33 in.
Brandywine River Museum, Chadds Ford

107

N. C. Wyeth, *Island Funeral* 1939
Tempera, 44 x 52 in.
Hotel Du Pont, Wilmington

These paintings suggest one of the most disconcerting vantage points used to "float" the spectator in the 1930's: that of looking down upon or up at a scene, the so-called bird's- or worm's-eye view. Such views were extraordinarily popular and inspired a wide range of pictorial and psychological effects. Charles Sheeler created startlingly inventive abstractions by looking up at skyscrapers or down into rooms of early American furnishings [left]. Grant Wood used such views panoramically to create storybook vistas of small Midwestern towns [below]. In a painting entitled *Island Funeral*, N. C. Wyeth, Andrew's father, looked down from a great height to survey the details and gloom of people gathering to attend a funeral on a small island in Maine [left].

Andrew Wyeth similarly likes to take us with him as he suddenly shoots up from below, as in the portrait of Karl [page 20], or, as is more common in his work, as he looks down from some point above to contemplate his universe. In his early works, he created lonely sweeps of landscape [opposite], one of them as if seen from the height

Charles Sheeler, *American Interior* 1934
Oil on canvas, 32 1/4 x 30 in.
Yale University Art Gallery, New Haven
Gift of Mrs. Paul Moore

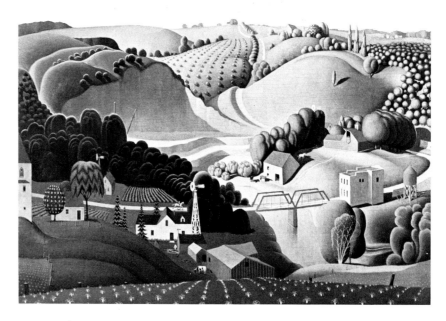

Grant Wood, *Stone City, Iowa* 1930
Oil on wood panel, 30 1/4 x 40 in.
Joslyn Art Museum, Omaha
Gift of Art Institute of Omaha, 1930

of a soaring turkey buzzard high over an isolated farm [page 110]. Later his focal length took on a more human scale as he looked down on his own boots in *The Trodden Weed* [page 111], down upon Maine rooftops in *Northern Point* [page 155] or *End of Olsons* [page 43], or down into a Maine cove or through the winter ice [pages 161, 163]. Such views in Wyeth's hands continually displace and disorient the spectator, never giving him a firm horizon or ground line and often leaving unresolved ambiguities. Are we meant to be a turkey buzzard? Shouldn't we be seeing the boots from the other direction in *The Trodden Weed*? This, as we shall see, is part of the elusiveness of Wyeth's art; we feel suspended and detached, not quite present in any physical sense.

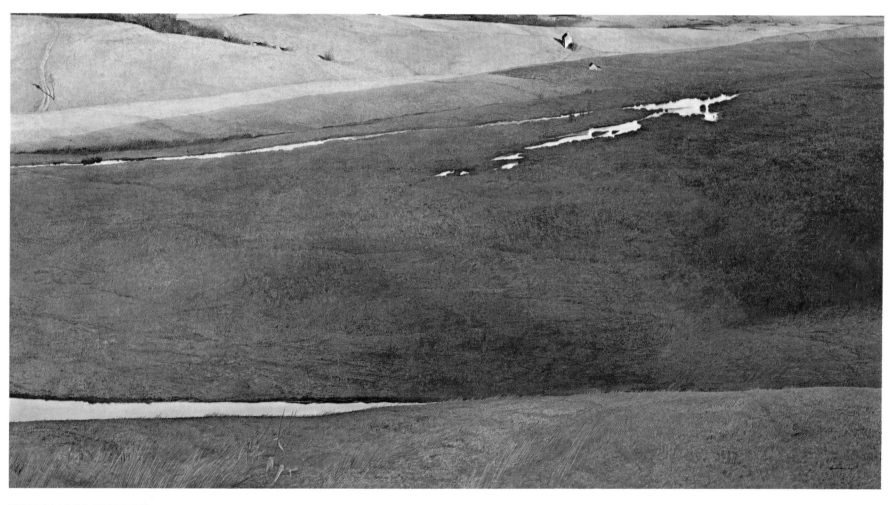

HOFFMAN'S SLOUGH 1947
Tempera, 29¾ x 55 in.
Mr. and Mrs. Charles Mayer

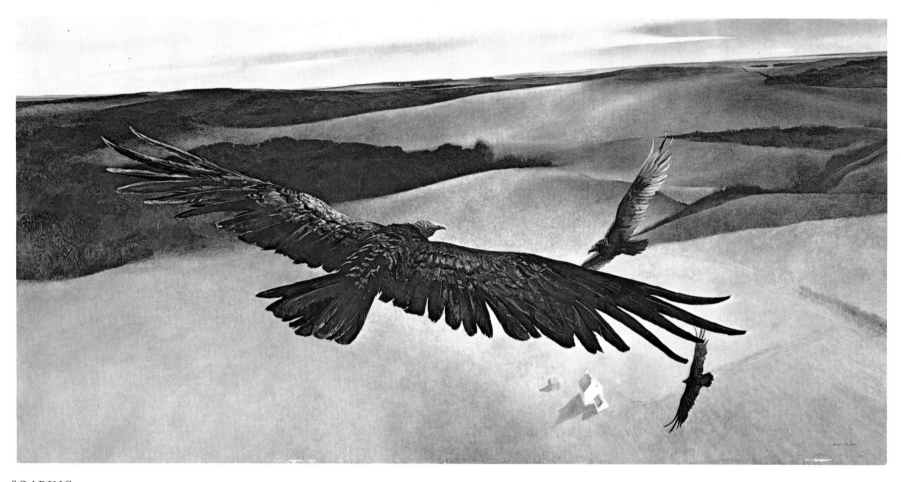

SOARING 1950
Tempera, 48 x 87 in.
Shelburne Museum Inc., Shelburne, Vermont

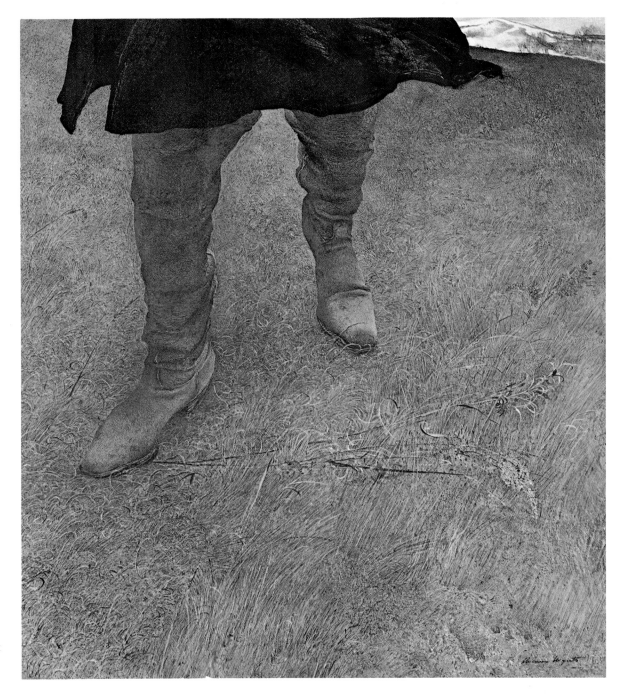

THE TRODDEN WEED 1951
Tempera, 20 x 18⅜ in.
Private Collection

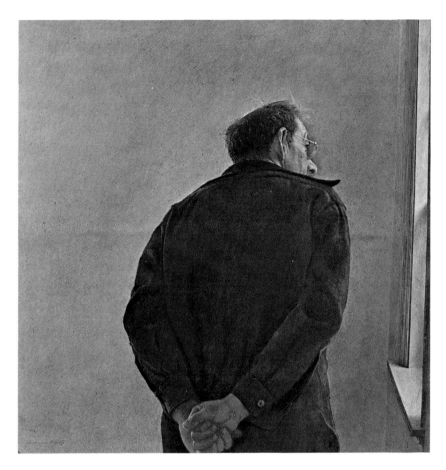

MAN FROM MAINE 1951
Tempera, 20¾ x 20 in.
Mrs. Stephen M. Etnier

Just as we are often surprised by the underlying abstractions and the complexity of spaces in Wyeth's paintings, so too are we confronted with a very individualistic use of a panel's framing edges. He likes to use the vertical and horizontal boundaries of a picture as integral compositional elements, letting them echo and repeat other forms in the composition, or crop a picture dramatically, or become the point of visual entry into a painting. In *Up in the Studio* [opposite] or *Man from Maine* [left], window sills, floor boards, and room lines lead us from the edges into the picture, giving us the beginning of a space that will never be completed. Somehow corners are always obscured, lines are blunted, back walls float forward to create what is less a physical chamber of space than a psychological chamber of privacy and loneliness. This concern with the edges of his works, greater than that of most American realists, has led Wyeth to vary considerably the outside dimensions of his temperas. Some are tiny, some are long and narrow, others are vertical and slim. He gives as much attention and care to the outer shapes of his works as to the ones that eventually go within.

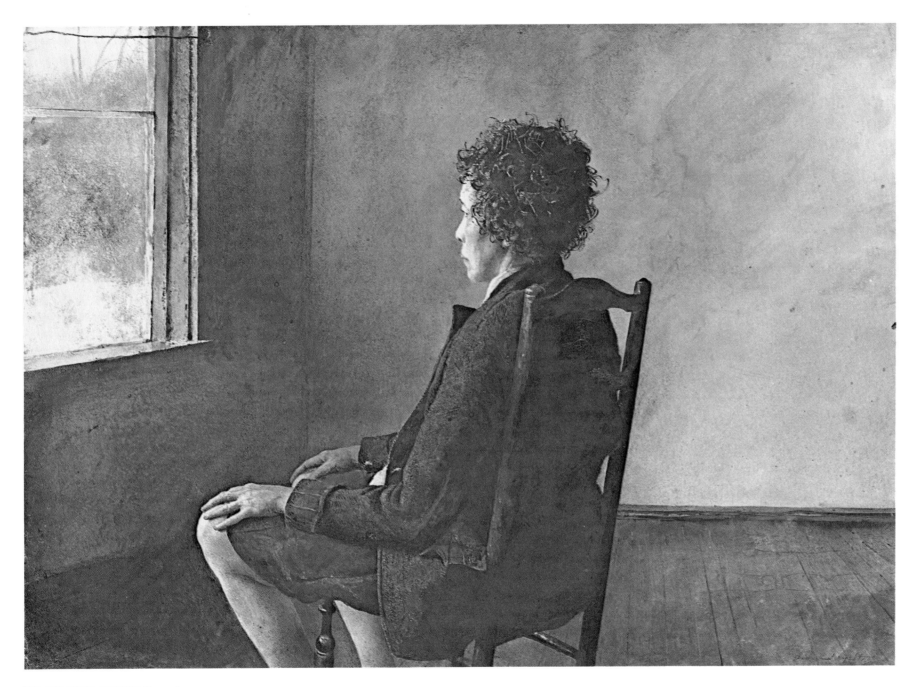

UP IN THE STUDIO 1965
Dry brush, 17¼ x 24¼ in.
Amanda K. Berls and The Metropolitan Museum of Art, New York

Walker Evans, *Farmer's Kitchen, Hale County, Alabama* 1936

As the comparisons throughout these pages suggest, Wyeth's subject matter, his habits of composition, and his varying "focal lengths" from wide angle to telephoto have close affinities to the work of many painters and photographers of the 1930's and 1940's. Indeed, Wyeth could be deemed the heir apparent and present-day advocate of some of the most dominant trends in earlier American art, one of the few interesting artists developing in the 1940's who continued these trends and did not turn to pure abstraction. But even if we are aware of Wyeth's visual and attitudinal ancestry, we must still explain that indefinable quality which is fundamental to his painting and which is generally absent in that of his predecessors. There is something highly personal to Wyeth's vision and to his transcription of it. When he paints, for example, isolated architectural fragments, as he did in *Cooling Shed* [opposite] and *Open and Closed* [page 117], we sense imminence and mystery, and begin to detect an obsession which draws the artist again and again to white walls, or to partial openings into unknown spaces. This is different from our experiencing of very similar works by Sheeler, Evans, or Weston, whose pictures do not arouse us in the same way, and whose impact is primarily on a formal and abstract level.

For Wyeth, however, abstraction obviously is never an end in itself. While he may distill the irregularities and confusion from nature's

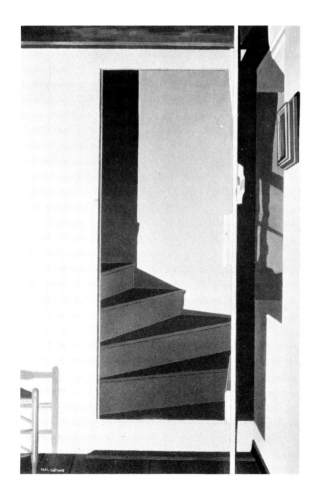

Charles Sheeler, *The Upstairs* 1938
Oil on canvas, 19½ x 12¾ in.
Cincinnati Art Museum

Edward Weston, *Church Door, Hornitos* 1940
(Photo courtesy of Cole Weston)

façade, he interjects into his compositions certain psychological tensions and preoccupations which mark his work and make it stand out from that of the other American scene painters and photographers. This is what Thomas Benton, the dean of regionalist painting, remarked upon when he said that a Wyeth work, while regionalist in character, is "unusual because of the poetic charm with which he is able to endow it, or which he causes it to evoke."[16] Whether we want to call Wyeth's strange allure poetic charm or something else, it is intimately tied to the man himself, his roots, and his own understanding of the meaning of art.

OPEN AND CLOSED 1964
Watercolor, 21 1/4 x 29 7/8 in.
Private Collection

N. C. Wyeth with the completed illustrations for "The Rakish Brigantine," a story by James B. Connolly which appeared in *Scribner's Magazine*, August 1914.

"Pa felt that with children you build a reservoir of reflection, a rich background, so that if you are an artist or a writer or a musician, or whatever—it gives you more meat in depth. He often said a person is like a sponge; you soak everything up and wring it out now and then—so don't run away from experiences."[17]

One of the most obvious ways in which Wyeth's work differentiates itself from that of other twentieth-century realists is in its charged depiction of homely objects and the common beauties of a bucolic world. One modern-day critic has questioned whether this intensity of response is "calculated or primitive."[18] The answer seems to lie partly in another realm. It is a carefully nurtured birthright, an integral part of the artist's family heritage, no element of which was more important than his father, Newell Convers Wyeth. For in so many ways, it was the patriarch who, like Daedalus, shaped the wings with which his son was later to fly.

N. C. Wyeth was a memorable person. Spiritually he belonged to that tough race of nineteenth-century individualists he so admired: Henry David Thoreau, Walt Whitman, and Theodore Roosevelt. Like these men, he characterized himself as "unconventional, democratic, free and careless of formalities, contemptuous of restraint, and with a wayward enthusiasm."[19] The robustness suggested by such a self-description was matched by an equally robust six-feet-two, two-hundred-pound frame. Curly-headed and bespectacled, his emotional temperature always seemed to be at an extreme; he could be as tenderhearted and gentle as St. Nicholas or as dignified and terrifying as Zeus. Whatever his mood, he had a ruler's authority, a strenuous imagination, and a penchant for hard work which left an indelible mark on his family and friends.

Without ever having met the man, one can sense N. C.'s driving energy in what he left behind as one of America's most prolific and greatest illustrators. Through his pictures, we enter the world of manly, violent and daring action, his brush bringing to life the exotic and heroic exploits of *Treasure Island, Kidnapped, Robinson Crusoe, Robin Hood*, and *The Last of the Mohicans*. Long before Hollywood, N. C. knew how to stimulate the armchair fantasies of the Walter Mitty in us all. Time after time, his heroes are locked in deadly struggle against their enemies, righting the wrongs done to others, or plotting in midnight secrecy to find the treasure first. His talent lay in isolating and giving pictorial form to the most telling and gripping moment, an intuitive process which he would foster in and bequeath to Andrew.

These fictional heroes and villains were almost flesh-and-blood brothers to the young Andrew as he grew up. Their adventures were told repeatedly in the family circle, and their world was made concrete in the picture-in-progress on father's easel, or by the colorful historic costumes, pistols and swords, that adorned the studio, and that came alive when the handyman or a neighbor dressed up in them to model for the artist. To young Andrew, the hills and woods of Chadds Ford were Sherwood Forest, possessed of medieval castles, knights-in-armor, pirates, or even Dracula. The tone was not that of flappers and jazz, but of fictional adventure as real as life.

N. C. Wyeth, *Fight in the Forest*
Illustration for *The Last of the Mohicans* by James Fenimore Cooper
Charles Scribner's Sons, 1919
Oil on canvas, 40 x 32 in.
Brandywine River Museum, Chadds Ford

His unconventional childhood also lacked fixed routines, a training in the parlor graces, and a father absent during the day. To be a Wyeth meant an idiosyncratic pace and flavor: self-indulgence, abundant family activity, and an open sharing of pleasures. Although the hamlet of Chadds Ford, where N. C. and his wife built a house and studio, was within fairly easy travel of Wilmington and Philadelphia, cities and their institutions rarely touched the lives of Andrew and his four older siblings. N. C. considered organized life to be "canned," schools a "menace," and analytical thinking destructive of creativity and feeling. Almost all of Andrew's education, and much of that of his brother and sisters, came at home with tutors, with generous amounts of time given over to individually inspired play and long wanderings in the unsettled countryside.

A good part of Andrew's "formal" education also came from N. C., who never withheld an ounce of his passion for certain books, poetry, and pieces of music, particularly those works that spoke directly to the heart and soul. Andrew's favorites reflect what he learned to know and love as a child—the music of Beethoven, Sibelius, Rachmaninoff; the writings of Thoreau, Tolstoi, Goethe; and the poetry of Walt Whitman and Robert Frost.

Besides listening to music and readings, all kinds of creative activity took place within the family setting, particularly at home on long winter evenings or alongside N. C. when he worked in his studio. The atmosphere strongly encouraged everyone to develop his or her proclivities: the telling of stories, the writing of good letters and descriptive prose; the composing of music, plays, and picture books for special occasions, and, of course, drawing and painting. For several years in a row, Christmas cards went off from the Wyeth household reproducing a musical composition written by daughter Ann, decorated by Andrew, sometimes with "Words by Dad" [left].

Certain family celebrations were particularly memorable. Such was the time when the young Andrew unveiled a toy theater he had finally completed after months of private inspiration and labor. A miniature world, fashioned out of cardboard and watercolors, it was an extravagant production. While an eighteenth-century audience of powdered ladies and gentlemen looked on from their boxes, a tableau of dozens of individually crafted soldiers and knights performed on a red and gold stage.[20]

At other times, N. C. was the chief impresario, orchestrating annual rituals. On the occasion of Halloween he would use pumpkins, field corn, and red Chinese lanterns to transform his studio into a storybook world of autumnal fantasy. Then, with the secret preparations completed, the room was darkened, the candles and fire lit, and the expectant children admitted. "Halloween favors were at each place," N. C. wrote to his parents, "and with the smirking and ogling pumpkins peeking through the ranked cornstalks and the fire on the hearth flickering over it all, another valuable impression has been registered on these children's minds—and *ours*!"[21] So it was indeed, for such rituals to this day provide much of the rich loam of memory and association from which Andrew works.

The most memorable Wyeth holiday, and the one Andrew refers to most often, was Christmas. Everyone contributed to the house decorating, a sumptuous and extravagant affair which induced particular smells and colors that still stimulate Andrew's mind with memories of the excitement and innocence of his childhood. The climactic moment in the celebration came early Christmas morning when N. C., charading as Old Chris, would thump his way across the roof, crying out, ringing his sleighbells, and then quickly descend a ladder into the house to deliver presents to the ecstatic and terrified children. "I used to wet my bed, I was so excited on Christmas Eve," recalls Andrew Wyeth, "—and then move to the other side of the bed to let it dry out. Pa used to scare the hell out of me, those big feet stamping on the stairs. Old Chris was always to me a giant, plus a marvelous, magic merry spirit—but a man who terrified me."[22] Even N. C. would become so moved during these occasions that he cried from pleasure and excitement.

Letter to William and Mary Phelps, January 2, 1964.
Watercolor and pencil, 9 x 5½ in.
Delaware Art Museum, Wilmington
William and Mary Phelps Collection

Such intermingling of fantasy and reality, play-acting and human warmth, ritual and creativity, or fear and exhilaration, constituted the extraordinary spice that was Andrew's childhood. While, in her own quiet way, his mother provided stability and continuity to the family life, N. C. Wyeth provided its basic rhythm and counterpoint. Dedicated to the passionate response, N. C. believed that anything less than total emotional involvement in work and in play was a denial of human life itself. His imagination being perpetually adolescent, he took great pains to stimulate and arouse his children's feelings, convinced that herein lay the secret to a rich and creative life. He found it to be a good sign, for instance, when Andrew as a young adult away from home, became depressed and homesick. "Intense nostalgia," he wrote him, "constitutes a very definite form of growing pains and is the truest barometer in the world of your spiritual and emotional potentialities. You have always had these qualities in abundance, of course, but as one swings into maturer years the reactions are more intense, more glorious—and more difficult."[23]

It was not only the emotions that N. C. awakened and fostered in his children, but the visual and auditory senses as well. On his long walks tramping around the hills of Chadds Ford with members of his family at his side, N. C. could respond with uncanny alertness to nature's most obscure colors and barely perceptible smells and noises, making even the most casual interchange of light and shadow into a miraculous and unique event. Nor did he ignore nature at her most violent: he taught his children to perceive in thunder, lightning, and floods a gothic drama, a text filled with magnificent and terrifying signals of nature's primary power and ruthlessness.

N. C. Wyeth in his apple orchard, about 1944.
(Photo: William E. Phelps)

N. C.'s letters, filled with microscopic observations, bear witness to the spectrum of phenomena he pointed out so that others might hear and see. A simple walk brought forth the following:

> . . . a heavy misty atmosphere smothered the earth. It had the effect of magnifying objects. A tree in the middle distance looked vague and huge; the ones in the foreground fairly towered and made me feel for the instant, awestruck. . . . The rustle and swish of the wet grass against my boots seethed unusually loud, the noise being so confined. A bell might have sounded like the click of two stones underwater. . . . To my right, hidden in the deep grass spotted gray-yellow with fading mustard flowers, I could faintly hear the gurgle and silvery tinkle of a brook. It sounded muffled, like the frozen brooks when you hear the water racing under the ice.[24]

Nothing pleased N. C. more than when his own children began to show signs of similarly sharp eyes, ears, and descriptive talents. When Henriette, the eldest child, remarked at an early age that a certain road reminded her of New England, her father

> . . . asked her reasons, for there were no trademarks of stone wall, frame house or evergreens to tell the tale—and yet it *did* look like New England to me. She quickly determined that it was first the color of the road . . . and also the colored blackberry vines along the level border to the fences on either side. She hit it exactly. I'll tell you, these things are significant to me and offer me great relief, in that they show an ability that will always give them a foundation reason why it is worthwhile to live, and secondly, as they weave the textures of their lives the background of memories will give them untold pleasures, and *perhaps* be the basis upon which they can build an important life work.[25]

The statement was prophetic. Much of Andrew Wyeth's life work is built on such a foundation. He has always walked his territories, even more than his father did, keeping mind and body alive to the sensing of new impressions and the memory of old ones. Most of his walks are private and self-absorbing, often to the point of total loss of self as he attunes his being to the languages of the natural world. He likes, he says, to lose so much consciousness that he becomes like an animal stalking nature. His own sensory perceptions are phenomenal: if blindfolded, a friend says, Wyeth could tell you the kind of tree he was sitting under by the mere sound of the wind playing through the leaves.[26]

With such capacity for discovery and self-renewal along even the most frequently traveled paths, Andrew has never wanted to travel abroad, and neither did his father. ("I haven't yet plumbed the depths of what's around me," says Andrew. "So why shouldn't I stay in one place and dig a little deeper?")[27] Cultivating one's own garden was the byword not only of the Wyeths but also of another famous American isolationist, Henry David Thoreau, and it is not surprising that his works were the favorites in the Wyeth household. N. C.'s admiration for Thoreau was boundless. Making frequent pilgrimages to Walden Pond, he considered Thoreau the "springhead for almost every move I can make, except in the intimate matters that transpire between a man and a woman. Here he is utterly deficient, as is Christ, on account of his lack of experience."[28]

N. C. responded to Thoreau on many different levels: on the surface it was to Thoreau's cocky independence, his avowed reliance on his own powers of observation, and his simple, nature-oriented lifestyle—characteristics N. C. prided himself on sharing with the lanky philosopher from Concord. On another level, Thoreau and the other New England Transcendentalists confirmed N. C.'s search for perpetual innocence and openness to experience, a quest that led him often to exclaim: "Oh! had I but the mind of a child and the abilities of a man!"[29]

Most importantly, Thoreau's basic contentions reinforced what became the most cherished ideal for all of the Wyeths: "to obtain the utmost of pleasure and inspiration from the simplest and homeliest events of the life around you."[30] As Thoreau could peer into the mirrored surface of Walden Pond and find in its depth and transparency a metaphysical analogy to the workings of the universe, so too could N. C. look out the window of his summer home in Maine and be transported by the ordinary beauty of the New England landscape. "This is," he wrote one day of such an experience,

> to all outward appearances, an extremely modest and commonplace vista, confined as it is by the four sides of the window frame and cut into eight exact panels by the window sashes; it is a scene that might be almost anywhere on earth. It is stripped of any glamour whatsoever; not a detail is outstanding or sensational; in fact, it is a glomeration *steeped* in utter commonplaceness and seems doomed to eternal oblivion in its own estimation, or in the memories of anyone or anything else. But a resurgent gust of wind sweeps across the tiny area! The lilac leaves shudder and fold themselves back into broken heart shapes of new-wet luster, then frantically restoring themselves into position to be swept again

and again into bright-varnished and twisted shapes. The tawny patch of long grass bends and leans into agitated motion, and the gray thin limbs of the spruce trees sway up and down in a ghostly slow dance. The deep gloom of the forest beyond remains still, like darkness.

> My imagination is suddenly whipped into an almost exalted appreciation of the magnificence of the little isolated and unrelated scene before me, and I am astounded at its vast beauty and its sublime importance, and am made to realize, in one poignant spasm, that before my eyes exists the profoundest beauty, the greatest glamour and magnificence possible for human sight and spiritual pleasure. The limitless ocean itself, the mountains and valleys of the *world* are of no greater importance in appearance or significance.[31]

N. C.'s contagion over nature, strikingly apparent in the recently published collection of his letters, worked its alchemy on his children and occasional students. Indeed, it was an extraordinary gift. His family and students would all carry into their own lives this intense Wyeth vision of and response to nature. Three of his children and two of his students would become respected painters. The most profound rooting of N. C.'s ideals, however, was to be in the child born July 12, 1917, one hundred years to the day after the birth of Henry David Thoreau. Could there have been any more fitting and prophetic sign for one who would, some day, looking out a commonplace Maine window, paint one of America's most memorable images, *Wind from the Sea?* [opposite] There is no reason to think that Andrew had ever read the letter, quoted above, which his father had written several years earlier. He didn't have to. He was, after all, a Wyeth.[32]

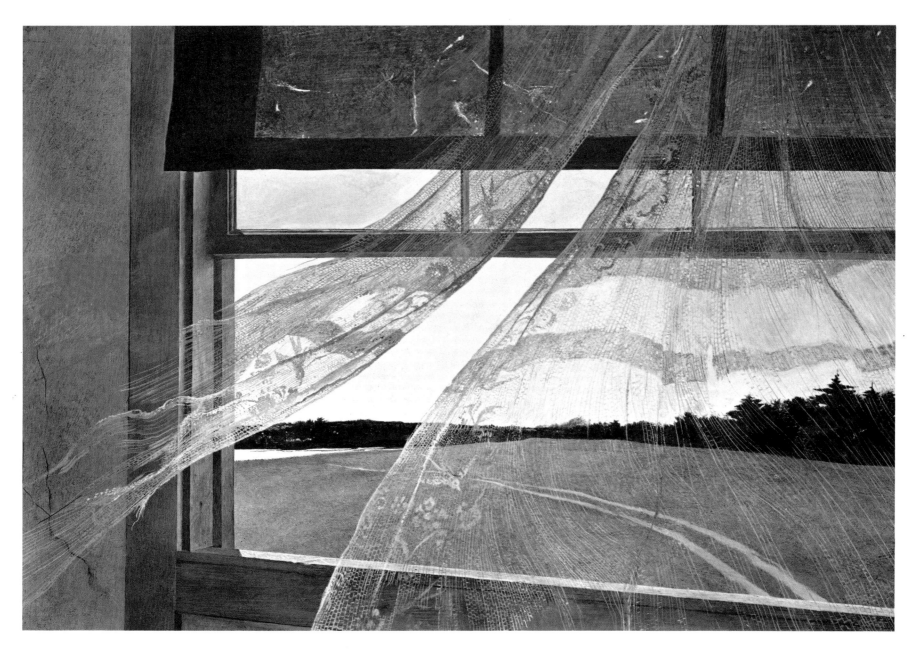

WIND FROM THE SEA 1947
Tempera, 19 x 28 in.
Private Collection

IV

"He was a great teacher because he made you feel (and really feel) things in your own way. He gave you a curiosity about the quality and character of an object. He'd set up a still life with some fabric in it, and he'd say: 'Now that material will never fall that way again. That's a very important thing— as important as the Battle of Waterloo.'"[33]

Wyeth began as a painter under the aegis of his father. He began work in the studio as a young teenager, having already been the family whiz as a childhood doodler and draughtsman. In the studio he began a more rigorous and regular term of study, often alongside the young men N. C. occasionally took on as students. Philosophically opposed to the teaching of painting rules or formulae, N. C.'s instruction stressed identification with the model, what might be called "method painting." He firmly believed, like those exponents of method acting, "that a man can only paint that which he knows even more than intimately, he has got to know it spiritually. And to do that he has got to live around it, in it and be a *part* of it."[34]

N. C. urged his students to give themselves up so much to the experiencing of what they paint that they practically become the person or thing itself. Andrew recalls his saying, "If you paint a man leaning over, your own back must ache." Further, Andrew continued, "He taught me to feel the cheekbones and eye sockets." Thus, even today Andrew will often run his hands over a model's head, get up so close he can feel a man's breath, or, as he did with Christina, comb her hair and feel "the drops of sweat on her neck and brow."[35] He is so open and absorptive that during an intense period of painting someone he often begins to talk and act like that person, a truly extraordinary suppression of self. This desire to eradicate his own presence in a painting relationship, and to become a "keyhole," as he puts it, underlies his remark: "I wish I could paint without me existing—that just my hands were there."[36]

Vicarious involvement was not all that N. C. stressed. He placed a great deal of emphasis on the fundamentals of drawing and painting, things that were to be learned before one moved on to individual interpretation. Very much the classicist in his attitudes toward an artist's education, he would set up plaster casts, still lifes, and landscape exercises to train the eye and the hand. Beginners worked in charcoal and the more advanced painted in oils. He inculcated a pride in craftsmanship, a sense of some of the longstanding traditions in art history, as well as encouraging the development of an individual expression.

N. C.'s emphasis on good training was perhaps in compensation for what he felt were his own artistic limitations. Although well trained under Howard Pyle, he had consistently followed the career of an illustrator, something he often bitterly regretted despite his great success. He was left with too little time to do other kinds of painting, to create the kind of works he so enjoyed, based on his observations and deep feelings for country life. This to him was the true calling of an "artist"—not the rendering of romantic and imaginary heroes to amplify a text. Illustration, he complained, placed too many restrictions on the creative process. It was commercial, dependent on deadlines, and "built up on superficial technique, pet receipts of effect and *everything* that's artificial, besides always containing a literary meaning and expressing some melodramatic incident."[37]

Despite the fact that N. C. never could find the extra time or make the real commitment to becoming a "fine" artist, he did produce a large number of independent paintings other than those intended for illustrations. He also expounded strong opinions about contemporary painting, thereby creating within his family circle a very art-conscious milieu. It was through him that Andrew was introduced to some of the commonly held American ideas about art discussed earlier in this essay. N. C. firmly believed that great American art would come only from artists who entrenched themselves against the fashionable styles of the moment and painted instead out of a profound identification with their own land and people. He was disdainful of artists who moved to the cities to be part of an "art scene" or who traveled abroad rather than steeping themselves in their own locale.

Andrew Wyeth in his studio, 1932.

GRASSES 1941
Drybrush drawing for *Winter Fields*, 17 x 21 ½ in.
Margaret I. Handy
(Finished painting on page 141.)

Thus N. C. admired painters like Dürer, Rembrandt, and Winslow Homer who "consistently hit through the commonplaces of familiar scenes and lifted them into extraordinary experience—emotional and intellectual."[38] N. C. felt deeply endowed with the same kind of passion and insight that motivated these earlier artists, and his frustration was his lack of the training and tools to express it.

These same painters provided some of the first inspirations for Andrew's early work, Winslow Homer being reflected in his early watercolors [pages 80, 81] and Dürer in some of the fine and detailed draughtsmanship of his early drawings and paintings [opposite]. The young painter was also indebted to his father-teacher for some of his first basic artistic models, as we can see in the comparison below. These included, for example, the building of a pictorial space in from the edges, and the use of evocative shadows and dark places behind half-opened doors. Andrew once remarked that his father "worked toward something like angle shots in motion pictures. Much as a camera does, you zoom in on things."[39] Such a device used by N. C. gave drama to a storybook illustration; in Andrew's hands it would become a basic exploratory tool for the study of nature.

N. C. Wyeth, *The Seige of the Round-House*
Illustration for *Kidnapped* by Robert Louis Stevenson
Charles Scribner's Sons, 1913
Oil on canvas, 40 x 32 in.
Mrs. Russell G. Colt
(Photo courtesy of Brandywine River Museum)

HENRY TEEL 1945
Tempera, 22 x 34 1/4 in.
Mr. and Mrs. Paul Geier

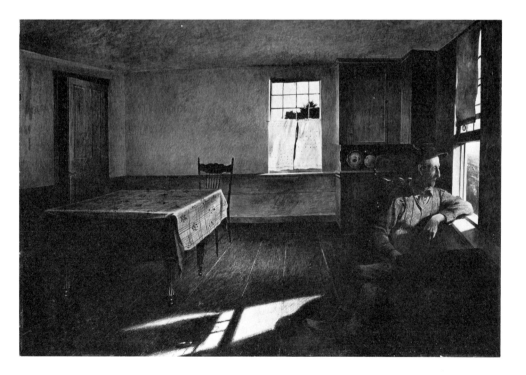

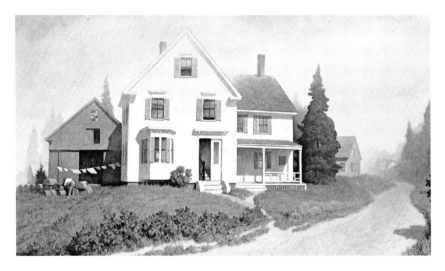

N. C. Wyeth, *Mrs. Cushman's House* 1942
Tempera, 21 x 36½ in.
The New Britain Museum of American Art
Harriet Russell Stanley Fund
(Photo: E. Irving Blomstrann)

But what is clear about the younger Wyeth is that, despite his development within the shadow of an enormously imposing and influential father, he very early distinguished himself both as a personality and as a painter. Much more introverted and understated than the gregarious N. C., Andrew early set his own work habits, sought out private places to walk and paint, and began to invent and enjoy, as he still does today, a rich and largely unshared secretive life.

His first public successes came with the watercolors he exhibited from 1937 onward: the first of these exhibitions, held when the artist was only twenty years old, sold out within a day.[40] He seems, however, to date himself as a serious artist from the beginning of his use of tempera, a much more exacting medium, which he adopted in the late 1930's as a kind of antidote to the loose and facile command he felt with watercolor. He found it to be a welcome means of submerging the flashy part of his craft, a brake, as he put it "on my real nature —messiness."[41] Andrew, basically concerned with using technique to hide himself, has always been leery of expressionism, "messiness," whether it be that of his own watercolors, the oil technique of an artist like John Singer Sargent, or the expansive gestures of the Abstract Expressionists. Tempera appealed to him in its dryness of surface, spectral quality of color, and suitability for recreating his subject in miniature, small-brush detail. The temperas of this period—the early 1940's—represent his first major period as an artist.

N. C. Wyeth also took up tempera painting. Both he and Andrew were introduced to the medium contemporaneously through Peter Hurd, an artist who had trained in N. C.'s studio and who later became a member of the family when he married Andrew's sister, Henriette.[42] It is symptomatic of the differences between father and son, however, that for N. C., unlike Andrew, tempera never basically affected his approach, for he employed it much in the fashion of oil paint, frequently combining the two media in a single work. To be sure, both artists shared basic aims and were often attracted to similar kinds of subject matter, whether that of the local landscape or more sobering events such as death and loss. But although they worked together in the same medium, and "believed absolutely the same things," they went about it, Andrew has said, "in a different way."[43]

Both men were concerned with creating paintings which caused the spectator to vicariously experience the artist's own feelings for the things he painted. N. C.'s methods of triggering the viewer's emotions were almost always tied to strong literary devices. As an illustrator he had told stories through pictures all his life, and it was exceedingly difficult to overcome what had become in fact a habitual way of thinking about pictorial communication. In *Mrs. Cushman's House* [opposite], for instance, to reinforce the mood of fog and mystery, he intentionally painted the door to the house open as if it were "leading into the unknown."[44] In *Island Funeral* [page 108] or *Nightfall* [right] he painted narrative scenes of death, scenes he had witnessed and which had so moved him that he felt challenged to convey their sadness and poignancy. In *Nightfall*, he was well acquainted with the farmer who, in the painting as in life, stood watch with his daughter while his wife lay dying in the room with the lighted windows of the farmhouse below. The artist spells out the mood of the picture in the many details: the farm buildings mysteriously glowing in the murky shadows, the drawn, tense face of the farmer and the averted one of the girl, and the thorny bramble bush and dark open door of the barn.

Andrew, more flexible than his father and without the habits of age, was never as predisposed to literary description and metaphor. Only a few times in his early years did he try to portray a very specific action. In *Night Hauling* [right], for instance, he chose a deliberately dramatic moment: the poaching of lobster pots in the dead of the night. While akin to his father's *Nightfall* in its nocturnal lighting and averted face, the composition is more ambitious, an attempt to rid the action of all diverting detail and to let the main action speak for itself.

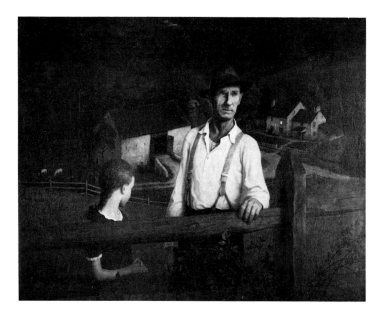

N. C. Wyeth, *Nightfall* 1945
Oil on canvas, 31 x 39 in.
Mr. Robert F. Woolworth
(Photo courtesy of Brandywine River Museum)

NIGHT HAULING 1944
Tempera, 13 x 37¼ in.
Mr. and Mrs. Burwell B. Smith

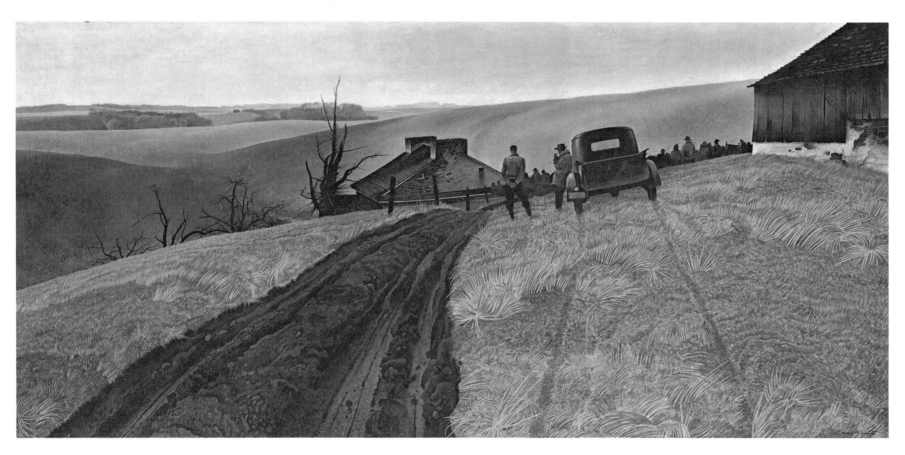

PUBLIC SALE 1943
Tempera, 22 x 48 in.
Mrs. Henry W. Breyer, Jr.

More often in these years, Andrew grappled with the problem of conveying drama and emotion without resorting to any specific scenario. In *Public Sale* [above] he paints, as his father did two years later in *Nightfall*, an occasion that had deeply moved him: a farmer forced to sell all his possessions and goods after the death of his wife. In the younger Wyeth's picture, the mood is conveyed less by an attempt to describe the scene than by using expressive pictorial elements that suggest its sadness: the bleakness of the gray sky and barren land, the lifeless, craggy trees, the parched colors of the hills, and the plunging dirt road which, as in a late Van Gogh landscape, uncomfortably pulls the eye inward and then suddenly disappears.

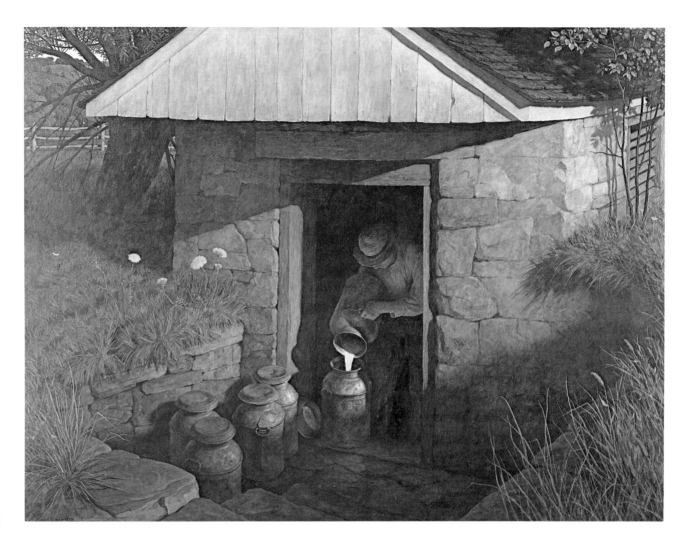

N. C. Wyeth, *Springhouse* 1944
Tempera, 36 x 48 in.
Delaware Art Museum, Wilmington

That Andrew was more pictorially adventuresome than his father suggests not a conflict, but rather a difference in outlook, one as much of generation as of talent. N. C.'s genre paintings are really pictorially more at home with Grant Wood's and Thomas Benton's paintings of these same years. In them people tend to be generalized into country types, and the scenes themselves are more regionally evocative than they are descriptive of a particular place and object. Even N. C.'s more explicit stylistic borrowings from respected painters of the past are suggestive of a regionalist attitude. *Springhouse* [above], for example, a painting strong in natural colors and based on a scene in N. C.'s own yard, brings to mind a number of associations with his favorite painters: the crisp definition of grasses suggests Dürer; the crosslighting, Rembrandt; and the bowed head and generalized features of the farmer, Winslow Homer.

MILK CANS 1961
Dry brush, 13 1/4 x 20 3/4 in.
Private Collection

DIL HUEY FARM 1941
Tempera, 22 x 40 in.
Private Collection

To Andrew, however, *Springhouse*, while well painted and free from anecdote, must have seemed somewhat cluttered and unfocused. The spiky tree in the background of N. C.'s work was alone a sufficient motif for the younger artist, as were the milk cans at a later date [opposite]. Andrew's eye and hand was a highly selective one, drastically minimizing the number of compositional elements in any one painting. Furthermore, he ignored local colors and was more inventive in his spatial constructions. In these early years the trees around Chadds

Ford, particularly the beech and buttonwood trees, were a constant source of interest. From all angles they were studied and worked at: he stood back in *Dil Huey Farm*, got up close to them in *Spring Beauty* [page 136], looked down on them like a bird in *The Hunter* [page 137], or painted them from midstream in *Spring Freshet* [page 139]. This last effort was especially arduous, his father marveling that for two weeks "Andy has been perched on a tall stool in the middle of the stream."

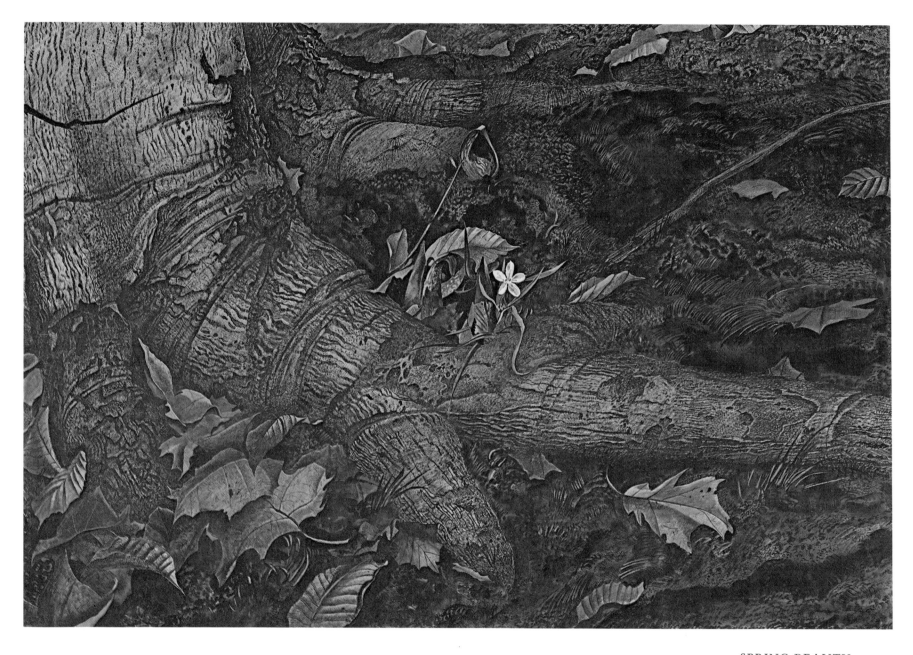

SPRING BEAUTY 1943
Dry brush and ink, 20 x 30 in.
University of Nebraska, Lincoln
The F. M. Hall Collection

THE HUNTER 1943
Tempera, 33 x 34 in.
The Toledo Museum of Art
Gift of Elizabeth C. Mau

The Saturday Evening Post cover by Andrew Wyeth, October 16, 1943.

One of Andrew Wyeth's illustrations for *The Brandywine* by Henry Seidel Canby, 1941, published by Farrar & Rinehart.

In these years of finding his way, illustration was always a possible alternative for Andrew: he had been only twelve years old when some of his ink drawings were first published as illustrations. During the war he created a poster for the Allied cause and accepted several book commissions to help make ends meet in what were generally hard times financially. In 1943 *The Hunter*, for instance, was used as a cover for *The Saturday Evening Post* [above], while another of his favored buttonwood trees appeared in one of the several illustrations he created for a book on the Brandywine River [above].[45]

Illustration might have become a career for the younger Wyeth, but when a tempting offer of a continuing contract with *The Saturday Evening Post* came along in 1943, he turned it down. From his father he knew the tension of a career torn between the two arts, and from his young wife, Betsy, whom he married in 1940, he received the encouragement to succeed as an artist. She was adamantly against his committing any of his energies to illustration.

Her inclination was a wise one, as the artist was already evolving those stylistic elements which would later soften and come to mark

his mature temperas. *Spring Freshet* [below] shows some of these new directions, particularly if compared with *Dil Huey Farm* [page 135], done just the year before. In the earlier panel the artist takes a landscape view, using the tree and its branches as a foil to the ordered country landscape. In *Spring Freshet* the artist boldly abstracts the trunk of a similar tree hovering over the rushing water; he moves in closely, magnifying the natural dimensions of the bark markings and leaves, sharply focusing the details, and foreshortening the space between the tree and the water. Here Wyeth begins to discover a principle of lasting value: if a detail of nature is microscopically described and its proportions subtly altered, a kind of eerie energy is generated. Isolated fragments of nature become magical "presences" and, as one critic put it, the "ordinary strikes us, if only momentarily perhaps, slightly extraordinary."[46]

Georgia O'Keeffe. *Pattern of Leaves*
Oil on canvas, 22 x 18 in. 1924
The Phillips Collection
Washington, D.C.

SPRING FRESHET 1942
Tempera, 31 x 22 in.
Mrs. Paul Codman Cabot, Jr.

Edward Weston. *Cypress, Point Lobos* 1930
(Photo courtesy of Cole Weston)

Edward Weston. *Pelican* 1942
(Photo courtesy of Cole Weston)

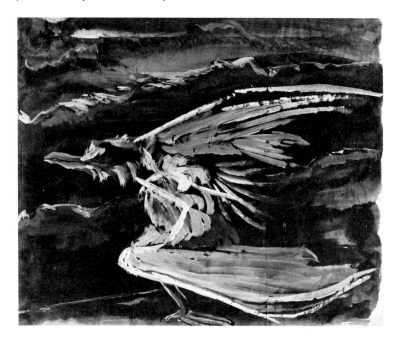

Morris Graves. *Wounded Gull* 1943
Gouache on rice paper, 23 x 28 in.
The Phillips Collection, Washington, D.C.

This kind of intensification to awaken wonder before the majesty of nature was one of the hallmarks of painting in the 1930's and 40's. Wyeth, despite his relative isolation, shares this with other American artists. It is what Georgia O'Keeffe was after when she said that she blew up flowers in her painting in order to make busy New Yorkers stop and look at them, or what the photographer Edward Weston expressed as an ideal in a 1930 diary entry: "I want the *greater mystery of things revealed more clearly than the eyes see*, at least more than the layman, the casual observer notes. I would have a microscope, shall have one some day."[47]

If Wyeth's paintings in the 1940's are more disquieting than the nature studies of O'Keeffe and Weston of the previous decade, it indicates the shifting emphasis found in paintings in the 1940's. The art of this war-scarred decade was far more sober and agitated than that of the outward-looking, socially conscious 1930's. Common to the art of the period are scenes of death, caskets, mourning figures, and tortures. Death and decay, a major motif in Wyeth's mature art begins to appear in these years in both explicit and symbolic forms: dead birds, dried leaves and cornstalks, abandoned and ruined buildings, themes similar to those taken up by Morris Graves, Edward Weston

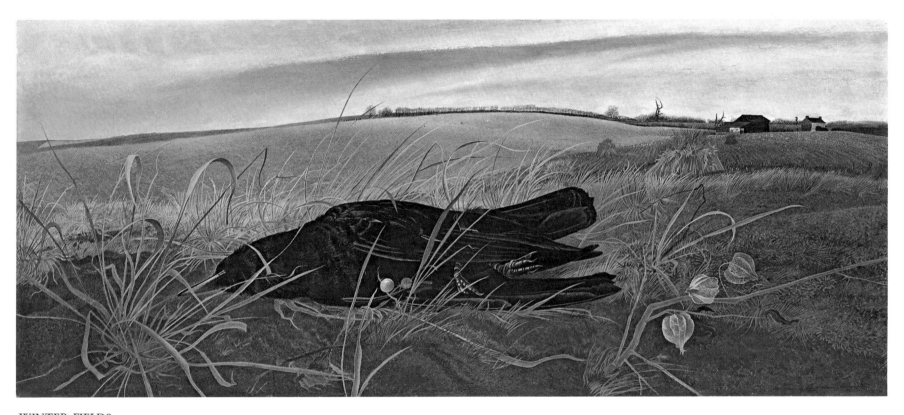

WINTER FIELDS 1942
Tempera, 17³/₈ x 41 in.,
Mr. and Mrs. Benno C. Schmidt

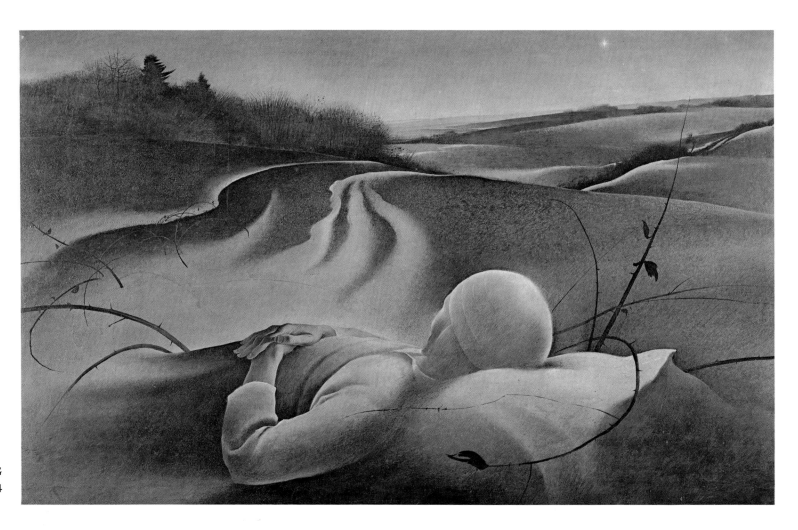

CHRISTMAS MORNING
Tempera, 23¾ x 38¾ in. 1944
The Richard Hamilton Family

or Ivan Albright. In *Christmas Morning* [above], he painted actual death, that of a close friend's mother who had died on Christmas morning and lay in state in the family dwelling, swaddled as one sees her in the painting. In the artist's memorial to her, his first attempt to paint his response to human death, the figure becomes one with the flowing Pennsylvania hills she had so loved, while a single star, like that of Bethlehem, glows in the sky above.

If surrealism immediately comes to mind in *Christmas Morning*,[48]

with its infinite dream space and strangely situated, anonymous figure, it is also recalled by the super-crisp realism and haunted house atmosphere of the anxious self-portrait, *The Revenant* [opposite], and by the Magritte-like window in *Seed Corn* [page 28]. But like the extreme magnification and close-up focus Wyeth used earlier in the decade, these works of the later 1940's represent but another form of brief experimentation: here his sure grasp of technique is used to create deliberate mood-provoking elements such as ghostly figures,

cracked walls, tattered shades, compressed box-like spaces, and eerie lighting. The disquiet and drama are generally overstated in these early pictures, the settings are still too elaborate and obvious, but they represent the artist's early search for his own way to express the Wyeth transcendental ideal: to evoke a sensation of the infinite within the context of the commonplace.[49]

The tension in these works is not only a response to the dark moodiness of a melancholy decade but also to the accidental death of his father in 1945, an event that so profoundly grieved him that even seventeen years later, in talking to a reporter about objects that bring back memories, he said: "A hump in the earth. Hell—a nice shape, but it reminds you of your father. Where he's buried."[50]

To come to grips with the death of the man who had been such a singularly important force in his life, Wyeth had but one way—through his painting. This had become his only real means of dealing with deep feelings and concerns. Thus the disorientation and bewilderment occasioned by his father's death could be metaphorically expressed in the young boy running uncontrollably down a hill in *Winter 1946* [page 59]; the bulges of the hill became so imbued with meaning for the artist that they "seem to be breathing—rising and falling—almost as if my father was underneath them."[51] The painting *Karl* [page 20], the artist once suggested, is an ambiguously stated, surrogate portrayal of his father, whom he never painted. The extremely popular *Christina's World* evolved as much from Wyeth's deepened sense of loss and aloneness as from any particular studies of Christina Olson.

This portrayal of persons and their actions or environments was new for Wyeth, and it signaled a considerable broadening of his expression. Finished was the youthful pleasure in the extravagant forms of trees or the exuberant dash of the early watercolors. With the loss of his father, the young artist experienced for the first time, in his twenty-eighth year, a grief that cleaved deeper than any before, the kind of bottomless emotion his father had always talked about and had taught him was the essential foundation for the making of great paintings. Now Wyeth knew why he had to paint and what he had to express. "For the first time in my life," he said, "I was painting with real reason to do it."[52]

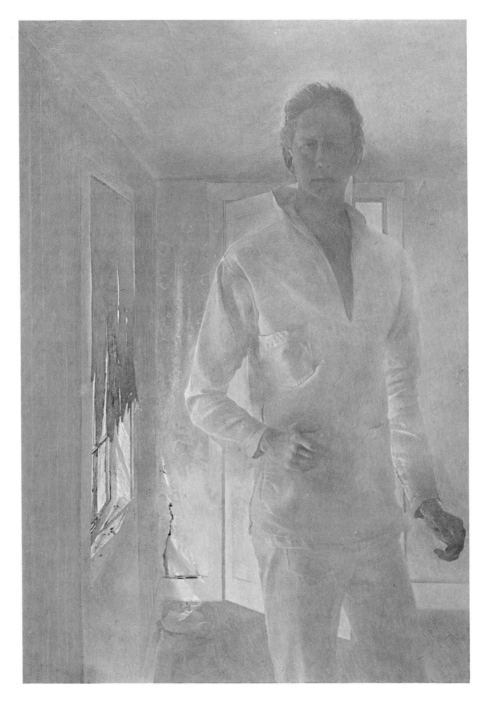

THE REVENANT 1949
Tempera, 30 x 20⅞ in.
The New Britain Museum of American Art
Harriet Russell Stanley Fund

143

V

"The way I feel about things is so much better than the way I've been able to paint them. The image I had in my head before I started is not quite—never quite—completely conveyed in paint."[53]

Andrew Wyeth's most memorable paintings of the 1940's came in 1947–48, just as he rounded the corner of his thirtieth year. A trio of paintings done in those years represents the high point of his early work: *Wind from the Sea*, *Karl*, and *Christina's World* [pages 125, 20, 39]. Still exhibiting the tense anxiousness and air of expectancy characteristic of earlier works, the pictures offer in addition the kind of simplification and resolution that comes when an artist hits upon both a subject matter and a style commensurate with his expressive ideals. These works introduce two of the families that were to become Wyeth's greatest fascinations, the Olsons and the Kuerners; and they further refine those elements of style that are his hallmark: the use of a dry and detailed realism, an economy of compositional elements, and the painting of scenes from unusual or unexpected vantage points. Moreover, in *Karl* and *Wind from the Sea*, Wyeth avoids the kind of obvious drama or symbolism that still lingers in *Christina's World*, where the woman seemingly strains or yearns for the mystery-shrouded house on the horizon. Now the artist transcends such literalism and discovers instead a pregnant moment or gesture for his sitters or landscapes—a gust of wind giving sudden life to the tattered curtains of an old window, or the cocking of Karl's head as he suddenly hears the movements of his mentally ill wife downstairs. It may be unnecessary and even distracting for us to know the reason for Karl's slightly turned head. Yet it was extremely important for the artist to find a revealing pose for the solid, ruddy-faced German farmer which could be counterpoised against the thrust of the menacing meat hooks and the cracked attic ceiling. For Wyeth, much of the picture's meaning comes through such a juxtaposition.

The discovery of a meaningful "moment" for a major picture becomes perhaps the most significant part of picture-making in Wyeth's mature style. It may be stimulated by the simplest experiences: seeing the light strike the side of a building or a person's face, inadvertently coming upon a child lost in his own thought, or meeting a face coming out of the darkness. It may happen on his prowling walks, or totally unexpectedly during an otherwise ordinary day, or while drawing, which he does almost daily as a kind of digital exercise. But whenever it happens, the artist feels an intuitive rightness about what he has seen, something akin to a revelation, as the potential of wider meaning dawns upon him. At such times his system becomes so alerted that his voice goes up in pitch, and he says he gets goose pimples or feels his hair standing up on the back of his neck. Sometimes he immediately begins to transform the magic moment into a major composition. At other times the idea may lie dormant for years before he feels ready to refine and develop it into a tempera. The genesis and happenstance of such moments are one of the few things the artist enjoys talking about in relationship to his work, suggesting the compelling importance they have in his own understanding of the artistic process.

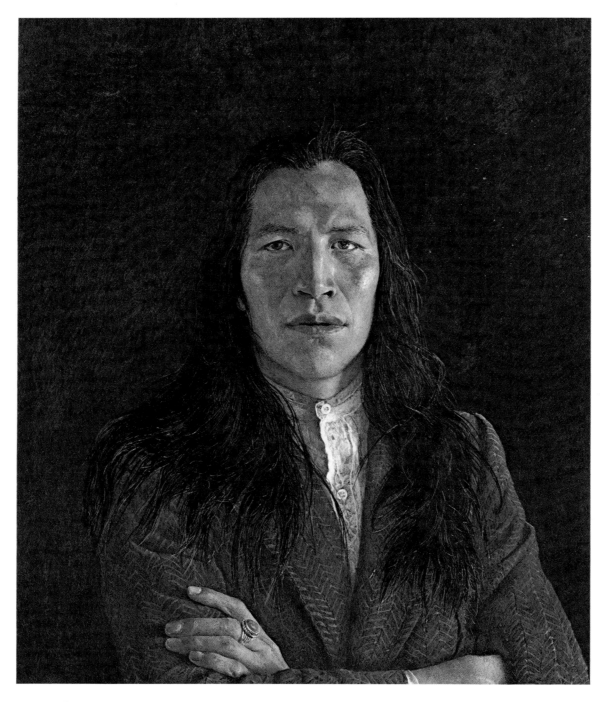

NOGEESHIK 1972
Tempera, 25 x 22½ in.
Private Collection

The charged and ominous atmosphere that characterizes Wyeth's early work begins to subside in the early 1950's. Landscapes such as the magnificent *Snow Flurries* [page 61] take on a new breadth and abstract simplicity. Human figures soften and draw into themselves, and the overt anxiousness seen in his self-portrait [page 143] gives way to a different kind of compassionate and empathic drama, one best understood by contrasting two of the temperas of Christina Olson, one painted in 1947 and the other in 1952. In the earlier picture, *Christina Olson* [page 34], a bony, angular figure is but one of the elements contributing to the overall mood, no more important than the histrionic beam of light raking across the weathered door. Five years later, in *Miss Olson* [page 35], the figure has become soft in her volumes and natural in her setting, her humanness now dominating the composition and establishing the tone of the entire work. Lost in herself and her tender affection for the kitten, she radiates warmth and dignity. We share the artist's devotion to her, and in her anonymity and self-reflection we sense our common humanity.

This new solemnity and personal reticence in Wyeth's art was in part a result of his own brush with illness and death in the winter of 1950–51. A lung disease made necessary a serious chest operation, one that came very close to taking his life and left him too weak to paint for several months. This personal crisis, simultaneously frightening and sensitizing, broadened Wyeth's artistic involvement with the preciousness of human life, its magnitudes and its frailities. In a symbolic way it marked the end of his conception of painting as a kind of self-conscious theater of cracked plaster, tattered window shades, and magnified leaves. The artist now sought to isolate and describe, and the exaggeration of his earlier years was left behind.

This new naturalness of pose and proportion does not mean that Wyeth was becoming a portraitist. On the contrary, he has never considered himself a reporter of likenesses, and for this reason rarely accepts a portrait commission. (The few commissioned portraits he has done do not represent his most interesting work.) His legend often makes him out to be the portraitist of the American common man. To his mind, nothing could be less true. He never paints people for their commonness, never paints a man he would call average. Those he paints sit by invitation, and with the possible exception of his family, represent Wyeth's profound and many-layered fascination with very particular kinds of people, faces, and situations. Some of those he paints are extensions of himself; some go deep into his past, reminding him of those now gone or of the romantic heroes known in his youth. Some he paints out of love and admiration, some out of hate or envy, and some for a shifting galaxy of reasons that may not be clear even to him.

Many of his models, like himself, do not travel far in their lifetimes: the hardy New Englanders of Maine, for instance, or the Negro families who have lived for generations around Chadds Ford. On one level he likes the country humor and manners of these people and is challenged by their hard core of reticence. On a more meaningful level, Wyeth admires their regional uniquenesses in today's increasingly homogenized world. Like his father, he is attracted to men and women who are still stalwartly independent and self-sufficient, and who need to rely little on the outside world for anything beyond the common amenities. Untraveled and without the knowledge that comes from books or wider acquaintances, they continually impress Wyeth with their innocence, their individuality, and their pragmatic wisdom. Henry Teel [page 129], Tom Clark [pages 50–53], Alexander Chandler [opposite], and Adam Johnson [pages 88–89] are like the Canadian woodchopper who used to visit with Thoreau at Walden Pond: a simple, natural man with an "exuberance of animal spirits" and "so genuine and unsophisticated that no introduction would serve to introduce him."[54] That so many of these people admit Wyeth into their company and intimacy attests to his Thoreau-like ability to be at ease with and to win the trust of people who generally have no more comprehension or appreciation of painting than the Canadian woodchopper had of Thoreau's writing.

Wyeth is also drawn to people who have roots sunk deep into the American experience, people who become for the artist living embodiments of this country's unique and mythical past. *The Finn* [page 103], a portrait of George Erickson, a Maine neighbor, is reflective of the determination and toughness of those Finnish immigrants who came here at the turn of the century to form their own solid farming community in Maine. The compellingly handsome face of Nogeeshik [page 145], an American Indian, becomes a vehicle for exploring the manly pride and stoicism tied to the very antiquity of this land. Often those whom Wyeth paints are loners, outsiders without roots or an established place within a larger society: Willard Snowden [pages 84, 148], for instance, who appeared unannounced looking for work, and who lived in Wyeth's studio a few years before disappearing again. Or the Lynch boys, one of whom has been described as trying "a little of everything—quarreling with the changes he cannot control, yearning for a different life, but not wanting to be tied down to any one thing" [page 149].[55] And then there are those like Karl Kuerner, whose ordered life, tidy farm, scrubbed walls, frothy apple cider, hanging dead deer, slaughtered pigs, and disturbed wife have become for Wyeth a microcosm of man's contradictions. Here he finds reason and its absence, purity and its antithesis, the enjoyment of life and its brutal extinction [pages 18–26].

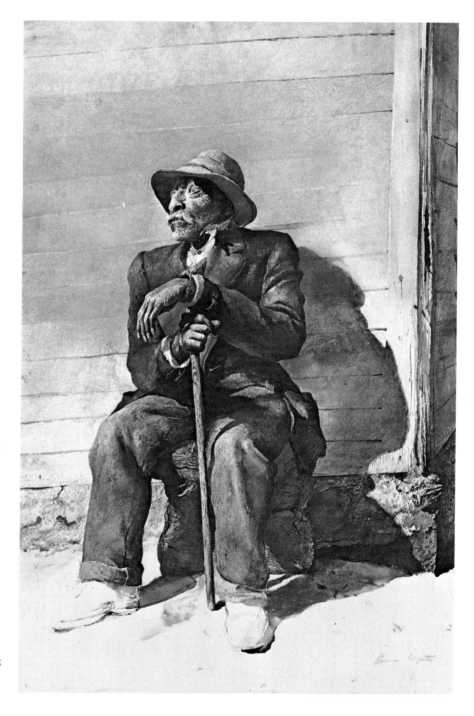

ALEXANDER CHANDLER 1955
Dry brush, 21¼ x 14½ in.
Mr. and Mrs. Robert Montgomery

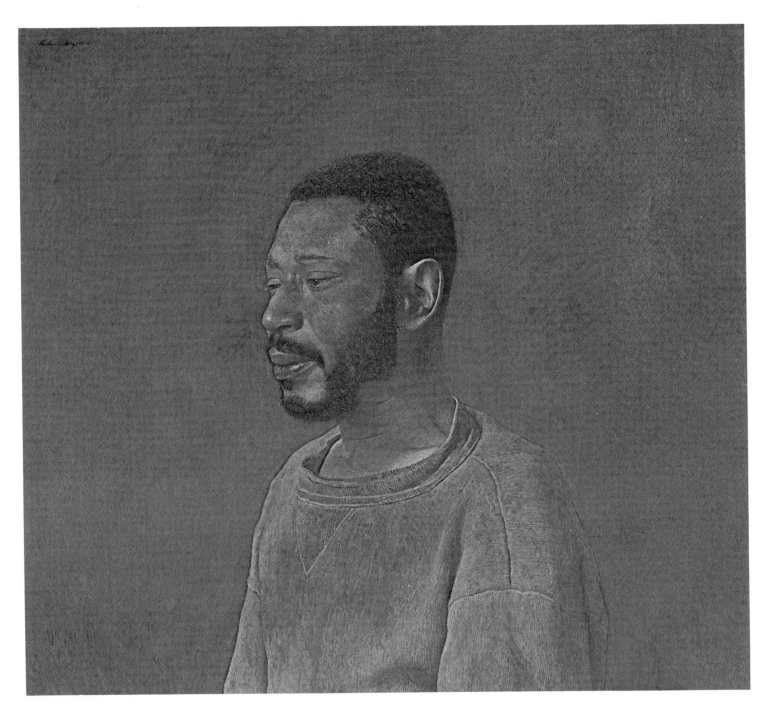

GRAPE WINE 1966
Tempera, 26 x 29 ½ in.
Amanda K. Berls and The Metropolitan Museum of Art, New York

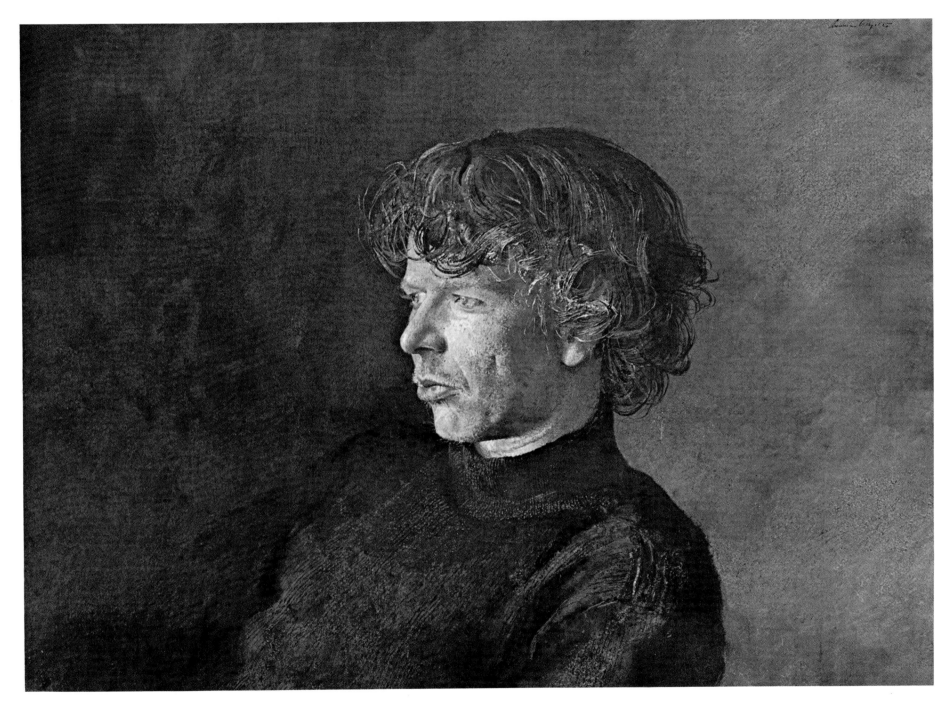

LYNCH 1970
Dry brush, 21 x 29 in.
Mr. and Mrs. John William Rollins

To draw such dramatic content from a not so extraordinary Pennsylvania farm suggests the symbolic nature of Wyeth's vision of the world. Only when a subject can become archetypal in the artist's mind is it interesting to him and a major work possible. Wyeth explains that by the time he had begun to paint *The Patriot* [page 44], the model, Ralph Cline, had become transformed in his imagination from a local sawmill operator into a soldier transcending time and place: he could have been one of the toy militiamen in Wyeth's collection, or an embattled farmer at Concord in 1775, or the "man who was killed in Serbia at the start of the [World] war. That could be his tunic Ralph has on."[56] As he works on minor elements in his compositions, associations well up in him and catalyze the creative process: Cline's bald head reminds him of the American bald eagle, the murky background of the painting is not just a color but "the thunder of the Meuse-Argonne—it's the dirt and mud he stood in in the trenches—it's the tobacco he chews, the smell of the wood in his sawmill."[57]

Similarly, in a portrait of his wife, *Maga's Daughter* [page 13], the artist's mind leapt backward through the generations. The painting became a declaration of love not only for his wife, but posthumously for her mother, Maga. The Quaker hat, a relic from the past, in its unadorned simplicity and platter-thinness became the quintessential headdress, its luminous ties becoming "all the ribbons that women ever wore."[58] Such fluidity of association, and blurring of past and present, can be easily imagined in the painting of Nogeeshik [page 145]. Here the artist would have dredged up the countless Indian tales he knew as a child, the arrowheads he had found, and the Indians he came to know in his father's illustrations. Looking us straight in the eye, Nogeeshik's challenging and awe-producing gaze is that of a modern-day Uncas, the handsome and intrepid hero in *The Last of the Mohicans*.

When painting people, Wyeth often seems at pains to describe the particulars and individual features of the person in front of him. He is freer and less tied to such physical fact in his approach to non-figural works where the general feelings and memories that well up in him as he works are more clearly expressed. When he paints the hills around Chadds Ford, their humps and swellings prompt rich and complex memories of his father, and his work becomes imbued with sadness, loss, and grandeur. Likewise, the sense of imminent drama one feels pervading *Her Room* [frontispiece] reflects what initially sparked the picture: his fear for one of his sons who was out on the water during a squall. He worried not only for his son, but was reminded of the sea calamities of history and fiction, those that befell his childhood heroes or generations of New England fishermen. As he worked on this picture, the chest in the room metamorphosed into a casket and the white bleached sea shells became the bleached bones of death. Death to Wyeth, is, like Moby Dick, pure white: the white of New England churches, gravestones, seashells and snow.

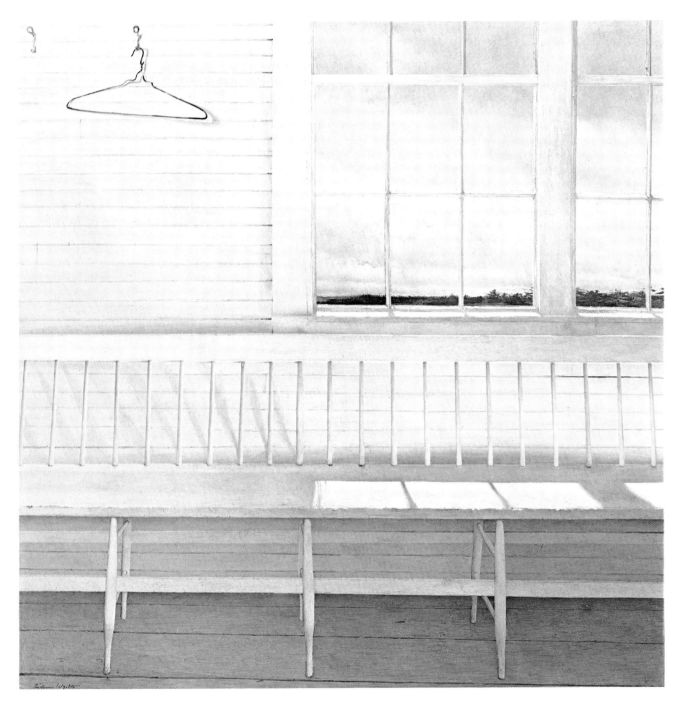

OFF AT SEA 1972
Tempera, 37 x 37 in.
Coe Kerr Gallery Inc.

The philosophical principle that a painting should be suffused with the artist's own wealth of memories and attached meanings was learned, of course, in N. C. Wyeth's studio. This passionate aim is still the essence of Andrew Wyeth's approach: "I'm a mental case when it comes to painting . . . because I have this idea, *want* it out and can't get it."[59] One of Wyeth's supreme disappointments is that many people see only the thing, or the realism of his paintings, and admire his work because they see "every blade of grass"[60] rather than feel the emotional overtones that were to him so much of the making of the work. The supreme compliment for him is not that one of his paintings nostalgically reminds a viewer of old houses or people he has known, but that it takes him back to his own private fantasies as a child; to his own memories of what it once felt like to discover, for instance, an arrowhead in the sand or an unexpected spring flower; to his own first intimations of life's loneliness, or of death, fear, and violence as a human condition.

Not that Wyeth ever directs one literally to particular memories or overtly reveals his own associations. In fact he rarely lets us glimpse the multitude of private associations any single painting holds for him, letting them simply suffuse a picture with a general flavor. Like Picasso, he has created a veritable private iconography, hard to penetrate and impossible fully to comprehend. We sense that *Spring Fed* [opposite], a typical barnyard scene, is haunted by stillness, bleached colors, and an atmospheric vacuum, but we will never know the far more complex associations and memories at play in the artist's mind. Wyeth's sister, Carolyn, however, gives us a partial clue when she interprets the picture with the particular Wyeth nuance. "It's absolute finality. That's it. That trough is like a casket. Those shadows are warm, and yet they're cold, a cold cement look. It's unrelenting. He just lets you look a little at the beautiful landscape. Don't be too contented. That damn pail up there is like a helmet, the way it shines. There's the Germanic—you know, Karl Kuerner making everything utilitarian—and that's the way a casket is to me, utilitarian."[61]

Sometimes the titles to Wyeth's works give clues to the artist's involvement with a painting. Oblique and elusive, they are given careful consideration by the artist and his wife. *End of Olsons* [page 43], Wyeth's last tempera dealing with that family, signifies not just the end of the roof top he painted but also the end of his generation-long association with Christina and Alvaro, both of whom had recently died. He would never paint them or their dwelling again. Another obscure title, *Far from Needham* [page 105], becomes meaningful when one knows that Wyeth's father often talked about the pine trees of his family home in Needham, Massachusetts. One such tree appears in the painting, done in Maine. When Andrew painted this picture, his wife Betsy was editing N. C.'s letters for publication and had created the title "Far from Needham" for one of the book's chapter headings. One suspects that Wyeth's memories of his father had been newly rekindled, and in coming across a field one day the rock in his path suddenly became his father's grave marker, a "hump in the earth," a swelling like the hills of Chadds Ford, a shape reminiscent of the remembered man himself.

One begins to sense, then, that part of the indefinable drama and tension in a Wyeth work comes from this very subjectivity, from the artist's cloaking his private feelings and associations in what appear to be innocent paintings of the obvious and commonplace. Most viewers detect this subjective quality but are generally content to define it as "poetic charm," nostalgia, loneliness, or an uncommon sympathy for plain folks and their artifacts or surroundings. To observe this of Wyeth's work—and its constant reiteration amply fuels the Wyeth myth—is not an error, but it fails to recognize the truly significant side of his talent, for in the best of his paintings one is not so much moved by the simple remembrance of times gone by as by a kind of brooding, haunting quality which is infinitely more sober and private than the feelings involved in ordinary nostalgia.

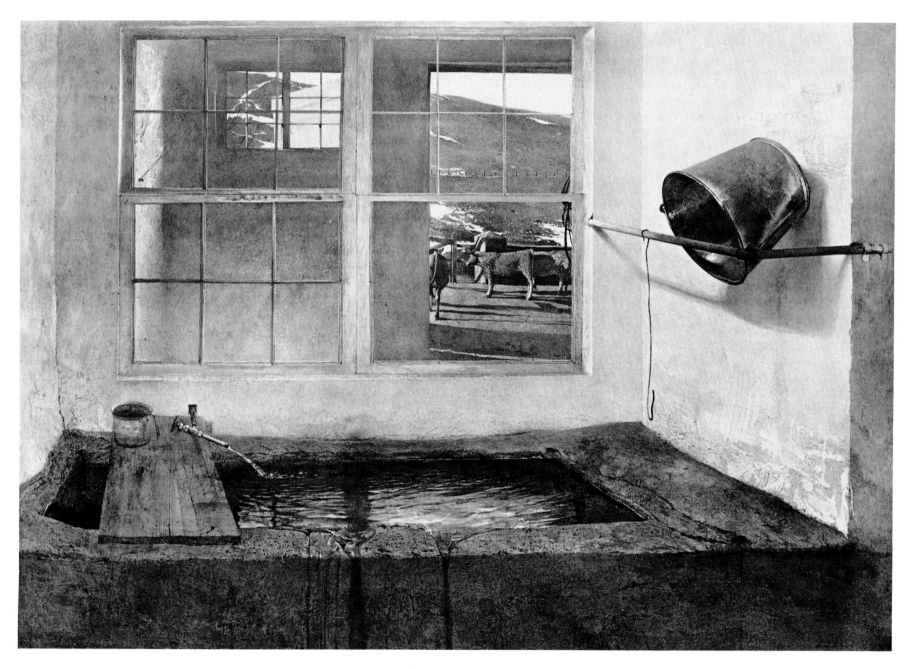

SPRING FED 1967
Tempera, 27⅝ x 39⅜ in.
Private Collection

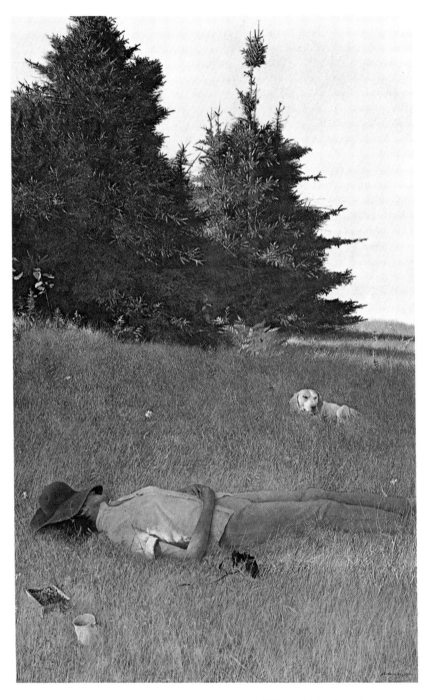

DISTANT THUNDER 1961
Tempera, 48 x 30 in.
Mrs. Norman B. Woolworth

This interior quality, akin to Wyeth's own creative states in which time and self-awareness are suspended, is communicated through several obvious traits in Wyeth's paintings. Some of these, such as his sober and brittle tempera colors, and his spatial and compositional devices, have already been discussed. Another is the curious dimension of people and things in his works. Things are so often small, reminiscent of a Lilliputian fantasy or of the artist's toy soldier collection, rather than being icons of the real, full-sized world. Furthermore, in Wyeth's world there is little trace of atmosphere or tangible, living movement. There are no clouds, no momentary gestures; air seems to have been sucked out of his paintings, leaving everything stilled, entombed in empty spaces. Time stops as his paintings make permanent what we know by experience to be transitory. Paths and tracks in the snow or sand, or birds in flight become as fixed and static as ancient hieroglyphs; a sunbeam's playfulness on a wall, a patch of snow in the sun, or a fleeting flush of anger on his wife's cheeks are made timeless and unchanging.

We are also driven inward through Wyeth's imagery, which unconsciously touches those things at the font of dream and memory. Often we simply identify ourselves with the people in his paintings who have already escaped to their own private worlds—of thought, sleep, or concentration [opposite]. Other images are commonly shared metaphysical metaphors, suggesting the enigma of existence: the transparent panes of glass in windows, the spherical globe of a lightening rod [right], the fluidity and translucency of water, empty objects or landscapes, and the voids that engulf all his sitters. In many compositions, the artist allows only a half glimpse through a window, through rooms, or into the dark places behind a half-closed door, thereby tantalizing the viewer with suggestions of the unknowable.

NORTHERN POINT 1950
Tempera, 36 x 18¼ in.
Wadsworth Atheneum, Hartford
Ella Gallup Sumner and Mary Catlin Sumner Collection

155

Wyeth is also attracted to things that for all of us signify time and its passage, or in the wider metaphysical sense, the transitory nature of things. Metaphors of time-gone-by appear in the cracks in walls, peeling wallpaper, well-worn clothes, battered pails and baskets, and abandoned carts and wagons. His paintings unnaturally distort the seasons, avoiding summer and spring in favor of winter and fall "when you feel the bone structures in the landscape—the loneliness of it—the dead feeling."[62] Perhaps he believes nature is more honest then, that the foliage of spring and summer cloaks too luxuriantly the inevitable sequence of decay and death.

There is yet more to Wyeth's gothic propensity. Again and again he takes us with him into dark chambers, cellars, attics, springhouses, sawmills, chicken coops, and barns where he paints. Never will he pamper our tactile senses with softness and fluff. Rather we are assaulted constantly with the shiny coldness of cement walls, brass buttons, metal pails, and ceramic crockery; the knobby waxed surfaces of apples and pumpkins; and the scratchy fibrous roughness of wool, canvas, burlap, fur, log-ends, barbed wire, and bushel baskets. His pictures make us tense as we continually come across things hanging: ropes, hooks, harnesses, hangers, clothes, and dead deer. Rafters or ropes uncomfortably stretch themselves across paintings, and we often feel menaced by the tools that appear alongside his sitters: their chains, scythes, peaveys, guns, and scissors.

TOLL ROPE 1951
Tempera, 29 x 11 1/4 in.
Mr. and Mrs. William A. Worth

These continuities in Wyeth's work are subtle and demand careful attention to all of his work before they really become apparent. Almost all of his paintings, in fact, fit into one or another of a thematic series, something rarely remarked upon or understood about his work. Like many novelists, the artist comes back time and again to interpret the same person, scene, or idea, giving us a body of work that offers insights in the aggregate that are less easily discerned in a solitary work. Obvious are those "chapters" dealing with the Olsons, the Kuerners, the Hill, or the theme of death and decay. If we look at the Olson paintings, for instance, we begin to clearly perceive two different personalities, Alvaro and Christina. Although the artist painted Alvaro's face only once in the early years, he constantly explored his dark features and the weathered, beaten-down character of the man who gave up the sea to care for his invalid father and then his sister. When Wyeth paints things outside the Olson house, and the dark places of the shed and barn, he is really painting Alvaro. The paintings of the inside of the house, with its sun-filled kitchen windows, red geraniums and blue kitchen door, pertain to Alvaro's crippled sister Christina, who in her pride and self-sufficiency was at once to Wyeth a New England Madonna, Queen, and Witch—and he painted her as all three [pages 34 – 39].

THE PANTRY 1969
Watercolor, 30½ x 22½ in.
Mr. and Mrs. Edward B. McLaughlin

THE ART OF ANDREW WYETH 157

Wyeth, then, works by indirection and innuendo, becoming as elusive in his art as he is in life. He makes it look as though he is never selective, never interested in one theme over another, never going beyond the power of description. But this is the sign of a good actor, which Wyeth, the lover of costumes and Halloween, basically is. He was delighted recently to read an article on Marlon Brando in which the actor said: "If you want something from an audience, you give blood to their fantasies."[63] Wyeth totally agrees.

The ability of many of Wyeth's paintings to give blood to our fantasies—to touch us psychically—suggests some final thoughts about those strange qualities that hover above the surface of his paintings. They are qualities akin to those found throughout nineteenth-century American literature, with which Wyeth has been familiar since childhood. D. H. Lawrence brilliantly defined these in his *Studies in Classic American Literature*. "Americans," Lawrence argued, "refuse everything explicit and always put up a sort of double meaning. They revel in subterfuge."[64] While realistic and storytelling on the surface, Lawrence continued, American expression has a nether world of darker meaning. "You *must* look through the surface of American art, and see the inner diabolism of symbolic meaning. Otherwise it is all mere childishness."[65] Following Lawrence's lead, the contemporary critic Leslie Fiedler finds in the tradition of American realism "a system of signs to be deciphered." Do this, he says, and one discovers "a gothic fiction, non-realistic and negative, sadist and melodramatic—a literature of darkness and the grotesque in a land of light and affirmation."[66]

Wyeth's art requires similar decoding to reach beyond its misleading and beguiling façade. Like *The Adventures of Huckleberry Finn* or *Moby Dick*, his paintings have that "clean and harmless" look, a sense of innocence, as if they are as much for children as for adults. And yet when we really allow ourselves to enter the world of a painting like *Weather Side* [opposite], we feel like intruders, as if we ought to be spirits rather than physical presences. Everything seems frozen, stilled, purified of any recent human contact. The steely-gray light is not "real" like the warm yellow light of naturalist artists. Wyeth's light is airless and foreboding, a "sign" for light rather than a transcription of it. Shadows, dark holes behind windows and doors, the glint of metal, the suspicious luminescence of his grays and whites, the strict geometry of the roof lines, are all too pure to be real. The pervading tonalities of gray begin to make one uneasy in the same way as do the dominant whites in *Moby Dick* or the darkness of Nathaniel Hawthorne's forests.

Hawthorne, in fact, provides the most interesting comparison to Wyeth. The Olson House in Cushing, Maine, built by a Hawthorne relation, ironically,[67] is a spiritual descendant of Hawthorne's House of the Seven Gables in Salem, Massachusetts [page 27]. Each is a New England house by the water, each filled with dark nooks and crannies and generations of history. Each is a house whose occupants and furnishings have been minutely described by the artist, and each has been used as a metaphor for the weight and romance of the past. Like Hawthorne, Wyeth saw both light and darkness, purity and evil, in the Olson House. He felt the heritage of former occupants, sensed witches still lurking, and likened the dark and unused rooms to the deep recesses of the human mind. Christina Olson might have been Hepzibah Pyncheon; Alvaro could have been her brother Clifford.

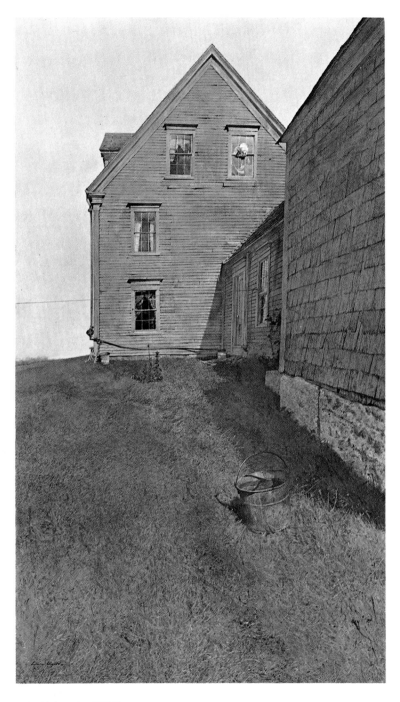

WEATHER SIDE 1965
Tempera, 48 x 27¾ in.
Mr. and Mrs. Alexander M. Laughlin

Like Hawthorne writing of Salem, or Melville of New Bedford whalers, or Thoreau of Walden Pond, Wyeth shapes the narrowest range of experience into his private psychological universe. One can ask why he doesn't use more contemporary images: mirrors instead of windows, machines instead of metal buckets, war instead of the guns of his farmer neighbors. But this is ultimately what makes Wyeth so elusive and fascinating. His intense attachment to place, his inability to transform things not laden with personal and private meaning, have set his creative limits, and he has had the courage and self-awareness to recognize them. Wyeth is precisely the complex, rooted, highly individualized person he likes to paint. This does not mean he is an "innocent." (Were Hawthorne, Thoreau, and Robert Frost "innocents"?) Although Wyeth carefully guards a childlike openness to experience, his memory bank is that of an aged man. He lives, of course, in the caverns of that storehouse, and painting is his only real intercourse with the world. He is deadly serious when he says that painting is the only thing he knows how to do.

Enormously self-critical, he has often expressed the difficulty of making his technique, despite his extraordinary command of it, say what he wants it to. Like an actor or novelist, he knows that method cannot become too obvious or too glittering, lest no one listens to what is being said. He also knows that sometimes too much subject can stunt a painting and get in the way of what one wants to say.

In Wyeth's most transcendent paintings, those in which the metaphor is most gripping and irreducible, one never notices technique nor feels the contrivance of subject. In *River Cove* [opposite] and *Thin Ice* [page 163], for instance, a moment is made an eternity, a detail of Wyeth's world ordered to reveal the cosmos. Here the dictum of Thoreau's Transcendentalism is made explicit; one feels a sense of the big in the small.

Thoreau's Walden Pond, however, was a paradise, a primeval Garden of Eden, restorative and bountiful in its powers. Wyeth's natural world is far less idyllic. Tension is too close to the surface. Energy seems pent up in the unmoving crystal surface of the water or in the dead leaves locked in their tomb of ice. Wyeth once described the St. George River, a portion of which is seen in the *River Cove*, as "perfectly calm, but underneath there's terrific currents."[68] As the eye floats from the solid land into the murkiness of the water, there is the constant tug to completely abandon oneself in the dark depth of the shadowy reflections. There one senses the undercurrents, contrasted metaphysically with the unnaturally pure crystalline water. "I lay for hours," Wyeth said, "watching the tide creep like little fingers up over the shells dried in the sun. What horrified me was that no power could stop it. And I thought of a friend of mine drowned years ago down river and found half eaten by crabs."[69]

RIVER COVE 1958
Tempera, 48 x 30¼ in.
Mr. and Mrs. David Rockefeller

In *Thin Ice*, solid and void, light and dark, surface and depth, life and death, are disarmingly juxtaposed. In this little microcosm, one's eye does not sweep panoramically as with the descriptive, naturalist landscapes of the nineteenth century. This is a twentieth-century landscape. Visually we see through the ice; emotionally we are brought to the very edge of our subterranean and hidden selves. A *psychic landscape* it might be styled, and its artist a *psychic realist*, for the experience is utterly private and totally modern in its ambiguities. "You don't have to paint tanks and guns to capture the war," Wyeth has said. "You should be able to paint it in a dead leaf falling from a tree in autumn."[70] Thoreau, the quintessential nineteenth-century man, would have seen the heightened reflection of a harmonious universe in that leaf. Wyeth, the son of the twentieth century which has shattered that universe, has no choice but to see things differently.

THIN ICE 1969
Tempera, 45⅜ x 48 in.
Nagaoka Contemporary Art Museum, Nagaoka, Japan

Notes to *The Art of Andrew Wyeth*

1. Henry C. Pitz, *The Brandywine Tradition* (Boston, 1969), p. 232.

2. Thomas B. Hess, "A Tale of Two Cities," in *The New Art*, ed., Gregory Battcock (New York, 1966), p. 171. (Originally published in *Location*, Vol. 1, No. 2, Summer 1964.)

3. Gene Logsdon, *Wyeth People* (Garden City, New York, 1971), p. 5. This book is the classic example of Wyeth's lionization as the modern painter who speaks to the common man. The author, a farmer-journalist, relays how he clandestinely trailed the Wyeths in Pennsylvania and Maine, and interviewed the painter's sitters for insights into his artist-hero.

4. See also the painted portrait of Andrew Wyeth by his sister, Henriette Wyeth Hurd, cover of *Time*, December 27, 1963. Mrs. Hurd did an earlier portrait of her brother in 1956, which is owned by the writer Paul Horgan and is reproduced in the 1960 Dallas Museum catalogue, *Famous Families in American Art*.

5. Wyeth's national notice began in the late 1930's giving him already well over thirty years of public and artistic recognition. At the 1941 International Watercolor Exhibition in Chicago, when he was only twenty-four years old, he was sufficiently well-known to be invited, along with Charles Burchfield and Marc Chagall, to display an individual roomful of his watercolors. In 1947, he received the American Academy's Award of Merit, an honor given but once every five years. He was elected in 1956, along with Edward Hopper, to the American Academy of Arts and Letters. His first large museum retrospective was in 1951, organized jointly by the Currier Gallery in Manchester, New Hampshire and the Farnsworth Museum in Rockland, Maine. In the 1960's the high prices fetched by his paintings and the popular appeal and attendance-breaking records of his museum exhibitions in Buffalo, Philadelphia, Baltimore, New York, Chicago and Boston (see chronology), have been highly publicized. National coverage has also been given to the Medal of Freedom awarded him in 1963 by President Lyndon Johnson, and to the White House exhibition that he had in 1970, the first ever honoring the work of a living American artist.

6. The differences between Wyeth's paintings and those of the Abstract Expressionists began to be remarked upon in the press in 1948–49. In *The New York Times*, December 26, 1948, for instance, the critic suggests that *Christina's World* by Wyeth and *She-Wolf* by Jackson Pollock, both on exhibition at The Museum of Modern Art, were the two "outposts of the Modern movement." In 1948, there was such controversy about the extremism of most modern art that *Life* magazine held a Round Table to discuss the issue. *See Life*, XXV (October 11, 1948), pp. 56–79. *See also* Lincoln Kirstein, "The State of Modern Painting," *Harper's Magazine*, CLXXXXVII (October 1948), pp. 47–53.

7. This remark by Larry Rivers is quoted in "Andy's World," *Time*, LXXXII (December 27, 1963), p. 49.

8. Katharine Kuh, "Why Wyeth?" in *The Open Eye* (New York, 1971), p. 12. This article originally appeared in *The Saturday Review*, LI (October 26, 1968), pp. 26–29.

9. Richard Meryman, "Andrew Wyeth," *Life*, LVIII (May 14, 1965), p. 116.

10. Wyeth was not drafted in World War II because of a physical disability. The war was of enormous concern to his family and a constant topic of conversation. *See* the letters written during wartime in *The Letters of N. C. Wyeth*, edited by Betsy James Wyeth.

11. The most useful pictorial surveys of realist painting in America during these years are: Peyton Boswell, Jr., *Modern American Painting* (New York, 1940); Aimée Crane, ed., *Portrait of America* (New York, 1945); and Alan D. Gruskin, *Painting in the U.S.A.* (New York, 1946). One of Andrew Wyeth's paintings is reproduced in Gruskin's book.

The obviously important role that realist modes played in this period was pointed up by the 260-odd paintings in the 1943 exhibition *American Realists and Magic Realists* organized by The Museum of Modern Art. An assortment of contemporary paintings with a few American old masters as precursors, the exhibition, as described by the catalogue, limited itself to "pictures of *sharp focus and precise representation*, whether the subject has been observed in the outer world—*realism*, or contrived by the imagination—*magic realism*" (p. 5). Including such diverse artists as Edward Hopper, Charles Sheeler, Peter Blume, Jared French, Louis Guglielmi, Ben Shahn, Peter Hurd, and Andrew Wyeth, the exhibition was a broad survey of the realism of the period. The new term used for the exhibition, "magic realism," was never really defined and became a confusing and misleading label which still is used sometimes to describe Wyeth's works.

12. William Carlos Williams, "Sermon with a Camera," *New Republic*, LXXXXVI (October 12, 1938), p. 283.

13. Quoted in "Two Realists," *Newsweek*, XXXIX (June 16, 1952), p. 95.

14. The revival of this medium has never, to my knowledge, been adequately explored. Peter Hurd has said that in the 1930's painters "independently and without knowledge of each other, rediscovered it." *See* Peter Hurd, "The Andrew Wyeth I Know," *Chicago Tribune Sunday Magazine*, April 23, 1967, pp. 36–41, 72–73. One of the most useful books on the medium written in this period was Zoltan Sepeshy's *Tempera Painting* (New York and London, 1946). I am grateful to Jim Rosen for this reference.

15. Two useful articles which discuss Hopper and his use of space are: Jerrold Lanes, "Edward Hopper, French formalist, Ash Can realist, neither or both?" *Artforum*, VII, No. 2 (October 1968), pp. 44–49; and Jean Gillies, "The Timeless Space of Edward Hopper," *Art Journal*, XXXI, No. 4 (Summer 1972), pp. 404–412.

16. Quoted from a letter to the author dated July 14, 1972.

17. Richard Meryman, "The Wyeths' Kind of Christmas Magic," *Life* (December 17), 1971, p. 125.

18. Barbara Novak, *American Painting of Nineteenth Century* (New York, 1969), p. 280.

19. *The Wyeths: The Letters of N. C. Wyeth*, edited by Betsy James Wyeth (Boston, 1971), p. 501. These letters provide a rich source of information about the Wyeth family, and profoundly characterize the man who wrote them. His paintings, illustrations and murals are catalogued and discussed in the recent book, *N. C. Wyeth*, by Douglas Allen and Douglas Allen, Jr. (New York: Crown Publishers, Inc., 1972).

20. For a brief recounting of this project and others entered into by the Wyeth children, *see* Paul Horgan, *Andrew Wyeth, Impressions for a Portrait* (University of Arizona Art Gallery, 1963). Reprinted in *Ramparts*, II (November 1963), pp. 69–84.

21. *Letters of N. C. Wyeth*, p. 607.

22. Meryman, "The Wyeths' Kind of Christmas Magic," p. 125.

23. *Letters of N. C. Wyeth*, p. 773.

24. *Ibid.*, pp. 341–342.

25. *Ibid.*, p. 537.

26. Logsdon, *Wyeth People*, pp. 98–99.

27. Roul Tunley, "The Wonderful World of Andrew Wyeth," *Woman's Day* (August 1963), p. 37.

28. *Letters of N. C. Wyeth*, p. 480. N. C. Wyeth illustrated a book of selections from Thoreau's journals: Francis H. Allen, editor, *Men of Concord and Some Others as Portrayed in the Journal of Henry David Thoreau* (Boston, 1936). There is also a typescript in the Delaware Art Museum Archives of a lecture he gave entitled, "Thoreau, His Critics, and the Public."

29. *Letters of N. C. Wyeth*, p. 355. This remark, N. C. said, was first made by the English landscape painter, John Constable.

30. *Ibid.*, p. 609.

31. *Ibid.*, pp. 774–775.

32. Andrew Wyeth's relationship to Transcendentalism is discussed in: Fred E. H. Schroeder, "Andrew Wyeth and the Transcendental Tradition," *American Quarterly*, XVIII (Fall 1965), pp. 559–567; and Brian O'Doherty, "Wyeth and Emerson: Art as Analogy," *Art and Artists* (London), II (April 1967), pp. 12–15.

33. Quoted in "Two Realists," *Newsweek* (June 16, 1952), p. 94.

34. *Letters of N. C. Wyeth*, p. 205.

35. Selden Rodman, *Conversations with Artists* (New York, 1961), p. 213. Many of N. C. Wyeth's principles of teaching were absorbed from his teacher, the illustrator Howard Pyle.

36. Meryman, "Andrew Wyeth," *Life*, p. 114.

37. *Letters of N. C. Wyeth*, p. 202.

38. *Ibid.*, p. 773.

39. Quoted in press release, entitled "Fact Sheet #2, Newell Convers Wyeth Exhibition," prepared by John Sheppard, Brandywine River Museum, 1972.

40. This exhibition of twenty-three watercolors was held at the Macbeth Gallery in New York from October 19 to November 1 in 1937. While this was Andrew Wyeth's first important New York show, he had had his first one-man exhibition of watercolors the previous year at the Art Alliance in Philadelphia. He did not exhibit temperas until his 1943 exhibition at Macbeth's.

The Macbeth Gallery was one of very few galleries supporting American art at this time. Among many others, it exhibited Charles Burchfield, Edward Hopper, and Reginald Marsh. In 1939, Robert Macbeth presented the first exhibition of N. C. Wyeth's independent paintings, and in 1941 he gave Peter Hurd his first exhibition. Andrew Wyeth exhibited at Macbeth's until 1952 when the galleries closed. For further listings of Wyeth's exhibitions see the chronology at the end of this book.

41. Meryman, "Andrew Wyeth," *Life*, p. 108.

42. Peter Hurd, an artist well known for his regional paintings of New Mexico, received a great deal of national notice in the late 1930's and in the early 1940's for both his paintings and his very popular war illustrations for *Life* magazine. N. C.'s early temperas often have similar characteristics to Hurd's, suggesting N. C.'s stylistic indebtedness to his student and son-in-law as he learned the new medium. In taking up tempera in the late 1930's, N. C. also returned to a more realistic kind of painting, having gone through a brief flirtation with modernist modes in the late 1920's and early 30's. In 1928, for example, he used a quasi-futurist background in a *Self-Portrait in Opera Cape and Hat* and tried a more organic line and distorted space in *Portrait of My Mother* (1929) and in a portrait of his wife (1933).

43. E. P. Richardson, "Andrew Wyeth," *The Atlantic Monthly*, CCXIII (June 1964), p. 68.

44. N. C. Wyeth," *Life*, XX, No. 24 (June 17, 1946), p. 79.

45. This illustration appears on pages 26–27 of *The Brandywine* by Henry Seidel Canby, published in New York in 1941. Other books illustrated by Andrew Wyeth include *Around the Boundaries of Chester County* (1934) by W. W. MacElfree, and *Toward the Morning*, *The City in the Dawn*, *The Forest and the Fort*, and *Bedford Village*, all by Hervey Allen and published by Farrar and Rinehart in the early 1940's.

46. Patrick Hutchings, "Peter Hurd's Fences and the Boundaries of Surrealism," *British Journal of Aesthetics*, IX (January 1969), p. 47. This article considers not only the art of Peter Hurd but also that of Andrew Wyeth and Alex Colville.

47. Nancy Newhall, ed., *Edward Weston* (New York, 1971), p. 42.

48. In this painting one sees strong similarities to some of Andrew Wyeth's contemporaries who painted the figure in surrealist modes. The works of Jared French, George Tooker and Paul Cadmus come to mind.

49. Although Wyeth now dislikes the word "mood" when used in reference to his paintings, he would often use the word in earlier years as a way of describing the emotional effects that he sought. "Mood is what I'm after," he told a *Time* reporter in 1948. "Close to Home," *Time*, LII, No. 22 (November 29, 1948), p. 48.

50. Allene Talmey, "Andrew Wyeth," *Vogue*, CXL (November 15, 1962), pp. 20, 160.

51. "American Realist," *Time*, LVIII, No. 3 (July 16, 1951), p. 72.

52. Meryman, "Andrew Wyeth," *Life*, p. 110.

53. George Plimpton and Donald Stewart, "An Interview with Andrew Wyeth," *Horizon*, IV (September 1961), p. 97.

54. Henry David Thoreau, *Walden* (Signet Classic edition, New York, 1962), p. 102.

55. Museum of Fine Arts, Boston, *Andrew Wyeth* (Boston, 1970), p. 50.

56. Meryman, "Andrew Wyeth," *Life*, p. 106.

57. *Ibid.*

58. Meryman, *Andrew Wyeth* (Boston, 1968), p. 71.

59. Plimpton and Stewart, "Andrew Wyeth," *Horizon*, p. 101.

60. This is the phrase that *Time* magazine, for instance, uses over and over again to describe the technical achievement evidenced by Wyeth's work.

61. Meryman, *Andrew Wyeth*, p. 55.

62. Meryman, "Andrew Wyeth," *Life*, p. 110.

63. Shana Alexander, "The grandfather of all cool actors becomes the Godfather," *Life* (March 10, 1972), p. 44.

64. D. H. Lawrence, *Studies in Classic American Literature* (New York, 1964) (original edition, 1923), p. viii.

65. *Ibid.*, p. 83.

66. Leslie A. Fiedler, *Love and Death in the American Novel* (rev. ed., New York: Delta, 1966), p. 29.

67. Nathaniel Hawthorne's family name was "Hathorne," the same as that of the Olsons' ancestors. Both Hathorne families were seafaring. Nathaniel Hawthorne, who personally added "w" to the spelling of his name, lived as a child for a while in Maine and attended Bowdoin College.

68. Meryman, *Andrew Wyeth*, p. 153.

69. Meryman, "Andrew Wyeth," *Life*, p. 100.

70. Rodman, *Conversations with Artists*, pp. 218–219.

BIBLIOGRAPHY

Deborah H. Loft

This is the first published bibliography on Andrew Wyeth and his work, and has required the collection of references from unusually varied sources. Pertinent material has often appeared in journals outside the art field, in newspapers of small circulation, and among published comments about other artists in the Wyeth family. Because these sources are so scattered and diverse, we cannot offer our compilation as an exhaustive list, but we hope it will be a useful source for both the student and the general public, and provide the groundwork for future Wyeth bibliographers. All available references were included, with the exception of general studies of American art or those which mention Wyeth only in passing.

We are grateful to Mr. and Mrs. Andrew Wyeth for giving us access to reference materials in their possession.

I. LETTERS, STATEMENTS, AND INTERVIEWS
(arranged chronologically)

THE MUSEUM OF MODERN ART, New York. *American Realists and Magic Realists.* 1943.

Statement by the artist, p. 58.

WYETH, ANDREW. "Note on 'The Trodden Weed,'" *Art News*, LI, No. 3 (May 1952), p. 6.

Letter to the Editor.

WYETH, ANDREW. Telegram to Reginald Marsh, April 13, 1954, Archives of American Art, D 308/1474.

Brief congratulations on Marsh's receipt of gold medal.

RODMAN, SELDEN. "Andrew Wyeth," *Conversations with Artists*, New York: Capricorn Books, 1961, pp. 211–221. (Original edition, Old Greenwich, Conn.: The Devin-Adair Company, 1957.)

WYETH, ANDREW. Letter to John Canaday, undated (early January 1961), Archives of American Art, NY JC 2/254.

In reference to Canaday review of Charles Burchfield's paintings, *The New York Times*, January 8, 1961.

PLIMPTON, GEORGE, and STEWART, DONALD. "An Interview with Andrew Wyeth," *Horizon*, IV, No. 1 (September 1961), pp. 88–101.

INGERSOLL, BOB. "Wyeth, Giant Among Artists, Says He's Never Satisfied," *Evening Journal* (Wilmington, Del.), Tuesday, May 14, 1963.

Based on interview.

"Pennsylvania Painter: Andrew Wyeth," *Grackle*, XXXV, No. 3 (Spring 1963). (Published by students of Chestnut Hill College, Philadelphia.)

Based on interview.

WYETH, ANDREW. Letter to John Canaday, October 5, 1964, Archives of American Art, NY JC 5/292.

In reference to Canaday review of Edward Hopper's paintings, *The New York Times*, October 4, 1964, Section II, p. 21.

MERYMAN, RICHARD. "Andrew Wyeth: An Interview," *Life*, LVIII (May 14, 1965), pp. 92–116, 121–122.

MERYMAN, RICHARD. "The Wyeths' Kind of Christmas Magic," *Life*, December 17, 1971, pp. 122–129.

Includes interview with the artist.

II. BOOKS

LOGSDON, GENE. *Wyeth People.* Garden City, New York: Doubleday & Company, Inc., 1971.

MERYMAN, RICHARD. *Andrew Wyeth.* Boston: Houghton Mifflin Company, 1968.

Fine reproductions of the artist's work. Printed in two limited editions, one of them a deluxe edition.

PITZ, HENRY C. *The Brandywine Tradition.* Boston: Houghton Mifflin Company, 1969.

WYETH, BETSY JAMES, ed. *The Wyeths: The Letters of N. C. Wyeth.* Boston: Gambit, 1971.

III. MAJOR EXHIBITION CATALOGUES

ALBRIGHT-KNOX ART GALLERY, Buffalo. *Andrew Wyeth: Temperas, Water-Colors and Drawings.* 1962.

Introduction by Joseph Verner Reed.

ARIZONA UNIVERSITY ART GALLERY, Tucson. *Andrew Wyeth: Impressions for a Portrait.* 1963.

Introduction by Paul Horgan. Reprinted in *Ramparts*, II, No. 3 (November 1963), pp. 69–84.

BRANDYWINE RIVER MUSEUM, Chadds Ford, Pennsylvania. *The Brandywine Heritage.* 1971.

Introduction by Richard McLanathan.

CURRIER GALLERY OF ART, Manchester, New Hampshire, and WILLIAM A. FARNSWORTH LIBRARY AND ART MUSEUM, Rockland, Maine. *Paintings and Drawings by Andrew Wyeth.* 1951.

Introduction by Samuel M. Green.

DALLAS MUSEUM OF FINE ARTS, Dallas. *Famous Families in American Art.* 1960.

Text by J. Bywaters.

DELAWARE ART MUSEUM, Wilmington. *Brandywine Tradition Artists.* 1971–72. New York: Great American Editions, 1971.

Introduction by Rowland Elzea.

FOGG ART MUSEUM, Harvard University, Cambridge. *Andrew Wyeth: Dry Brush and Pencil Drawings.* 1963.

Introduction by Agnes Mongan.

INSTITUTE OF CONTEMPORARY ARTS, London. *Symbolic Realism in American Painting, 1940–1950.* 1950.

Introduction by Lincoln Kirstein.

KNOEDLER, M., & CO., New York. *Exhibition of Paintings by Andrew Wyeth.* 1953.

Introduction by Robert G. McIntyre.

LOS ANGELES COUNTY MUSEUM OF ART, Los Angeles. *Eight American Masters of Watercolor.* 1968.

Introduction by Larry Curry.

MUSEUM OF FINE ARTS, Boston. *Andrew Wyeth.* 1970.

Introduction by David McCord.

THE MUSEUM OF MODERN ART, New York. *American Realists and Magic Realists.* 1943

Foreword by Dorothy C. Miller. Introduction by Lincoln Kirstein.

PENNSYLVANIA ACADEMY OF FINE ARTS, Philadelphia. *Andrew Wyeth.* 1966.

Text by E. P. Richardson.

OKLAHOMA MUSEUM OF ART, Oklahoma City. *The Wonder of Andrew Wyeth.* 1967.

WICHITA ART MUSEUM, Wichita. *Wyeth's World.* 1967.

IV. ARTICLES AND REVIEWS

"Above the Battle," *Time*, LXXX, No. 18 (November 2, 1962), pp. 70–71.

Announces opening of Albright-Knox Gallery exhibition.

"Addition to the Mau Collection: 'Hunter'," *Toledo Museum News*, No. 114 (December 1946), p. 11.

" 'Afternoon' Acquired by the Institute," *Milwaukee Gallery Notes*, XXI (March 1949), p. 3.

ALLOWAY, LAWRENCE. "Critique: The Other Andy," *Arts Magazine*, XLI, No. 6 (April 1967), pp. 20–21.

Review of Whitney Museum exhibition.

"American Realist," *Time*, LVIII, No. 3 (July 16, 1951), pp. 72–75.

Review of Currier Gallery and Farnsworth Museum exhibition.

AMMONS, A. R. "For Andrew Wyeth," *The New York Times Book Review*, October 27, 1968, p. 56.

Poem.

"Andrew Wyeth, an American Realist Paints What He Sees," *Life*, XXIV, No. 20 (May 17, 1948), pp. 102–106.

"Andrew Wyeth," *Art Digest*, XXVII, No. 4 (November 15, 1952), p. 19.

Review of Macbeth Gallery exhibition.

"Andrew Wyeth, in Debut, Wins Critics' Acclaim," *Art Digest*, XII, No. 3 (November, 1937), p. 15.

Review of Macbeth Gallery exhibition.

"Andrew Wyeth, One of America's Youngest and Most Talented Painters," *American Artist*, VI, No. 7 (September 1942), pp. 17–24.

"Andrew Wyeth Repeats Critical Success," *Art Digest*, XVI, No. 2 (October 15, 1941), p. 15.

Review of Macbeth Gallery exhibition.

"Andrew Wyeth: Subjective Realist," *Time*, LXIX, No. 1 (January 7, 1957), pp. 60–61.

Review of Delaware Art Museum exhibition.

"Andrew Wyeth Turns His Attention from Landscapes to Portraits," *Horizon*, IX, No. 2 (Spring 1967), pp. 86–87.

"Andy Wyeth Honored," *Art Digest*, XXI, No. 14 (April 15, 1947), p. 13.

Brief notice of the Award of Merit by American Academy of Arts and Letters.

"Andy's World," *Time*, LXXXII, No. 26 (December 27, 1963), cover and pp. 44–52.

Cover story.

"Appalled and Amazed," *Time*, LXXXIX, No. 8 (February 24, 1967), p. 68.

Review of Whitney Museum exhibition.

"Art in America Annual Award," *Art in America*, LI, No. 6 (December 1963), p. 24.

"Art Has Its Place in the Winning of the War," *The New York Times*, January 3, 1943, Section IX, p. 48.

War poster designed by Wyeth. Illustrated.

"Artist Paints a Ghostly House," *Life*, XXXV (July 27, 1953), pp. 80–83.

" 'Arthur Cleveland,' Favorite Painting in the Pepsi-Cola Show," *Art Digest*, XXII, No. 3 (November 1, 1947), p. 17.

Artist Jr., IX, No. 5 (March 1968).

Entire issue (8 pages) devoted to Wyeth.

BAUR, JOHN I. H. "Andrew Wyeth," in *New Art in America*. Greenwich: New York Graphic Society, 1957, pp. 277–281.

BEAM, PHILIP C. "A Watercolor by Andrew Wyeth and a Short Critique," *Bulletin*, Bowdoin College Museum of Art, II, No. 2 (Winter 1963), pp. 3–11.

The watercolor is "Bermuda."

"Boston Gets 'Memorial Day,'" *Art News*, XLVI, No. 7 (September 1947), p. 8.

BOWER, ANTHONY. "Andrew Wyeth and the Four Seasons," *Collector's Quarterly Report*, I, No. 1 (Winter 1962–63), pp. 2–7.

BOYLE, RICHARD J. "Paintings of the Later Twentieth Century: Cincinnati Museum Acquires Andrew Wyeth's 'Back Pasture,'" *The Cincinnati Art Museum Bulletin*, VIII, No. 4 (October 1968), p. 13.

"Brandywine: A Triumph of Spirit and Strength," *The Saturday Evening Post*, CCXXXXIII, No. 2 (Fall 1971), pp. 68–73.

Review of Brandywine River Museum exhibition.

"Breakthroughs: Exhibition at Manhattan's Knoedler Galleries," *Time*, LXII, No. 20 (November 16, 1953), p. 83.

BREUNING, MARGARET. "Recent Paintings at Knoedler," *Arts*, XXXIII, No. 3 (December 1958), p. 58.

———. "Revealing Anew the Magic of Andrew Wyeth," *Art Digest*, XXIII, No. 4 (November 15, 1948), p. 28.

Review of Macbeth Gallery exhibition.

BRIAN, DORIS. "Is the Sharp Focus Clear?" *Art News*, XLII, No. 2 (March 1–14, 1943), pp. 19–20f.

Review of *American Realists and Magic Realists* exhibition, The Museum of Modern Art.

———. "Watercolor's White Knight: Andrew Wyeth," *Art News*, XL, No. 13 (October 15, 1941), p. 27.

Review of Macbeth Gallery exhibition.

"Briskness and Discipline in A. Wyeth's Work," *Art News*, XXXVIII, No. 2 (October 14, 1939), pp. 12–13.

Review of Macbeth Gallery exhibition.

BUTLER, JOSEPH T. "Andrew Wyeth Retrospective," *The Connoisseur*, CLXV, No. 664 (June 1947), pp. 145, 147.

Review of Pennsylvania Academy of Fine Arts exhibition.

CANADAY, JOHN. "Andrew Wyeth Faces First News Conference," *The New York Times*, February 14, 1967, p. 40.

Review of Whitney Museum exhibition.

———. "A Doubleheader Down East," *The New York Times*, August 1, 1971, Section II, p. 17.

Opening of Christina Olson's house as a museum.

———. "In Boston, Fine Wyeth Retrospective," *The New York Times*, July 16, 1970, p. 38.

Review of Museum of Fine Arts, Boston, exhibition.

———. "Kline and Wyeth," *The New York Times*, November 4, 1962, Section II, p. 23.

Review of Albright-Knox Gallery exhibition.

———. "Natural Wonder," *The New York Times*, October 11, 1959, Section II, p. 16.

Reprinted in *The Embattled Critic*, New York: Farrar, Straus, & Co., 1959.

———. "A Phenomenon of Contradiction: Wyeth's Works to Be Shown in Buffalo," *The New York Times*, November 1, 1962, p. 28.

Review of Albright-Knox Gallery exhibition.

———. "The Wyeth Menace," *The New York Times*, February 12, 1967, Section II, p. 17.

Review of Whitney Museum exhibition.

———. "Wyeth Painting is Bought for $58,000," *The New York Times*, September 25, 1962, p. 39.

Acquisition of *That Gentleman* by Dallas Museum of Fine Arts.

———. "Wyeth Show Opens at White House Today," *The New York Times*, February 20, 1970, p. 28.

———. "Wyeth's Art to Open Museum in Mill; Homely Virtue Depicted," *The New York Times*, June 2, 1971, p. 32.

Announces opening of Brandywine River Museum.

———. "Wyeth's Nostalgia for a Vanished America Is Still a Best-Seller," *The New York Times*, July 26, 1970, Section II, p. 19.

Review of Museum of Fine Arts, Boston, exhibition.

———. "Wyeth's Quiet Art," *The New York Times Magazine*, November 24, 1963, pp. 74–75.

Double-page spread of illustrations; brief text.

CLARK, ELIOT. "Andrew Wyeth: America's Most Popular Painter," *The Studio*, CLX, No. 812 (December 1960), pp. 206–209, 234–235.

———. "New York Commentary," *The Studio*, CLVII, No. 793 (April 1959), pp. 119–122.

Review of Knoedler & Co. exhibition.

"Close to Home," *Time*, LII, No. 22 (November 29, 1948), p. 48.

Review of Macbeth Gallery exhibition. Discusses *Christina's World*.

COHEN, HENNIG. "Wyeth's World," *The Reporter*, XXXV, No. 10 (December 15, 1966), pp. 56–60.

Review of Whitney Museum exhibition.

COOK, MARGE. "Christina," *Down East* (Maine), XIII, No. 9 (June 1967), pp. 34–37, 76.

Biographical article on Christina Olson.

Country Gentleman, CXX, No. 10 (October 1950).

Cover illustration by Wyeth.

CUNNINGHAM, CHARLES C. "Andrew Wyeth Exhibition," *Chicago Art Institute Collections*, LXI (March 1967), pp. 1–4.

DAVIS, CHRISTOPHER. "Christina's World," *Travel and Leisure*, I, No. 4 (Autumn 1971), pp. 46–49, 98.

Christina Olson's house as museum.

DAVIS, DOUGLAS. "The Brandywine School," *Newsweek*, LXVII, No. 26 (June 28, 1971), p. 93.

Brandywine Heritage exhibition; opening of Brandywine Museum.

DE KOONING, ELAINE. "Andrew Wyeth Paints a Picture," *Art News*, XLIX, No. 1 (March 1950), pp. 38–41, 54–56.

Detailed description of Wyeth's process in painting *A Crow Flew By*.

DEVREE, HOWARD. "Four Good First Shows," *The New York Times*, October 24, 1937, Section XI, p. 11.

Review of Macbeth Gallery exhibition.

———. "New Shows," *The New York Times*, October 15, 1939, Section IX, p. 9.

Review of Macbeth Gallery exhibition.

———. "Nordfeldt, Wyeth and Others," *The New York Times*, November 5, 1945, Section II, p. 7.

Review of Macbeth Gallery exhibition.

————. "A Reviewer's Notebook: Brief Comment on Some of the Recently Opened Shows—Wyeth's Water-Colors," *The New York Times*, October 12, 1941, Section IX, p. 10.
Review of Macbeth Gallery exhibition.

DIETZ, LEW. "Andrew Wyeth of Cushing," *Down East* (Maine), V, No. 9 (July 1959), pp. 28–31.

"Disarming Realist," *Time*, XLIX, No. 16 (April 21, 1947), p. 76.
Award of Merit from American Academy of Arts and Letters.

"Does Wyeth's Success Reflect Public's Distaste for Contemporary Art Trends?," *Art Digest Newsletter*, II, No. 5 (March 1, 1967), pp. 1–2.

"An Early Wyeth," *Newsweek*, XXIX, No. 16 (April 21, 1947), p. 94.
Award of Merit from American Academy of Arts and Letters.

"Elected to Membership in the American Academy of Arts and Letters," *Art News*, LIV, No. 9 (January 1956), p. 7.

EISENDRATH, CHARLES. "Wyeth Seeks a 'Certain Thing,'" *The Evening Sun* (Baltimore), December 2, 1966.
Review of Baltimore Museum exhibition.

"Exhibition at Knoedler," *Art News*, LVII, No. 8 (December 1958), p. 13.

"Exhibition at Macbeth Gallery," *Art News*, XXXVI, No. 4 (October 23, 1937), p. 15.

"Exhibition at Macbeth Gallery," *Art News*, XXXXIV, No. 14 (November 1, 1945), p. 6.

"Exhibition, Macbeth Gallery," *Art Digest*, XXV, No. 5 (December 1, 1950), p. 16.

FESS, MARGARET. "Wyeth is Unassuming Despite Claim of Art," *Buffalo Courier Express*, November 2, 1962.
Review of Albright-Knox Gallery exhibition.

FITZSIMMONS, JAMES. "Andrew Wyeth, Rational Romantic," *Art Digest*, XXVIII, No. 3 (November 1, 1953), pp. 16–17.
Review of Knoedler & Co. exhibition.

FOSBURGH, JAMES W. "Andrew Wyeth, an Appreciation," *Harper's Bazaar*, No. 2909 (April 1954), pp. 138–139, 203.

————. "New Light in Andrew Wyeth," *Art News*, LXI, No. 7 (November 1962), pp. 34–36, 62.
Review of Albright-Knox Gallery exhibition.

"Four to Carry On," *Time*, XLVII, No. 4 (January 28, 1946), p. 44.
Brief notice of memorial exhibition to N. C. Wyeth.

FRANKENSTEIN, ALFRED. "An Immense Wyeth Show," "This World," Sunday Magazine Section of the *San Francisco Chronicle*, November 6, 1966, pp. 25–26.
Review of Pennsylvania Academy of Fine Arts exhibition.

FREMONT-SMITH, ELIOT. "Books of the Times," *The New York Times*, November 8, 1968, p. 45.
Review of R. Meryman, *Andrew Wyeth*.

FROST, ROSAMUND. "Andrew Wyeth's Magic Reality," *Art News*, XXXXII, No. 12 (November 1, 1943), p. 14.
Review of Macbeth Gallery exhibition.

GEHMAN, RICHARD. "Andrew Wyeth: Modern Master of Realism," *Cosmopolitan*, CXLVI, No. 2 (February, 1959), pp. 58–65.

GENAUER, EMILY. "Klee and Wyeth—The Hermetic Bond," *New York World Journal Tribune*, February 19, 1967.
————. "A Rear-Mirror View of the Year," *New York Herald Tribune*, December 29, 1963, p. 29.

GETLEIN, FRANK. "Wyeth at the Whitney," *The New Republic*, CLVI, No. 10 (March 11, 1967), pp. 33–34.

GIBBS, JO. "Americans Who Have Passed the Portals of the Modern Museum," *Art Digest*, XXII, No. 7 (January 1, 1949), pp. 9, 30.

————. "Andrew Wyeth Scores High . . ." *Art Digest*, XX, No. 3 (November 1, 1945), p. 15.
Review of Macbeth Gallery exhibition.

GILROY, HARRY. "Book of Art by Wyeth to Sell for $1,500 to $2,000," *The New York Times*, July 9, 1968, p. 36.
Discusses R. Meryman, *Andrew Wyeth*.

GLUECK, GRACE. "Nixon to Fete Wyeth at the White House," *The New York Times*, January 14, 1970, p. 35.
Announces White House exhibition.

GOLD, BARBARA. "Wyeth, An Antidote to Modernism," *The Morning Sun* (Baltimore), December 11, 1966.
Review of Baltimore Museum exhibition.

"Gold Medalist," *American Artist*, XXIX, No. 7 (September 1965), pp. 4–5.

GOODRICH, LLOYD. "Andrew Wyeth," *Art in America*, XLIII, No. 3 (October 1955), pp. 8–23.
Many illustrations with captions provided by the artist.

————. "The Four Seasons: Dry-Brush Drawings by Andrew Wyeth," *Art in America*, L, No. 2 (1962), pp. 32–49.
Portfolio of Wyeth dry-brush drawings.

GORER, GEOFFREY. "American Symbolic Realism," *The Listener*, August 3, 1950, p. 172.
Review of *Symbolic Realism in American Painting, 1940–1950*, exhibition, Institute of Contemporary Arts, London.

HAGAN, R. H. "Andrew Wyeth Paintings of Maine at de Young," *San Francisco Chronicle*, July 27, 1956, p. 17.

HAVERSTOCK, MARY SAYRE. "An American Bestiary," *Art in America*, LVIII, No. 4 (July-August 1970), pp. 38–71.
History of animals in American art, with reference to Wyeth.

HESS, THOMAS V. "The Carnegie Likes The Real Thing," *Art News*, XLVII, No. 7 (November 1948), pp. 15–16, 51.

"Honored by the American Academy of Arts and Letters," *Art News*, XLVI, No. 3 (May 1947), p. 9.

HOOPES, DONELSON F. "The Brandywine Tradition," *The New York Times Book Review*, February 2, 1969, Section 7, pp. 7, 28.
Review of Pitz, *The Brandywine Tradition*.

"Houston Acquires Wyeth's 'Oil Lamp,'" *Art News*, XXIII, No. 16 (May 15, 1949), p. 27.

HUDSON, ANDREW. "The Slack in Andrew Wyeth," *Washington Post*, December 18, 1966.
Review of Baltimore exhibition.

HURD, PETER. "The Andrew Wyeth I Know," *Chicago Tribune Sunday Magazine*, April 23, 1967, pp. 36–41, 72–73.

"Indomitable Vision," *Time*, XCI, No. 6 (February 9, 1968), p. 40.

Notice of Christina Olson's death. Discussion of Wyeth's paintings related to her.

JACOBS, JAY. "Andrew Wyeth—An Unsentimental Reappraisal," *Art in America*, LV, No. 1 (January-February 1967), pp. 24–31.

Letters responding to this article: *Art in America*, LV, No. 2 (May 1967), p. 126.

JANSON, DONALD. "Wyeth's Art to Open Museum in Mill; New Works by Andrew Will Be in Show," *The New York Times*, June 2, 1971, p. 32.

Announces opening of Brandywine River Museum.

JEWELL, EDWARD ALDEN. "Brief Mention," *The New York Times*, November 7, 1943, Section II, p. 7.

Review of Macbeth Gallery exhibition.

KOETHE, E. JOHN. "The Wyeth Craze," *Art News*, LXIX, No. 6 (October 1970), p. 30.

Review of Museum of Fine Arts, Boston, exhibition.

KRIEBEL, CHARLES. "Wyeth Country," *Harper's Bazaar*, No. 3126 (May 1972), p. 136.

KUH, KATHERINE. "Why Wyeth?," *The Saturday Review*, LI (October 26, 1968), pp. 26–29.

Reprinted in *The Open Eye*. New York: Harper & Row, 1971, pp. 11–17.

LANE, JAMES W. "Soldier Stuff in Watercolor," *Art News*, XL, No. 1 (February 15–28, 1941), p. 31.

Group exhibition, New York Water Color Club and American Water Color Society.

"Less is More," *Time*, LXXIV, No. 15 (October 12, 1959), p. 94.

Philadelphia Museum of Art acquires *Ground Hog Day*.

LIONE, LOUISE HICKMAN. "The World of Andrew Wyeth," *The Sun Magazine* (Baltimore), December 11, 1966, pp. 22–27.

Review of Baltimore Museum exhibition.

LOUCHEIM, ALINE B. "Wyeth—Conservative Avant-Gardist," *The New York Times Magazine*, October 25, 1953, p. 28f.

Macbeth Gallery Records, Archives of American Art, NMC4.

Includes exhibition lists and reviews.

McBRIDE, HENRY. "All Quiet on the Whitney Front," *Art News*, L, No. 8 (December 1951), pp. 18–20, 67.

Review of Whitney Annual; reference to Wyeth.

———. "Wyeth: Serious Best-Seller," *Art News*, LII, No. 7 (November 1953), pp. 38–67.

Review of Knoedler & Co. exhibition.

MONGAN, AGNES. "The Drawings of Andrew Wyeth," *American Artist*, XXVII, No. 7 (September 1963), pp. 28–33, 74–75.

Illustrated reprint of introduction to *Andrew Wyeth: Dry Brush and Pencil Drawings*, Fogg Art Museum.

"The Museum of Fine Arts, Boston, Acquires Wyeth's 'Portrait of Anna Christina,'" *The Burlington Magazine*, CXII, No. 812 (November 1970), p. 777.

NEESON, MARGARET GRAHAM. "The Watcher from the Shore," *The Skipper*, XXIII, No. 4 (April 1963), pp. 24–25, 39–41.

NEMSER, CINDY. "Exhibition at the Whitney Museum," *Arts*, XLI (March 1967), p. 54.

NEUMEYER, ALFRED. "Andrew Wyeth," *Die Kunst und das Schoene Heim*, April 1956, pp. 256–259.

NICHOLS, LEWIS. "An American Notebook," *The New York Times Book Review*, December 1, 1968.

Review of R. Meryman, *Andrew Wyeth*.

O'CONNOR, JOHN J. "Kline and Wyeth, Disparate Realists," *Wall Street Journal*, February 28, 1967, p. 18.

O'DOHERTY, BRIAN. "Andrew Wyeth," *Show*, V, No. 4 (May 1965), pp. 46–55, 72–75.

———. "Andrew Wyeth, Art Loner," *The New York Times*, March 30, 1963, p. 5.

Review of Morgan Library exhibition.

———. "Wyeth and Emerson: Art as Analogy," *Art and Artists* (London), II, No. 1 (April 1967), pp. 12–15.

———. "Wyeth Drawings Are Displayed," *The New York Times*, April 1, 1963, p. 55.

Review of Morgan Library exhibition.

"Oslo Museum Gets First U.S. Art," *The New York Times*, November 24, 1960, p. 14.

Acquisition of *Albert's Son*.

PARKHURST, CHARLES. "Wyeth, the Autumnal Mind," *The Sun* (Baltimore), November 3, 1968.

Review of R. Meryman, *Andrew Wyeth*.

"Picky Painting Picker," *Life*, XXXVIII (February 28, 1955), p. 83.

Wyeth as one-man jury for Corcoran Gallery exhibition.

PITZ, HENRY C. "Andrew Wyeth," *American Artist*, XXII, No. 9 (November 1958), pp. 26–33, 65–66.

PORTER, FAIRFIELD. "Andrew Wyeth," *Art News*, LVII, No. 8 (December 1958), p. 13.

Review of Knoedler & Co. exhibition.

"The Preservationist," *Time*, LXXXVIII, No. 17 (October 21, 1966), p. 88.

Review of Pennsylvania Academy of Fine Arts exhibition.

"Presidential Choice," *Time*, XCV, No. 8 (February 23, 1970), pp. 62–65.

Review of White House exhibition.

PRESTON, STUART. "Exhibition Contrasts," *The New York Times*, November 1, 1953, Section II, p. 10.

———. "The Main Line," *The New York Times*, August 5, 1962, Section II, p. 9.

Review of watercolor exhibition at Islesboro, Maine.

———. "Spotlight on Wyeth," *Art News*, XLVII, No. 7 (November 1948), p. 19.

Review of Macbeth Gallery exhibition.

PRICE, MATLECK. "Do Painters Think Posters—or Just Paint Them?" *American Artist*, VI, No. 8 (October 1942), pp. 18–19, 35.

Illustration of Wyeth war poster.

"Q and A with Andrew Wyeth," *The Sunday Bulletin Magazine* (Philadelphia), January 21, 1962, pp. 10–12.

Photo-essay with condensation of Plimpton-Stuart interview.

RAOUL, ROSINE. "Weber and Wyeth: A Study in Opposites," *Apollo*, LXXVIII, No. 19 (September 1963), pp. 222–223.

Review of Morgan Library exhibition.

RAYNOR, VIVIAN. "New York Exhibitions in the Galleries," *Arts Magazine*, XXVII, No. 9 (May-June 1963), p. 112.

Review of Morgan Library exhibition.

REED, JUDITH KAYE. "The Wyeth Family Honors Its Sire," *Art Digest*, XXI, No. 1 (October 15, 1946), p. 10.

REEVES, JOAN. "Wyeth Views His Paintings as He Does Life—as Realist," *Buffalo Evening News*, November 1, 1962.
Review of Albright-Knox Gallery exhibition.

RICHARDSON, E. P. "Andrew Wyeth," *Atlantic Monthly*, CCXIII, No. 6 (June 1964), pp. 62–71.
Based in part on interviews with Andrew Wyeth.

RILEY, MAUDE. "Andrew Wyeth's New Maturity," *Art Digest*, XVIII, No. 3 (November 1, 1943), p. 9.
Review of Macbeth Gallery exhibition.

SANFORD, JEAN. "And the House Wyeth Painted, Too," *The New York Times*, August 6, 1972, pp. 7, 13.
Christina Olson's house open to the public.

SCHROEDER, FRED E. H. "Andrew Wyeth and the Transcendental Tradition," *American Quarterly*, XVII, No. 3 (Fall 1965), pp. 559–567.

SEELYE, JOHN. "Wyeth and Hopper," *New Republic*, CLXVI, No. 11 (March 11, 1972), pp. 18, 22–24.
Review of *The Brandywine Heritage* and *The Wyeths: The Letters of N. C. Wyeth*.

SECKLER, DOROTHY GEES. "Problems of Portraiture, Painting," *Art in America*, XXXVI, No. 4 (Winter 1958–59), pp. 22–37.
Several artists interviewed. Wyeth mentioned and illustrated.

STEWART, PATRICK L., JR. "Andrew Wyeth and the American Descriptivist Tradition," unpublished Master's thesis, State University of New York at Binghamton, 1972.

STODDARD, KENT. "Will Andrew Wyeth Be Popular in 100 Years?" *Delaware Today*, VII, No. 4 (October–November 1968), pp. 14–17, 27.

TALMEY, ALLENE. "Andrew Wyeth," *Vogue*, CXL, No. 9 (November 15, 1962), pp. 118–121, 160–161.
Illustrated with photographs of Wyeth and his environment by Henri Cartier-Bresson.

Ten Color Reproductions of Paintings by Andrew Wyeth, foreword by Philip Hofer, New York: Triton Press, 1956.
Limited edition portfolio of ten reproductions.

"Three to S.A.C.," *The New York Times*, March 13, 1966, Section II, p. 29.
Appointment of Wyeth to the Post Office Department's Stamp Advisory Committee.

Time, LXXIV, No. 10 (September 7, 1959), cover and p. 5.
Cover is Wyeth's portrait of Eisenhower; photo and brief mention of the artist in "Letter from the Publisher."

TOFFLER, ALVIN. "Andrew Wyeth's Experiment in Forgiveness," *Cosmopolitan*, CLVIII, No. 5 (May 1965), pp. 98–103.
Vandalism of Wyeth's studio.

TUNLEY, ROUL. "Andrew Wyeth Revisited," *Woman's Day*, October 1966, pp. 35, 86.

———. "Maine and Her Artists," *Woman's Day*, August 1965, pp. 62–68.

———. "The Wonderful World of Andrew Wyeth," *Woman's Day*, August 1963, pp. 33–37, 67–68.
Reprinted in *Reader's Digest*, CXXXIV (January 1964), pp. 166–170, as "The Haunting World of Andrew Wyeth."

"Two Realists," *Newsweek*, XXXIX, No. 24 (June 16, 1952), pp. 94–95.

TYLER, PARKER. "The Dream of Perspective in Andrew Wyeth," *American Artist*, XIV, No. 1 (January 1950), pp. 35–38.

WAINWRIGHT, LOUDON. "The Mass Sport of Wyeth-Watching," *Life*, LXII, No. 10 (March 10, 1967), p. 27.
Review of Whitney Museum exhibition.

"Watercolorists Meet in Last Joint Session," *Art Digest*, XV, No. 10 (February 15, 1941), p. 12.
American Water Color Society exhibition.

WATSON, ERNEST W. "An Editor Remembers," *American Artist*, XXVI, No. 6 (June–August 1962), p. 41.

"What They Say About *Art News*' 'Ten Best of 1943,'" *Art News*, XLII, No. 17 (January 15–31, 1944), pp. 16–17.

"Will This Art Endure?" *The New York Times Magazine*, December 1, 1957, pp. 48–49.
American art museum directors select their favorites.

WILLIS, GARRY. "The Skylessness of Wyeth," *National Catholic Reporter*, January 18, 1967.
Review of Pennsylvania Academy of Fine Arts exhibition.

WINCHESTER, ALICE. "Living With Antiques, the Pennsylvania Home of Mr. and Mrs. Andrew Wyeth," *Antiques*, LXXXVI, No. 3 (November 1964), pp. 592–597.

"Within Limits," *Time*, LVI, No. 25 (December 18, 1950), p. 49.
Review of Macbeth Gallery exhibition.

"The World of Wyeth," *Newsweek*, LXXVI, No. 8 (August 24, 1970), pp. 54–57.
Review of Museum of Fine Arts, Boston, exhibition.

"Wyeth in New England," *Art Digest*, XXV, No. 19 (August 1, 1951), p. 14.
Review of Currier Gallery and Farnsworth Museum exhibition.

"Wyeth Paints the Solitary American," *The Worker*, March 14, 1967, p. 5.

"Wyeth at Work," *Newsweek*, LX, No. 20 (November 12, 1962), p. 94.
Review of Albright-Knox Gallery exhibition.

"Wyeth's 'Handsome' Show," *Art Digest*, XIII, No. 5, December 1, 1938, p. 21.
Review of 1937 Macbeth Gallery exhibition.

"Wyeth's World," *Newsweek*, LXIX, No. 10 (March 6, 1967), pp. 76–79.
Review of Whitney Museum exhibition.

WYRICK, CHARLES L., JR. "A Wyeth Portrait," *Arts in Virginia*, VIII, Nos. 1 and 2 combined (Fall-Winter 1967/68), pp. 67–69.

YOUNG, GRACE ALEXANDRA. "Andrew Wyeth of Chadds Ford," *The Chester County Artist*, I, No. 7 (July 1950), no pagination, 3 pages.

YOUNG, MAHONRI SHARP. "Letter from U.S.A.: Sublime and Beauteous Shapes," *Apollo*, LXXXVI (July 1967), pp. 65–66.

———. "Wyeth and Manet in Philadelphia," *Apollo*, LXXXIV, No. 57 (November 1966), pp. 403–406.

CHRONOLOGY OF EXHIBITIONS

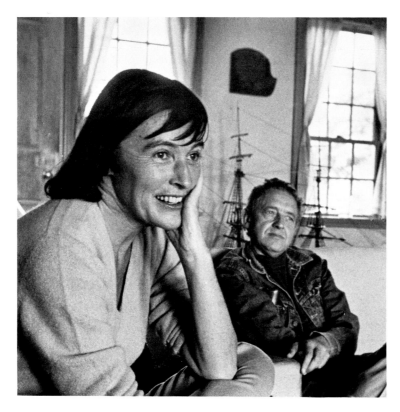

Andrew and Betsy Wyeth; Cushing, Maine, September 1967.
(Photo: Kirk C. Wilkinson)

I. ONE-MAN GALLERY EXHIBITIONS

Macbeth Gallery, New York

1937 *First Exhibition of Water Colors by Andrew Wyeth*
October 19–November 1

1939 *Second Exhibition of Water Colors by Andrew Wyeth*
October 10–October 30

1941 *Third Exhibition of Water Colors by Andrew Wyeth*
October 7–October 27

1943 *Temperas and Water Colors by Andrew Wyeth*
November 1–November 20

1945 *Temperas and Water Colors by Andrew Wyeth*
October 29–November 17

1948 *Andrew Wyeth*
November 15–December 4

1950 *Andrew Wyeth*
November 21–December 9

1952 *Andrew Wyeth*
November 6–November 29

Doll & Richards, Boston

1938 *Water Colors by Andrew Wyeth*
October 24–November 5

1940 *Water Colors by Andrew Wyeth*
November 29–December 14

1942 *Third Exhibition of Water Colors by Andrew Wyeth*
December 7–December 26

1944 *Water Colors by Andrew Wyeth*
December 4–December 23

1946 *Water Colors by Andrew Wyeth*
November 18–December 7

1950 *Water Colors by Andrew Wyeth*
April 17–April 29

M. Knoedler and Co., New York

1953 *Exhibition of Paintings by Andrew Wyeth*
October 26–November 14

1958 *Exhibition of Paintings by Andrew Wyeth*
October 28–November 22

Since 1969, Andrew Wyeth has been represented by Coe Kerr
Gallery Inc., New York.

II. OTHER ONE-MAN EXHIBITIONS AND GROUP EXHIBITIONS WITH MAJOR WYETH PARTICIPATION

1936 Art Alliance, Philadelphia
 Exhibition of thirty watercolors by Andrew Wyeth

1938 Currier Gallery of Art, Manchester, New Hampshire
 Exhibition of Water Colors by Andrew Wyeth

1939 Delaware Art Center, Wilmington

1941 Baldwin Galleries, Wilmington, Delaware
 Exhibition of Water Colors and Drawings by Andrew Wyeth
 February 10–February 24

 St. Andrew's School, Middletown, Delaware
 Exhibition of the Work of Andrew Wyeth
 April 1–April 22

 Art Institute of Chicago
 The Twentieth International Exhibition of Water Colors
 July 17–October 5
 Eighteen Andrew Wyeth watercolors were shown in a separate room of the exhibition.

 Corcoran Gallery of Art, Washington, D.C.
 Joint exhibition of Andrew Wyeth and Peter Hurd.

1943 Museum of Modern Art, New York
 American Realists and Magic Realists
 Eight works by Andrew Wyeth exhibited.

1944 Colby College, Waterville, Maine
 Exhibition of Water Colors and Temperas by Andrew Wyeth
 October 10–October 23

1945 E. B. Crocker Art Gallery, Sacramento, California
 Andrew Wyeth Water Colors
 July 1–July 28
 Organized by The Western Association of Art Museums. Exhibited also at the Seattle Art Museum.

1946 Portraits, Inc., New York
 An Exhibition of Portraits, Landscapes and Figure Compositions by the Painter Members of the Wyeth Family
 October 22–November 9
 A Memorial Exhibition to N. C. Wyeth.

1947 American Academy of Arts and Letters and National Institute of Arts and Letters, New York
 Annual Award Exhibition
 May 22–June 30
 The artist received the Award of Merit in this year. He exhibited nine works in the show.

 Pennsylvania Academy of Fine Arts, Philadelphia
 October 13–October 26

1948 Carnegie Institute, Pittsburgh
 Painting in the United States, 1948
 October 14–December 12

 Berkshire Museum, Pittsfield, Massachusetts
 Water Colors by Andrew Wyeth

1950 Institute of Contemporary Arts, London
 Symbolic Realism in American Painting, 1940–1950
 July 18–August 18
 Included three Andrew Wyeth temperas.

1951 Delaware Art Center, Wilmington
 January 9–January 29
 A Wyeth family exhibition; forty-seven works total, twelve by Andrew Wyeth.

 Currier Gallery of Art, Manchester, New Hampshire and William A. Farnsworth Library and Art Museum, Rockland, Maine
 Paintings and Drawings by Andrew Wyeth
 July 7–August 4 at the Currier; August 10–September 8 at the Farnsworth
 First major museum retrospective; sixty-eight works included.

 Berlin
 Amerikanische Malerei, Werden und Gegenwart
 September 20–October 24
 Two Wyeth temperas included.

1952 Institute of Contemporary Art, Boston
 Summer exhibition of Andrew Wyeth and Waldo Pierce.

1954 Contemporary Arts Museum, Houston
 Americans from the Real to the Abstract
 January 10–February 11
 Exhibition of Andrew Wyeth, Ben Shahn, Abraham Rattner, and Robert Motherwell.

1955 Worcester Art Museum, Massachusetts
 Five Painters of America
 February 17–April 3
 Andrew Wyeth, Louis Bouché, Edward Hopper, Ben Shahn, and Charles Sheeler.

 Museum of Art of Ogunquit, Maine
 Third Annual Exhibition
 July 1–September 11

1956 M. H. de Young Memorial Museum, San Francisco
 Andrew Wyeth
 July 12–August 12
 Also exhibited at Santa Barbara Museum of Art, California, August 28–September 23

1957 Delaware Art Center, Wilmington
 January 8–February 3

1960 Dallas Museum of Fine Arts
 Famous Families in American Art
 October 8–November 20
 Works by ten members of the Wyeth family were exhibited.

 Hayden Gallery, M.I.T., Cambridge, Massachusetts
 Andrew Wyeth, A Retrospective Exhibition of Temperas and Water Colors
 November 9–December 4

1962 Town Hall, Islesboro, Maine
 Exhibition of Dry Brush and Water Colors by Andrew Wyeth
 July 21–August 6

 Albright-Knox Art Gallery, Buffalo, New York
 Andrew Wyeth: Temperas, Water Colors and Drawings
 November 3–December 9
 Large museum retrospective of 143 works.

1963 University of Arizona Art Gallery, Tucson
 Andrew Wyeth
 March 16–April 14

1963 Fogg Art Museum, Harvard University,
Cambridge, Massachusetts
Andrew Wyeth: Dry Brush and Pencil Drawings
Also exhibited at Pierpont Morgan Library,
New York; Corcoran Gallery of Art, Washington, D.C.;
William A. Farnsworth Library and Art Museum,
Rockland, Maine.
> Seventy-three works exhibited.

1964 Brandywine Lions Club, Chadds Ford, Pennsylvania
Andy Wyeth Day
May 30

Swarthmore College, Swarthmore, Pennsylvania
Three Generations of Wyeths

Boardwalk Art Exhibit, Ocean City, New Jersey
Special Wyeth Exhibit

Wilmington Society of Fine Arts, Delaware
*The William and Mary Phelps Collection of Paintings
and Drawings by Andrew Wyeth*
October 14–November 6

1965 Schauffler Memorial Library, Mount Hermon School,
Massachusetts
Wyeth Exhibit
May 8–May 23
> Exhibition of N. C., Andrew, and James Wyeth.

1966 Parrish Art Museum, Southampton, New York
Loan Exhibition of Paintings by the Wyeth Family
July 30–August 22

Pennsylvania Academy of Fine Arts, Philadelphia
Andrew Wyeth
October 5–November 27
Also exhibited at the Baltimore Museum of Art,
December 11, 1966–January 22, 1967;
Whitney Museum of American Art, New York,
February 6–April 12, 1967; Art Institute of Chicago,
April 21–June 4, 1967.
> Retrospective of 222 works.

1967 Wichita Art Museum, Kansas
Wyeth's World
September 15–November 15

Virginia Museum of Fine Arts, Richmond
A Wyeth Portrait
November 13, 1967–January 14, 1968
> This exhibition of one tempera and its fourteen
> prestudies traveled throughout state of Virginia
> in an Artmobile during 1968.

Oklahoma Museum of Art, Oklahoma City
The Wonder of Andrew Wyeth
December 3–24

1968 Los Angeles County Museum of Art
Eight American Masters of Water Color
April 23–June 16
Also at M. H. de Young Museum, San Francisco,
June 28–August 18, 1968; Seattle Art Museum,
September 5–October 13, 1968

Delaware Art Center, Wilmington
The Phelps Collection
May 10–October 20

William A. Farnsworth Library and Art Museum
Rockland, Maine
> Summer exhibition of twenty-five Maine paintings
> by the artist.

Chadds Ford Historical Society, Chadds Ford,
Pennsylvania
The Chadds Ford Art Heritage, 1898–1968
Chadds Ford Mill, September 6–September 15
> Exhibition of the Brandywine artists.

1969 Chadds Ford Historical Society, Chadds Ford,
Pennsylvania
Chadds Ford Reflections of a Culture
Tri-County Conservancy Mill, July 4–July 6

Bamberger's, Newark, New Jersey
November 17–December 27

1970 Washington County Museum of Fine Arts, Hagerstown,
Maryland
Andrew Wyeth, Temperas, Watercolors and Drawings
February 8–March 22

The White House, Washington, D.C.
February 19–March 31

Museum of Fine Arts, Boston
Andrew Wyeth
> Retrospective of 170 works.

1971 Brandywine River Museum, Chadds Ford, Pennsylvania
The Brandwine Heritage
> Exhibition of Howard Pyle, various Howard Pyle
> students, N. C., Andrew, and James Wyeth.

Delaware Art Center, Wilmington
Brandywine Tradition Artists
October 1971–October 1972

INDEX

Page Numbers in bold refer to illustrations.
Titles of paintings by artists other than Andrew Wyeth
are listed under the artists' names.